ADAM

THE MALE FIGURE IN ART

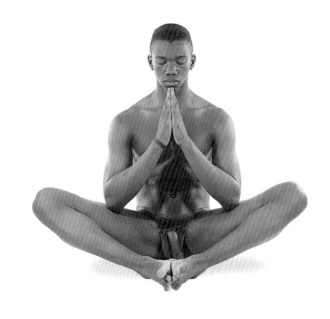

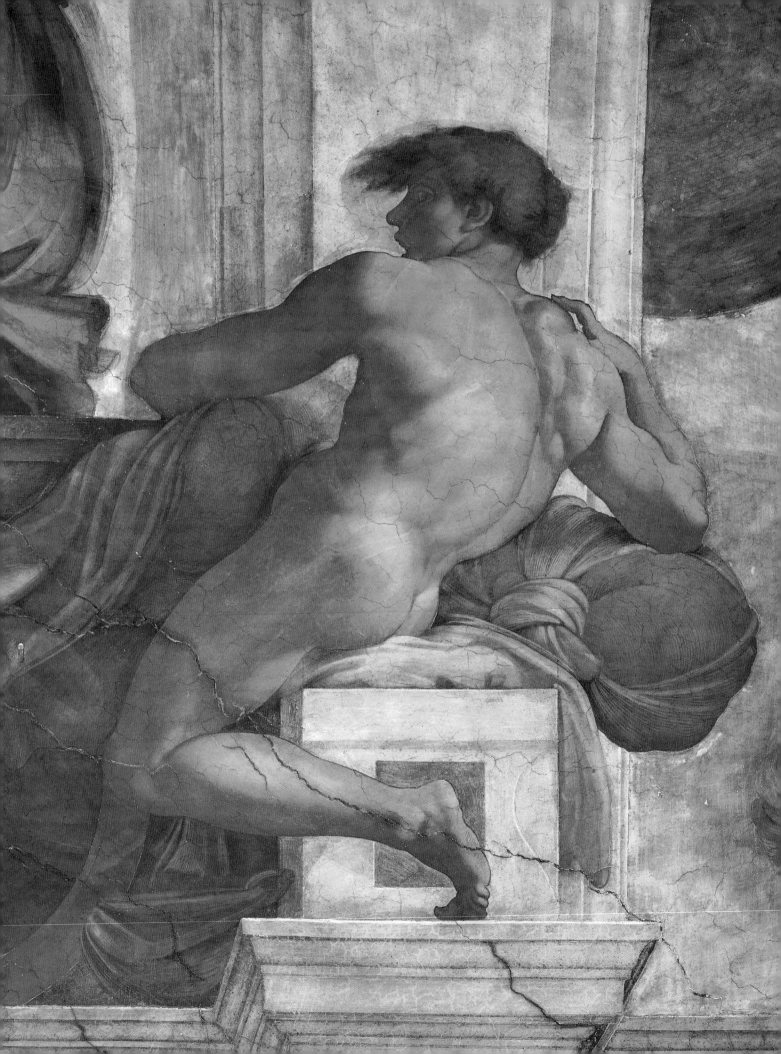

ADAM

THE MALE FIGURE IN ART

EDWARD LUCIE~SMITH

RIZZOLI
NEW YORK

First published in the United States of America in 1998 by

RIZZOLI INTERNATIONAL PUBLICATIONS INC.

300 Park Avenue South, New York, NY, 10010

Design copyright © The Ivy Press Limited 1998

Text copyright © Edward Lucie-Smith 1998

ISBN 0–8478–2125–0

LC 98–65445

This book was conceived, designed and produced by

THE IVY PRESS LIMITED

2/3 St. Andrews Place

Lewes, East Sussex BN7 1UP

Art Director: *Peter Bridgewater*

Editorial Director: *Sophie Collins*

Editor: *Nicola Young*

Designer: *Clare Barber*

Page Makeup: *Richard Constable*

Picture Research: *Liz Eddison*

Printed and bound in Singapore

Illustration–Page 1: *Tony Butcher* (1996)

Illustration–Page 2: *Michelangelo* from the Sistine Chapel (1508–12)

Illustration–Page 5: *Tony Butcher* (1997)

CONTENTS

INTRODUCTION

REPRESENTATIONS OF THE MALE *play a major role in the tradition of Western art —*
much more than in other cultures. In the West, these images preserve the remnants of pagan
tradition. At the same time they are central to the myth of Original Sin, which, in turn, stands
at the heart of the Judaeo-Christian tradition. A Greek kouros, *celebrating the*
beauty of the young male, and making it an offering to the gods, is as much
a part of the story of art as Masaccio's Adam as he stumbles naked and
ashamed from the Garden of Eden.

There is, however, something even more striking and curious than this
simple dichotomy. Masaccio's figure, though asymmetrical in outline and
depicted in motion, is undoubtedly a descendant of the classical prototypes
which were in the process of being rediscovered as Masaccio painted
Expulsion *in the Brancacci Chapel in 1425. In fact, one can make a*
case for the idea that, despite Christian hostility to the body, which had
been greatly reinforced by the writing of the early Church Fathers, such

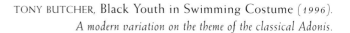

TONY BUTCHER, Black Youth in Swimming Costume (1996).
A modern variation on the theme of the classical Adonis.

as St Augustine, fascination with the naked male figure had never wholly disappeared from Western art, despite the transition from paganism to Christianity.

The basic purpose of this book is to discuss the paradoxes inherent in Western attitudes to the image of the nude or naked male — it should be remembered that writers on the subject have frequently tried to make a distinction between these two states. In the course of the discussion I will, of course, be taking sidelong glances at the attitudes of other cultures towards male nudity.

Although it is clear that Western attitudes, both among artists

and among commentators on art, have evolved historically, it seems more convenient to discuss the material thematically, rather than to attempt to put it in strict chronological order. My first chapter, therefore, looks at the male image as a mirror held to the ideal. One reason for treating the subject in this way is that it high-lights the correspondences between very different epochs, which might otherwise be concealed by stylistic differences.

It is important, however, to realize that the nude male body is not simply a way for artists to explore their sense of what is beau-tiful and what is not. It is also a potent — in all senses of that

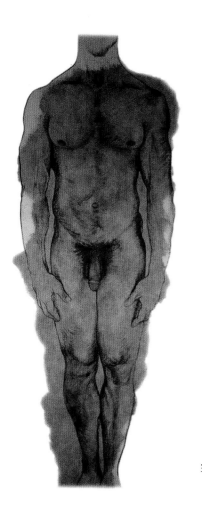

3 PETER LIASKOV (b. 1939), Man (1995).
A contemporary version of the traditional life-drawing.

4 TONY BUTCHER'S *1996*
photographic study
isolates the torso so as to
make the image resemble
a traditional life-drawing.

adjective — means of conveying emotion. At the same time, changing attitudes towards male nudity cast a revealing light on the process of social change viewed as a whole. The second part of my text devotes attention to this aspect of the subject, which seems particularly relevant today because such changes have been especially rapid during the last thirty years, and have sometimes taken directions which no-one could have predicted as recently as the late 1960s.

In effect, representations of naked males are not an enclosed, self-contained department of art (or of art and photography, if one thinks one can separate the two forms of expression). They are social catalysts, perhaps at the moment even more so than female nudes, and a consideration of why artists have made, and continue to make them, and of how the audience reacts, reaches into every corner of our society.

For example, one of the subjects any author of a book of this nature must immediately consider is the different ways in which the two genders seem to react to this kind of subject-matter. It has long been accepted that men respond very directly to representations of nude women. The sexual nature of this reaction is undoubted because these are images which speak of men's control and dominance over women — so much so that, in recent years, feminist theoreticians have put forward the idea that images of nude females are equivalent to a form of rape. Despite the increasingly liberal nature of our society in other respects, images of nude females

now enjoy less, rather than more acceptance than they did thirty years ago. One of the most dated elements of the Pop Art of the 1960s, for example, is its fascination with the pin-up as an icon of mass-market, blue-collar culture.

The question is, do women react or have they reacted in the same way to representations of nude men? And how are these representations to be construed in present circumstances? The issues here are fairly complex, since they involve ideas about both nature and nurture — what human beings are like essentially, and how their behaviour is shaped by external circumstances. If women were not interested in men as sexual partners, then it seems logical to say that the human race would not have succeeded in perpetuating itself, however great the masculine reservoir of force and fraud. If they do have this interest, it seems logical that they might be interested in the physical appearance of a potential partner, as well as in his other qualities. The success of the matinée idol and the beefcake movie star in twentieth-century Western culture does seem to confirm that women are

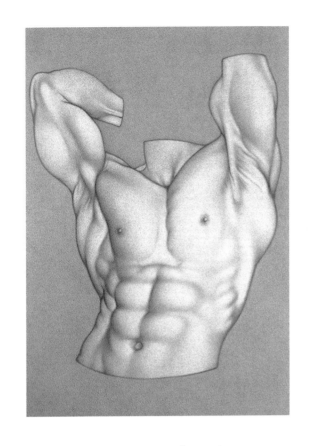

WILLIAM FOGG (b. 1953), **5**
Blue Poser (1994). An image which alludes both to traditional life-drawing and the poses struck by contestants in modern bodybuilding competitions.

SIR PETER PAUL RUBENS (1577–1640), Hercules. **6**
In this drawing Rubens exaggerates the already ample forms of the Greco-Roman Farnese Hercules.

interested in the way men look. A not insignif-icant detail is the notorious disparity of salaries between male and female movie stars. This, in turn, is predicated by the Hollywood studios on their perception that male stars are bigger box-office draws than female ones. At least 50 per cent of the core movie audience is female.

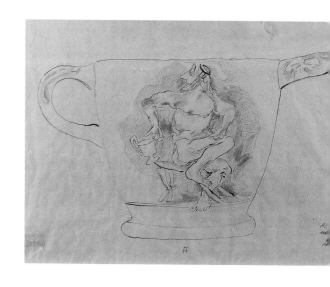

OSKAR KOKOSCHKA (1886–1960), Study for a Murano glass cup (1953). *In designing this decorative item, the famous Austrian Expressionist referred to classical images of male nudity.*

Prior to this century, however, society made it very difficult to express this kind of physical attraction openly. One reason, paradoxically, was the perception, supported by the Bible and by the Fathers of the Church, that woman was the 'weaker vessel', unable to resist physical temptation. There was also the notorious double standard – women were required to be chaste, while this requirement was not imposed on men. This sprang in part from the primitive perception that a woman could never be in a position safely to deny the parentage of a child. A man, on the other hand, could scatter his seed broadcast and get away with it.

When applied to the field of artistic activity, these prohi-bitions meant that it was very difficult for a woman to obtain

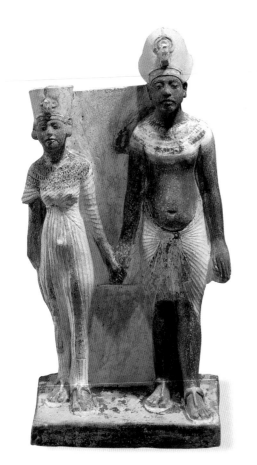

Pair statuette of Akhenaten and Nefertiti (*Egyptian, Amarna Period, 1365–49 BC*). *An image of the 'heretic pharaoh' which shows the androgynous portrait type the king seems to have preferred.*

professional artistic training in Western societies, since, certainly from the Renaissance onwards, much of this was based on the meticulous study of the male nude. This was not the only barrier to female participation in the visual arts. The Renaissance studio was itself the product of the earlier medieval guild system. In the later Middle Ages, the tightly organized guilds, which governed most forms of craft production, were

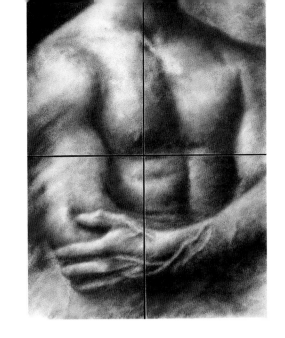

9

KIM POOR, Tamacavi (1997). Part of a series referring to the plight of the Amazonian Indians in Brazil. Nudity and 'innocence' are equated.

male-dominated. Female participation, it was felt, would lower wages and threaten the control the guilds exercised over the market for their skills. Women did, however, enter the system through marriage, but their role was generally that of managing a workshop rather than participating with their own skills. It was, for example, a common practice for businesses to change ownership through inheritance by females. A middle-aged master craftsman, having married a much younger wife, would in due course die and leave her his business. She, in turn, would make a second marriage to a young journeyman, ready to graduate to the status of master and carry on the workshop. The pattern would then repeat itself in the next generation.

In these circumstances, women who became professional painters generally did so because they

10 F. SCOTT HESS (b. 1955), Self-Portrait (1994). Artists have frequently used themselves as models. In this nude study Hess follows a tradition set by Egon Schiele and Stanley Spencer.

11 JOHN SONSINI (b. 1950), Miguel
(1997). *The image makes piquant use of
the contrast between nudity and clothing.*

were members of an established family firm, that probably lacked enough men to fulfil all the orders that it was receiving. Marietta Tintoretto (c. 1560-90) and Artemisia Gentileschi (c. 1597-1651) had fathers who were celebrated artists. In both cases it is sometimes difficult to separate what they produced from work done by these fathers, and, in Marietta's case, by other members of the Tintoretto shop. Independent female artists, rare creatures indeed, but commoner in France and the Netherlands than in Italy, were almost invariably specialists in 'lesser' genres – flowers and still life rather than paintings of the human figure. Louise Moillon (1609/10-96) and Rachel Ruysch (1664-1750) are well-known cases in point.

When women began to push for an independent creative existence in the second half of the nineteenth century, one of the battles that faced them was for the right to study the male nude on the same terms as male entrants into the same profession. Thomas Eakins (1844-1916), not only one of the most celebrated American artists of the period, but also one of the most celebrated teachers of art, was forced to resign his position as director of the Pennsylvania Academy of Fine Arts in 1886 due to his insistence that the model, whether male or female, should be studied completely nude: 'I am sure [he wrote at the time] that the study of anatomy is not going to benefit any grown person who is not willing to see or be seen seeing the naked figure and my lectures are only for serious students wishing to become painters and sculptors.'

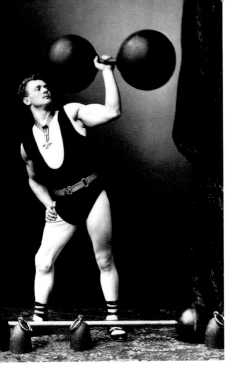

The problem was that the Pennsylvania Academy admitted women, and it was the worried mothers of some of these female students, in combination with envious colleagues, who contrived to push Eakins out.

By the time women began to achieve something approaching equality with men in the art world, the study of the nude had long since fallen into disuse and was no longer a standard means of training artists.

The rise of feminist art, from the mid-1970s onwards,

2 The World's Strongest Man (c. 1890). *A photograph showing the very different masculine ideal of a century ago.*

did not do much to change this situation, though one of the pioneers of the movement, Judy Chicago (b. 1939), has made some fine studies of male nudes, one of which is reproduced in this book. The reasons for this are complex. One is the visceral distaste for all nude representations which inspired many feminists. If the female nude chiefly aroused their ire, then the male nude also attracted condemnation, since in the eyes of some feminists every form of nude representation was an expression of patri- archal control on the part of the artist or

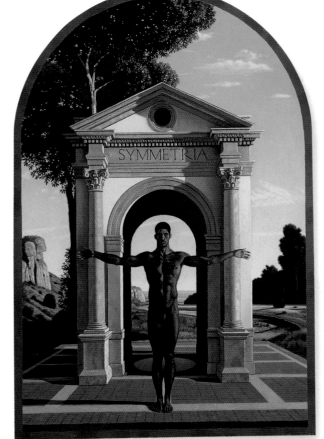

3 DAVID LIGARE, Symmetria (1997). *A contemporary image which takes up the age-old idea of the body as the measure of beauty and proportion.*

photographer who made it, just as all varieties of sexual intercourse were to be seen as a form of rape. Alternatively, if this version was not acceptable, then images of naked males could be seen as threatening icons of masculine potency. That is, if male nudes in paintings and photographs were not a form of rape, then they threatened rape. This form of feminism offers in another guise a revival of the old puritan fear of the body.

RAJPUT SCHOOL, A Prince and a Lady (c. 1790). This erotic illustration to the Kama Sutra shows only a schematic understanding of the male body (above).

Hellenistic herm from the Mahdia shipwreck (c. 100 BC). The male nude is reduced to its operative parts — head and genitals (left).

In addition to this, feminist art often tended to avoid established forms, such as painting and sculpture, on the grounds that these are freighted with patriarchal meanings, and has turned to conceptual expressions and performance work, in which the image of the nude male seldom has a place.

At the same time, however, two things began to happen. One was gay liberation, which offered a new perspective on the male nude — a subject fully dealt with later in this book. Another was a gradual loosening of female as opposed to feminist attitudes, as society at last seemed to tell women 'Yes, it's OK to look.' One can attribute the first stage of this liberation to the cinema. There, in a private but collective darkness, women were free to indulge their

fantasies without shame or guilt. From this, by gradual stages, we have reached the situation we now have, where male strippers perform for women at hen nights, and where male performance groups like the Chippendales target a female audience not a male homosexual one.

In her pioneering study, The Nude Male: A New Perspective, *published in 1978, Margaret Walters pinpointed some of the problems created by the new situation – in particular, the fact that pictures of naked men directed at women often seemed to take over stereotypes derived from pictures of naked women designed for an audience of men. The male was no longer aggressive in these images, but passive, vulnerable, manipulable. And such pictures were still largely the creation of males, trying to imagine what women might want to look at, rather than the creation of women for themselves.*

In two decades, the situation has not changed that much. The female audience for the male nude exists, and is at long last not afraid to declare itself. But the definitive female painter or photographer of the subject has yet to appear. In that respect, this is an unfinished book.

6 ZSUZSI ROBOZ, Nicholas Johnson. *Roboz is one of the few contemporary female artists to have made studies of the male nude – in this case a dancer with the Royal Ballet.*

The Measure of the Beautiful

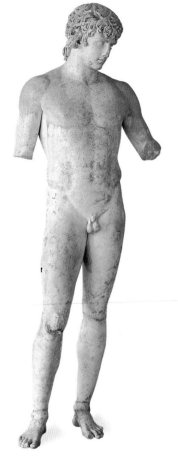

H OW DID THE MALE NUDE *become, not merely the instrument of measure, but the measure of beauty in Western art? It seems natural enough that humans, when they began to think in terms of spatial division, also thought in terms of their own bodies — so many palms, or lengths of the hand; so many feet; so many strides to cover a distance. No doubt it seemed equally natural, in patriarchal societies, where men were more physically active than women, that these measurements should be codified in terms of the male rather than the female body. A fifth-century Greek relief in the Ashmolean Museum, Oxford, showing the head and shoulders of a man, and his two outstretched arms, was evidently meant to serve as a standard of measurement, and makes my point succinctly. But to consider the male rather than the female body as the measure of beauty, the aesthetic norm? That is surely a rather different question.*

Greek art, originally influenced by the art of Anatolia and the Near East, began to renew itself in the mid-seventh century BC under the influence of the ancient Egyptians. It was from the Egyptians that the Greeks learned to make monumental sculptures in stone. From the beginning, however, there were differences in the works produced by the Greeks which marked fundamental differences between the two cultures.

17 Statue of Antinous (*second century* AD). *This portrait of Hadrian's favourite sums up the Greco-Roman ideal of youthful beauty.*

18 PABLO PICASSO (1881–1973), Les Adolescentes (1906). *This Blue Period work shows the young Picasso reshaping classical ideas in a way unusual for a modernist artist of his generation* (right).

16

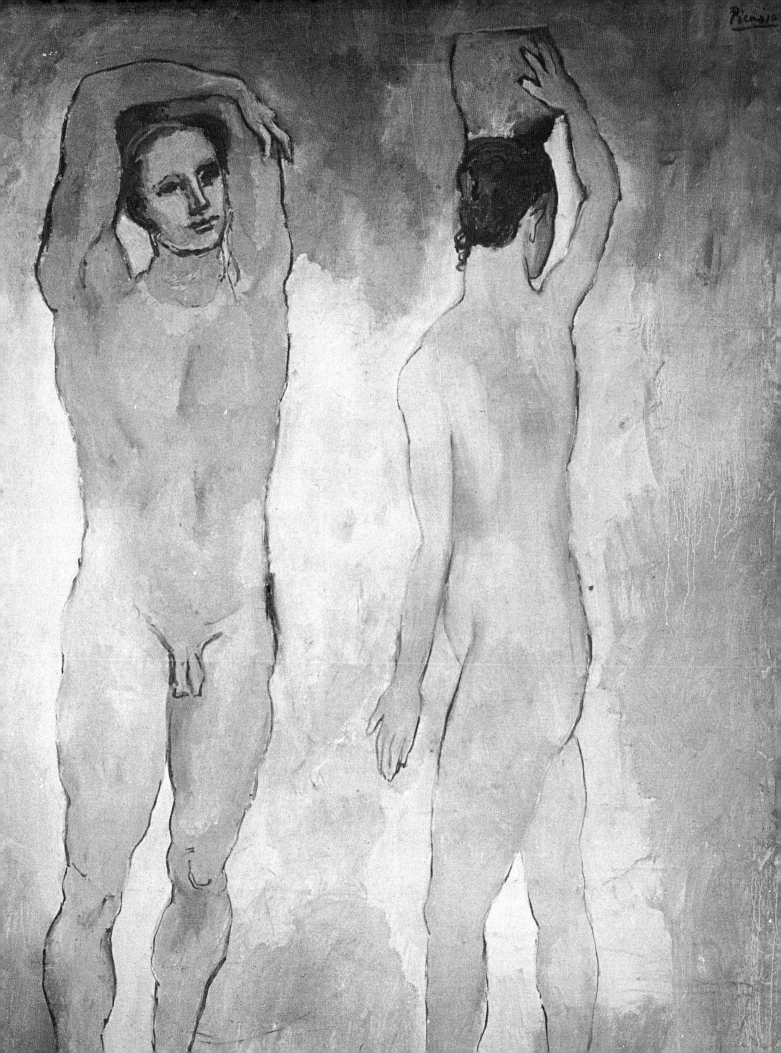

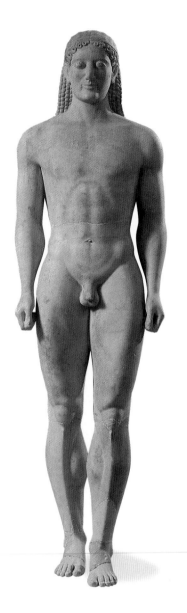

19 Kroisos. *Attic* kouros *from Anavyssos* (c. 520 BC). *A superb example of a Greek late Archaic* kouros *statue, erected as a memorial to a named person.*

Though some ancient Egyptian sculptures, even those produced as early as the Fifth Dynasty have a surprisingly naturalistic effect, the artists who made them seldom represented either male or females entirely unclothed. When they did make a figure of a nude male, it usually took the form of a stylized and massively ithyphallic image of Min, the Egyptian god of fertility. There do survive, however, one or two nude portrait images which were meant to provide a refuge for the *ka*, or spirit, of a dead man if his embalmed body was destroyed. The best-known example is the wooden image of King Hor, one of the monarchs of the Old Kingdom, which is now in the Cairo Museum. This is, as its purpose demanded, 'complete' in every detail, but remains surprisingly unsensual and austere in its effect. It is also a private work in the strictest sense, meant to be hidden in a tomb, and never intended for public display.

The opposite is the case with the Greek *kouroi*, or statues of youths, which are the artistic successors, on the other side of the Mediterranean, of the standing figures created by the Egyptians. Dedicated in shrines, or intended as grave monuments, these were celebrations of the strength and beauty of the youthful human male. In the earliest examples, the sculptures are assemblages of parts, each part conceptualizing a different fragment or aspect of the human body – eyelid, nose, elbow, belly, buttock, thigh, kneecap, toe. *Kouroi* are invariably nude. Their female counterparts, *korai*, or statues of maidens, which were also made as dedications in shrines, are, however, always elaborately clothed.

Even at this stage the Greeks emphasized sensual aspects of the male body to which the Egyptians had remained blind. The powerful buttocks and thighs of early *kouroi* are eloquent not only of their potential ability to run and leap, but also of their latent sexual energy. When similar figures are set in motion, as we see them on the Greek black-figure vase-paintings of the same epoch, these sensual or sexual aspects are, if anything, further emphasized.

Both the statues of *kouroi* and the vase-paintings make it clear that male nudity had overtones in Greek society which are very different from those which nudity holds in our own. Greek education placed great emphasis on the practice of athletic sports, initially a form of training

20 *This* cippus *(tomb slab) from Ptolemaic Egypt is carved with a representation of the youthful sun-god Horus, which has been influenced by the conventions of Greek art.*

21 *Egyptian sculptor's model showing a king smiting his foes. This Egyptian carving of the same date as the Horus opposite maintains purely Egyptian conventions for depicting the figure.*

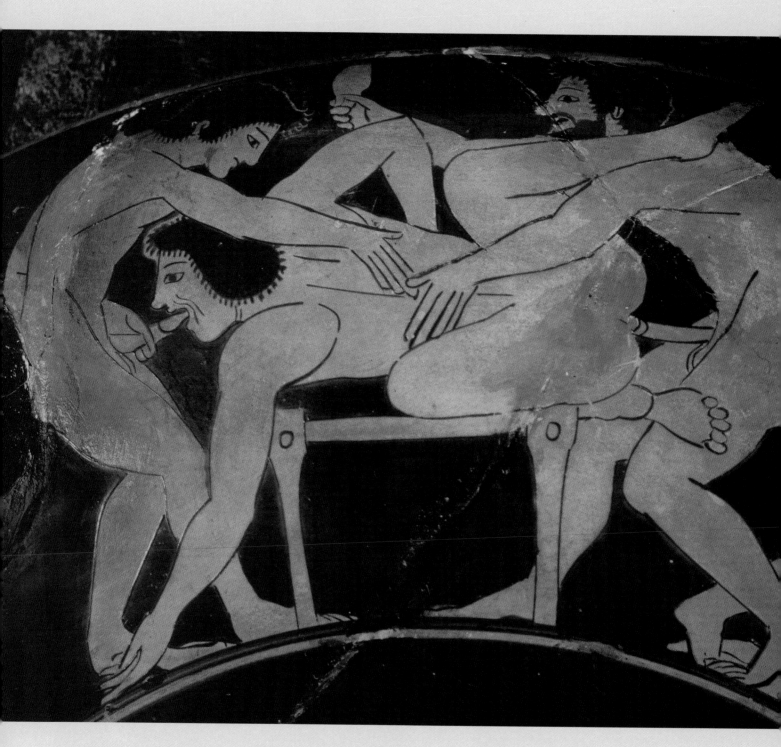

22 *Attic red-figure cup of c. 500 BC showing an orgy. This demonstrates the freedom from convention shown by Greek artists when called on to portray the male nude as part of a non-standard subject.*

for a warrior class. These sports were practised nude, and the Greek *palaestra*, or open-air sports ground, usually surrounded by colonnades which contained not only cloakrooms and massage-rooms but actual classrooms, were the favoured social meeting place of boys and young men. This segregation of the sexes encouraged the formation of emotional attachments between males which the Greeks regarded as truer and purer than heterosexual bonds. Many Greek vases, for example, carry so-called *kalos* inscriptions, either praising a particular boy, or declaring in more general terms that 'the boy is *kalos*', or beautiful. A number of vases are adorned with actual courtship scenes, showing flirtations between slightly older and slightly younger males.

The sexual element in these courtship scenes sometimes declares itself openly, when the older of the two lovers or would-be lovers is shown with an erection. More often it is alluded to symbolically, when the older male presents the object of his desire with a cockerel.

There is one aspect in all of these representations – in the statues of *kouroi* as much as the vase-paintings – that seems to contradict the idea that the Greeks of the Archaic period (*sixth century* BC) were totally at ease with male nudity, and this is the fact that the actual genitalia are always undersized in proportion to the rest of the figure. The same thing can be observed in the Egyptian portrait statue of the previously mentioned King Hor. This seems to argue that the Greeks did have a certain wariness about giving fullest expression to the idea of male sexual potency.

The vase-paintings and sculptures that address the idea of male sexuality directly (three-dimensional works in this case are almost invariably small-scale statuettes) are usually representations of satyrs – creatures of the wild who were part man and part beast. These were shown in one of two ways, either with a horse's tail and ears, or with a goat's legs and tail, but always with an erect phallus. In the vase-paintings, it is these satyrs, part man and part beast, who commit the most blatantly sexual acts, both heterosexual and homosexual.

At the beginning of the fifth century BC, Greek art gradually became more naturalistic. Whereas the *kouroi* of the Archaic period had always been stiffly frontal, figures now begin to bend and twist in a much greater variety of attitudes. One of the earliest examples is the *Discobolus* of Myron (*fl. 480–440* BC), which survives in a number of Roman copies. The *Discobolus* already seems to propose itself, in a much more complete sense than the *kouroi*, as a representation of the ideal male – that is, as an amalgamation of all the characteristics that could lead one to think of the male body as beautiful.

23 *Greco-Roman copy after Myron, the* Discobolus *(original c. 480 BC). An early attempt to show the athletic male body in action, full scale.*

24 *This atmospheric photograph of Roman statues in the archaeological museum in Naples gives a good idea of the degree to which classical sculpture of the male nude became standardized under the Roman Empire.*

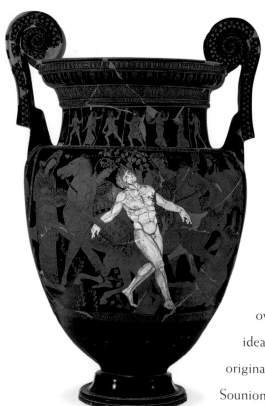

25 *Greek volute crater showing the death of the mythological bronze giant Talos, red-figure with additions in white (c. 420-390 BC). The vase-painting attempts a heroic subject matter, not entirely successfully.*

26 ROBERTO RINCÓN (b. 1967), Warrior (1994). *A young Venezuelan photographer working in New Orleans offers a slightly parodistic version of classical conventions (right).*

This tendency was carried forward in two sculptures by Myron's younger contemporary, Polyclitus (*fl. 440 BC*), both also known only through copies. The *Diadumenus* ('Man Tying a Fillet', *c. 430 BC*) and the *Doryphorus* ('Spear Bearer', *c. 450–440 BC*) were widely accepted in antiquity as canonical representations of male nudity in its fullest perfection. The *Doryphorus* was used as the prime exemplar in a theoretical work on sculpture which discussed the ideal mathematical proportions and relationships of the different parts of the human body. The notion of the naked human male as the fullest measure of perfection here emerges for the first time in its developed form. It was to remain influential throughout the whole later history of Greek and Roman art.

There are two things to be said here, however. One is that, even in Polyclitus' own time, the male nude remained a profoundly expressive form, often loaded with ideas that have little to do with stereotyped ideas of 'classical' perfection. Surviving originals from the same period, notably the striding *Zeus* (or *Poseidon?*), found in the sea off Sounion, and the two *Riace Warriors*, discovered as recently as 1972 in the waters near Reggio Calabria, emphasize that representations of the male could now be vehicles for a wide variety of different emotional states. The uneasy ferocity of the two Riace bronzes issued a challenge to all received ideas about the nature of Classicism as the Greeks themselves understood it.

The other is that the Polyclitan canon did not remain fixed. It had already begun to be varied by the sculptors of the following generation, such as Praxiteles (*c. 370–330 BC*) and Lysippus (*c. 336–270 BC*), who made heads of the figures smaller in proportion to the body as a whole, and the whole effect more elongated. In the Hellenistic period (*300 BC–AD 1*), Greek artists developed a much wider range of physical types. On the one hand they evolved images of exaggerated masculinity, like the *Farnese Hercules* and the *Belvedere Torso*. On the other, they made sculptures not only of youths, but of pre-pubescent male children, both as images of Eros, the god of love, and as participants in various genre scenes, such as the image (once again known only through Roman copies) of a boy trying to strangle a goose.

It is also significant that, in the late-Classical period, the female nude at last began to play a significant role in Greek art. Praxiteles' fame rested on his female nudes even more than it did on his male ones. The masterpiece that sustained his fame was his *Aphrodite of Cnidus*, where the goddess of love is shown naked after her bath.

Though the tradition of making representations of nude male figures did not collapse completely with the coming of Christianity – there was a notable revival of the motif, for example, in the hands of the thirteenth-century Italian sculptor Nicola Pisano (*c. 1220–78/84*) – it was not

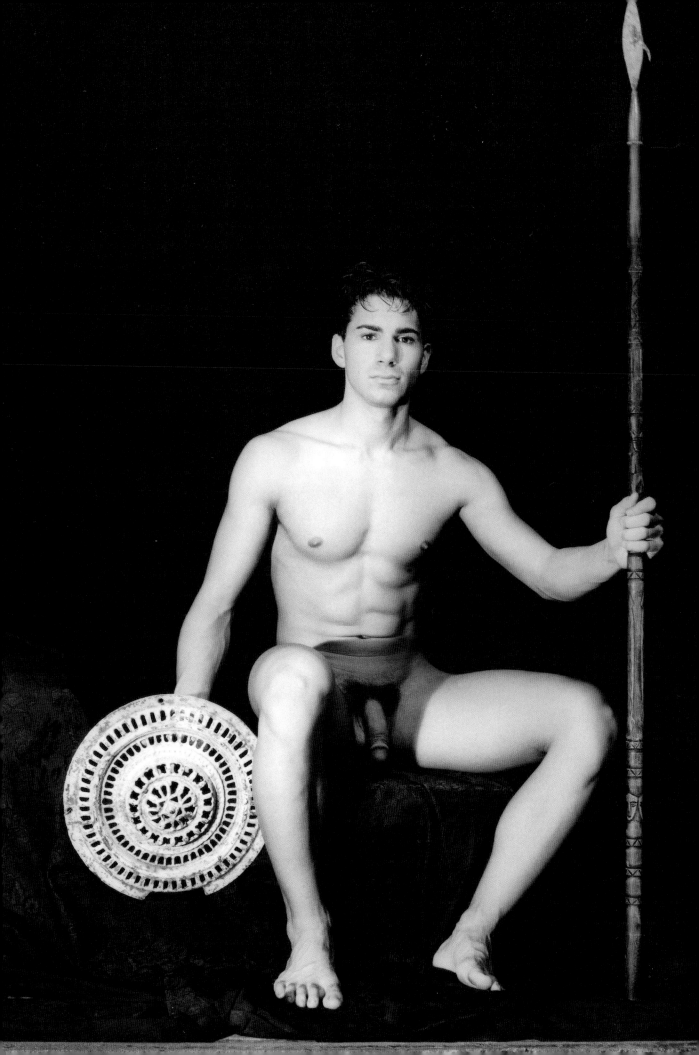

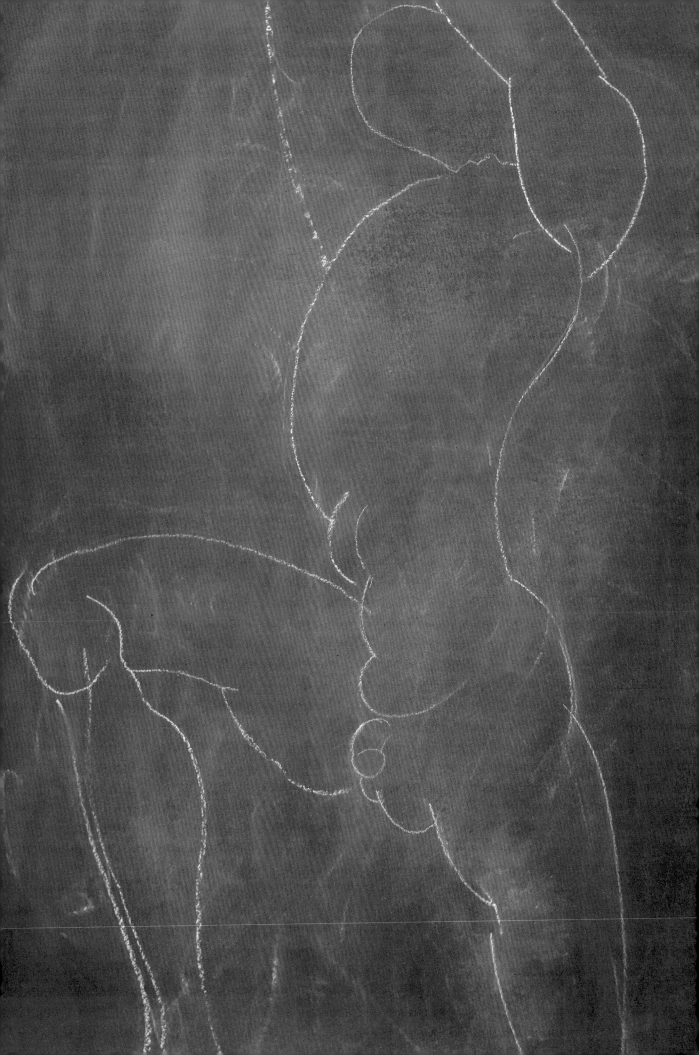

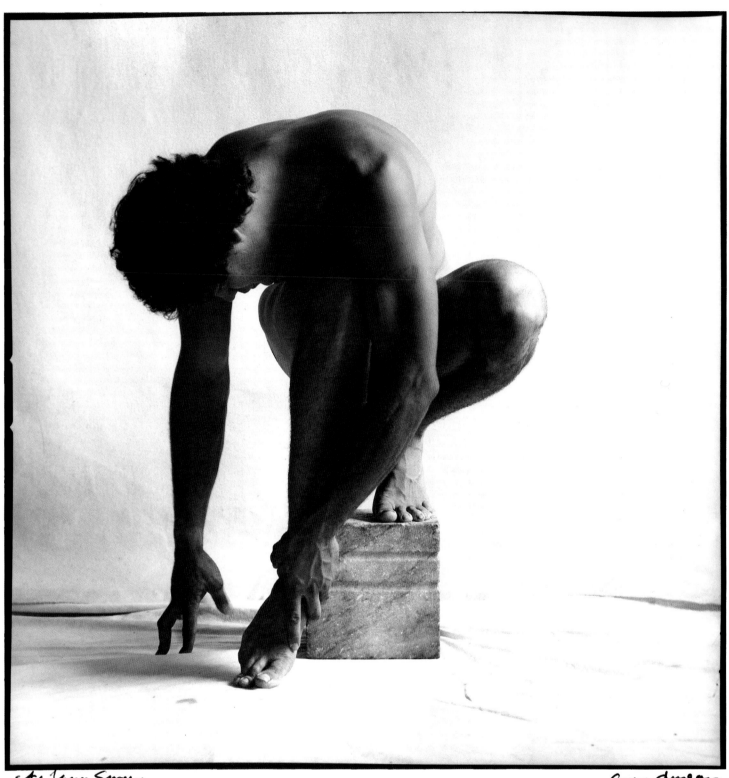

27 SANTIAGO CARDENAS, Atleta (1997). This
 'blackboard drawing' by a leading Colombian
 contemporary artist has a classicism tempered
 by Cardenas' admiration for Matisse (left).

28 GEORGE DUREAU (b. 1930), Lann
 Sawyer (1985). An immensely
 accomplished photographer of the male
 nude, Dureau has a liking for twisting,
 complex poses which recall Hellenistic
 sculpture (above).

until the coming of the Renaissance that representations of naked men once again became the common currency of art.

Both sculptors and painters became obsessed with the nude as the measure of human perfection, and a series of notable images were created by masters who were otherwise as different in temperament from one another as Masaccio (1401–28), Donatello (1386–1466), Leonardo da Vinci (1452–1519), Michelangelo (1475–1564) and Raphael (1483–1520).

Certain elements made this enterprise necessarily different from what the Greek and Roman artists had achieved. The first of these was the fact that, while Renaissance artists modelled themselves on antiquity, the antiquity they knew was one, not of Greek originals, but of Roman copies. The Romans, with their omnivorous appetite for everything Greek, telescoped the development of Greek art. They also truncated it, since, while a few 'archaising' sculptures were made in copyists' workshops for decorative purposes, the focus of Roman interest was the products of Classicism and what followed it. Some of the Greek works that Renaissance artists admired most, such as the *Laocoön Group* (50 BC) and the *Belvedere Torso* (c. 350 BC), were very late products of Greek workshops, originals perhaps, but made for wealthy Roman patrons.

Another factor was the first stirring of the modern scientific spirit. While Greek sculpture in 'developed' styles often astonishes us with its apparent correctitude and fidelity to nature, there is little evidence that the Greeks made an intensive study of human anatomy. Indeed, what we know of Greek medicine suggests the contrary. Traditional Greek anatomy, as handed down in the writings of Galen (c. AD129–199), a physician who served the Emperor Marcus Aurelius, is largely based on analogies with animals, among them the pig and the monkey. The dissection of human bodies was strictly forbidden by Roman religion of the time.

In the fifteenth century, despite equally strong Christian religious prohibitions to the contrary, artists began to dissect corpses and record what they observed in meticulous drawings. According to Giorgio Vasari (1511–74), the Florentine painter and engraver Antonio Pollaiuolo (1432/3–98) 'dissected many bodies in order to examine their inner anatomy, being the first to show the method of searching for the muscles to take form and order in the figure'[1]. One product of this was Pollaiuolo's engraving *The Battle of the Nude Gods* (c. 1480) which demonstrates his preoccupation both with the study of anatomy, and with the male nude as the image of a physical ideal.

The Renaissance artist best known for his anatomical investigations is Leonardo da Vinci, not merely because he seems to have pursued them more passionately than anyone else, but because a number of his anatomical drawings have survived. He began his anatomical studies when he was living in Milan in 1485, and returned to them in 1510–11. His ultimate aim was to publish a book, but, like so many of Leonardo's projects, this was never realized.

[1] *Giorgio Vasari, Lives of the Artists, trans. George Bell, 2 Vols (Penguin, 1987), Vol. 2, p.76.*

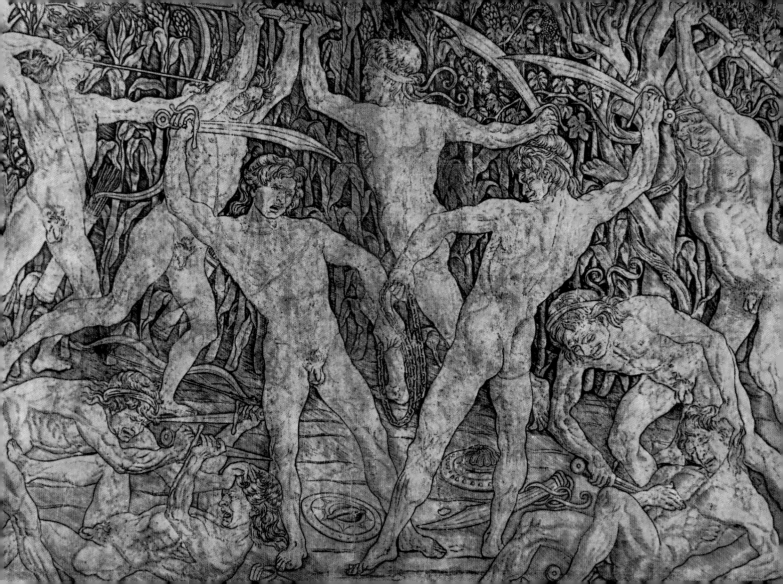

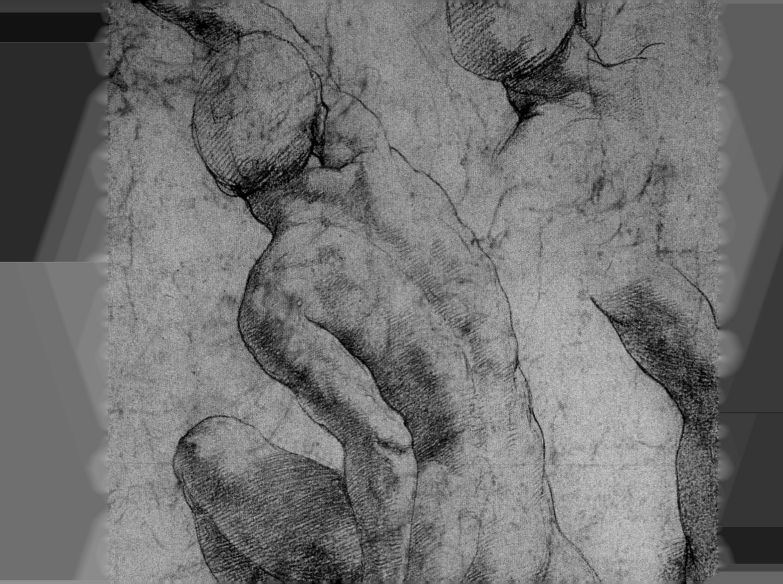

Renaissance anatomical studies were not codified until the appearance of an epoch-making work by the Flemish physician Vesalius (Andreas van Wesel, 1514–64). Vesalius' major work *De humani corporis fabrica libri septem* ('The Seven Books on the Structure of the Human Body'), commonly known as the *Fabrica*, was first published in Basel in 1543. It was based on dissections Vesalius had made himself, and was illustrated with superb woodcuts made under his own supervision, probably in the studio of Titian (1487/90–1576). Vesalius' intentions were primarily scientific, but his book had an immense impact on artists. Henceforth, the professional artist was not only expected to make meticulous observations of the external appearance of the human body, but also to have some knowledge of its internal structure.

Vesalius' observations, and those of the anatomists who followed him, were almost entirely based on the male, not the female body. When women's bodies were illustrated in anatomical textbooks, this was always in connection with specialist observations of the human reproductive system. Similarly, the studio practice of Renaissance artists concentrated on the male, not the female. Artists' studios were at first organized according to a bottega, or workshop, system inherited from the Middle Ages. In addition to doing preparatory work, such as grinding colours for the master, studio apprentices were also expected to pose when required.

There are preparatory drawings made by Raphael (1483–1520) for some of his Madonnas which show that the pose of the Virgin was in fact studied from a young boy. Since painters' workshops were nearly always completely masculine affairs, it would have been considered indecent for a woman to pose – still more indecent if she were to be even partially unclothed.

Gradually, towards the end of the sixteenth century, the situation altered as art began to be thought of as a profession rather than a trade. The result was the foundation of academies of art, in imitation of the other sorts of learned and scientific societies then appearing in Italy. The most influential of these early artistic academies was the Accademia degli Incamminati, founded in Bologna around 1585 by members of the Carracci family, in order to foster their ideas and train young artists. Opposed to the Mannerist style which then still prevailed in Italy, the Carracci favoured a clear, direct presentation of what was seen. The foundation of their method of training was the study of the nude – specifically the male nude, since female models, though no longer completely taboo, remained rare. The teaching methods evolved by the Carracci were hugely influential, and formed a foundation for artistic education throughout Europe, a system which lasted until the opening years of the present century, when it was challenged by the competing methods of the Bauhaus (not founded until 1919).

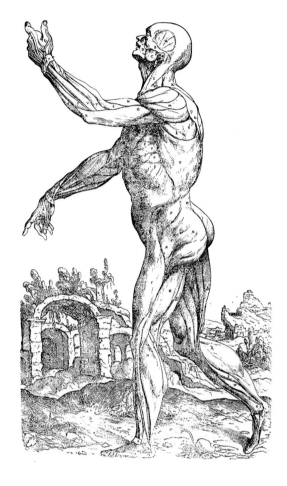

30 RAPHAEL (1483–1520), Seated Nude (1511–14). *In this drawing Raphael shows the impact made on him by Michelangelo's cartoon for the unfinished fresco* The Battle of Cascina. *Raphael saw this in Florence before moving to Rome in 1508 (left).*

31 STEPHEN VON CALCAR (1499–1546/50), *after Titian.* Woodcut for Vesalius' Fabrica. *These anatomical woodcuts had an enormous impact on artists from the sixteenth century onwards (above).*

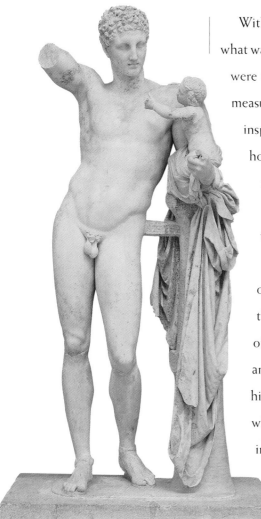

Within the academic system there was always a certain tension between the observation of what was real, and the search for ideal forms initiated by the Greeks. Leonardo's anatomical studies were undertaken with the underlying idea that man – and therefore the male body – was the measure of all things. The proportional drawings made by Albrecht Dürer (1471–1528) were inspired by the same idea. Academic artists studying the male nude from life, were taught how to generalize and idealize the form presented by the model. A curious relic of this impulse are anatomical illustrations based on the forms of Greek statuary – for example, a book published in 1812 by the Frenchman Jean-Galbert Salvage (1772–1813), analyzing the anatomy of the *Borghese Gladiator*, a statue of the first century BC now in the Louvre.

It is no accident that Salvage's work is, as its date of publication indicates, a late product of the neo-Classical movement in art. Neo-Classicism evolved from a reconsideration of the artistic heritage of antiquity. This was inspired in almost equal parts by the rediscovery of the buried cities of Pompeii and Herculaneum, destroyed in a volcanic eruption in AD79 and first excavated in the early eighteenth century, and the theories of the German art historian, Johann Joachim Winckelmann (1717–68). In 1755 – which was also the year in which he visited the excavations at Pompeii – Winckelmann published an enormously influential essay, *Gedanken über die Nachahmung der griechischen Werke in der Malerei und Bildhauerkunst* ('Reflections on the Painting and Sculpture of the Greeks').

It was followed by a general history of Greek art, *Geschichte der Kunst des Altertums* ('History of the Art of Antiquity', 1764). This perceived in ancient art an organic development of growth, maturity, and decline, and inaugurated the division of ancient art into periods, a system which remains in common use today: a pre-Phidian (or Archaic) epoch; the high or sublime style of the great Greek sculptors Phidias and Polyclitus of the fifth century BC; then, the elegant or beautiful style of the sculptor Praxiteles; and, lastly, a period of eclectic imitation, Hellenistic and Roman. Though in fact few Greek originals were known to him, Winckelmann preached with great eloquence concerning the 'noble simplicity and quiet grandeur' of Greek sculpture. He was the source of a renewed impulse towards idealization in art, which applied particularly to representations of the human figure. Effective visual propaganda for his doctrines was made by the widely circulated outline engravings made by the British sculptor John Flaxman (1755–1826) as illustrations to the *Iliad* and *Odyssey* of Homer (1793) and the plays of Aeschylus (1795).

Neo-Classicism was the first movement in the history of Western art to be led by intellectuals rather than artists. Where representations of the human body, and especially the male body, were concerned, it created enormous tensions through the pressure it put on artists to conform to a

32 PRAXITELES (*fl.* 370–330 BC), Hermes Carrying the Infant Cephistodotus. *Thought to be the only surviving original work, this statue was discovered at Olympia (above).*

33 LUCA SIGNORELLI (1441/50–1523), Resurrection (*detail, Orvieto Cathedral, 1499–1502). One of the most ambitious Renaissance attempts to depict the male nude in as many poses as possible (right).*

34 MAERTEN VAN HEEMSKERCK (1498–1574). *A leading northern artist tackles a classical subject –* The Triumph of the Bibulous Silenus. *The subject is an excuse to show male nudes, in a variety of attitudes (over page).*

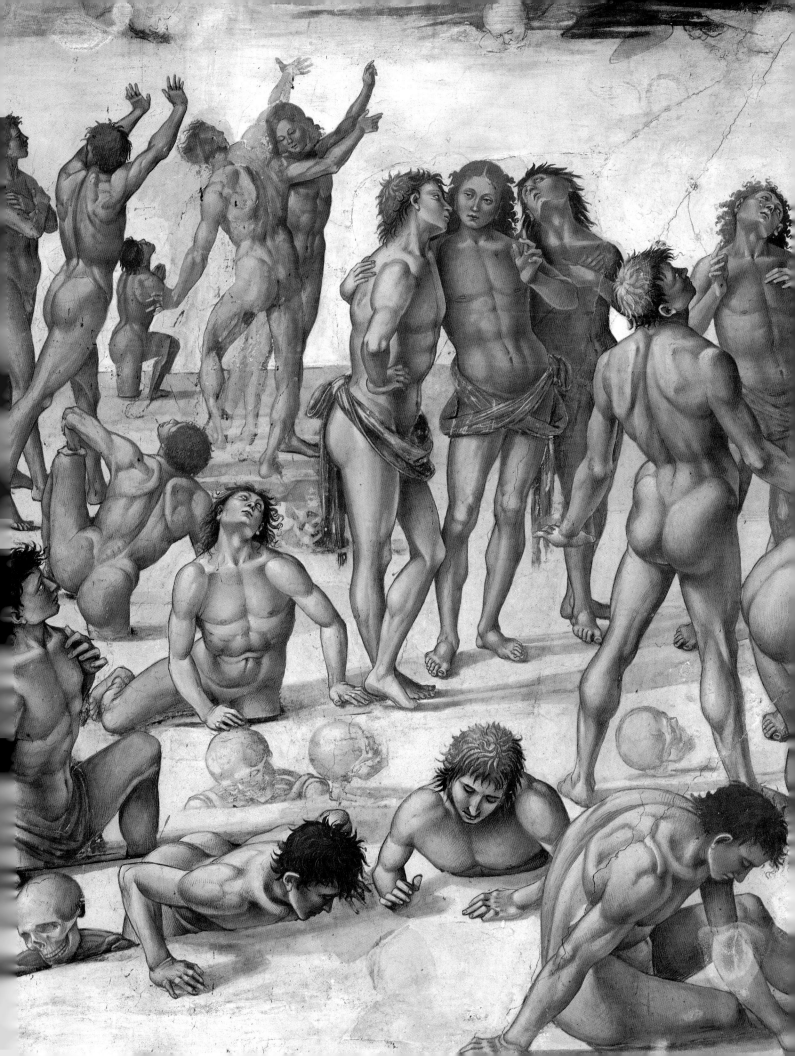

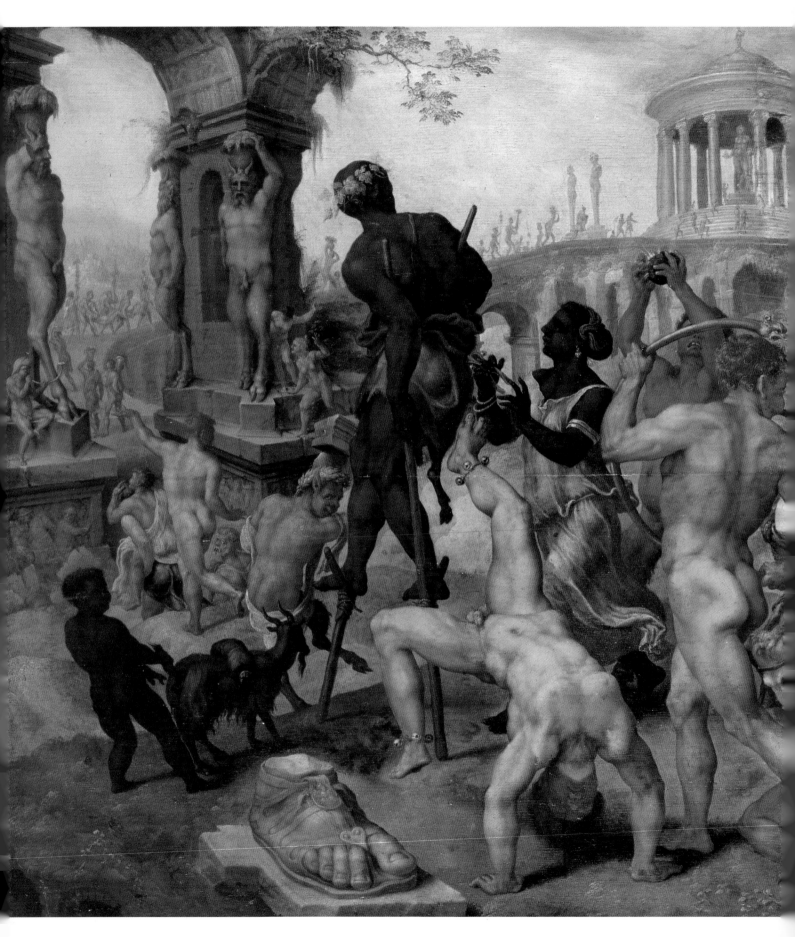

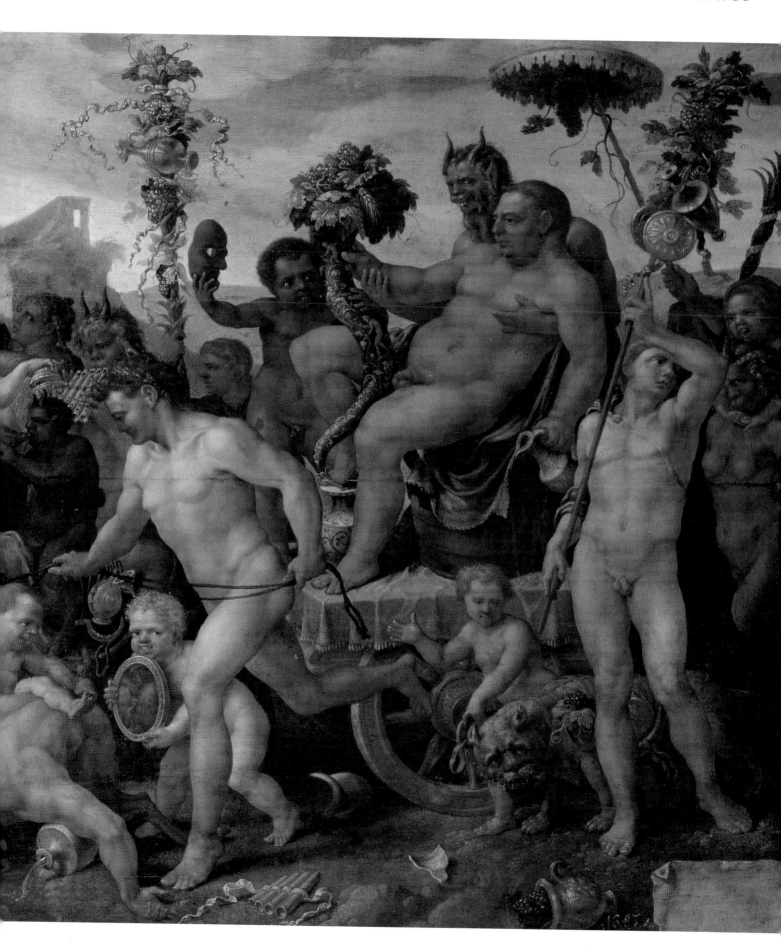

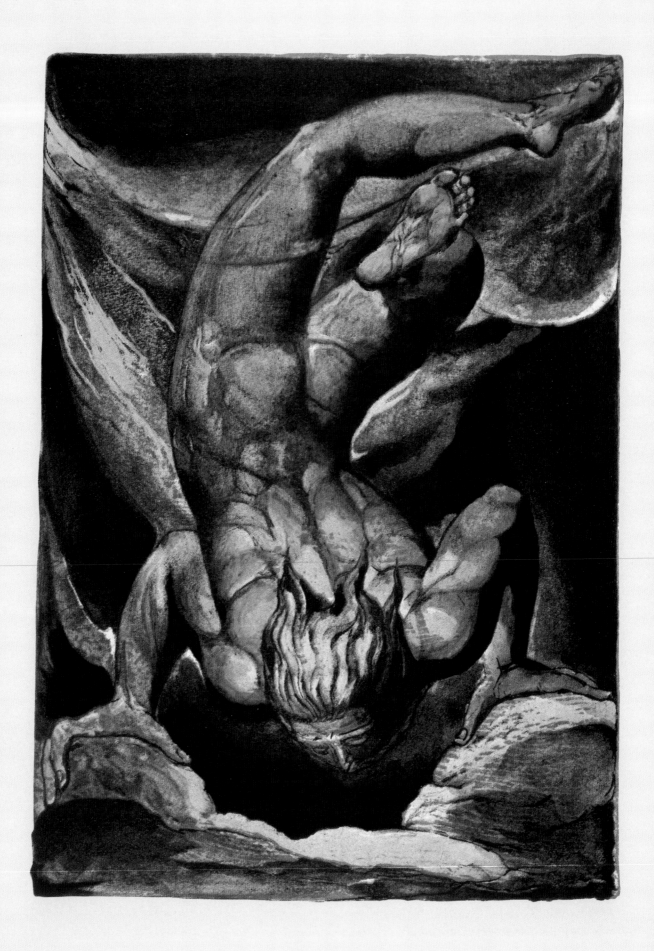

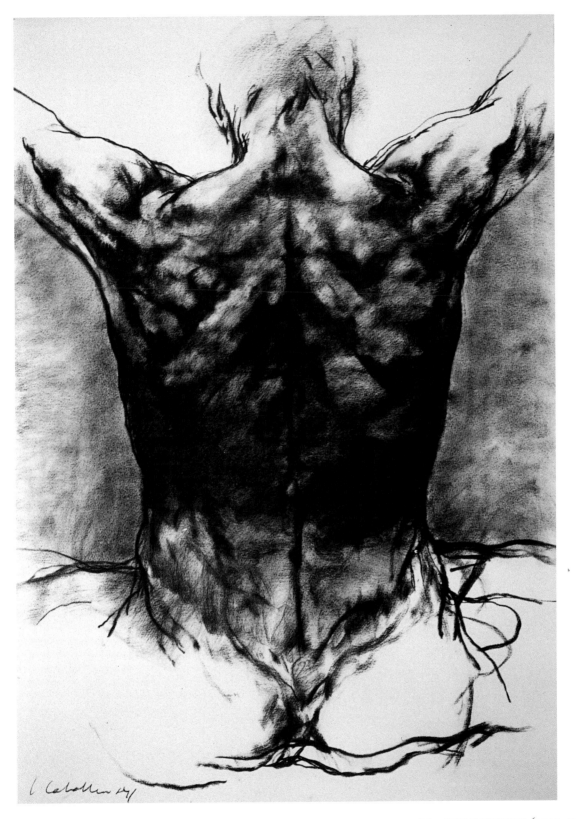

35 WILLIAM BLAKE (1757–1827), *illustration to his poem*
The First Book of Urizen (1794). *Though one or two life-
studies by Blake are known, it is evident that his main source
for nudes of this sort was engravings made after other artists (left).*

36 LUIS CABALLERO (1943–85).
*A powerful torso by a leading
Colombian artist, which
demonstrates the continuing
strength of the academic tradition
in Latin America (above).*

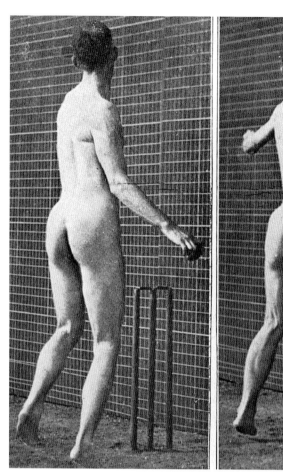
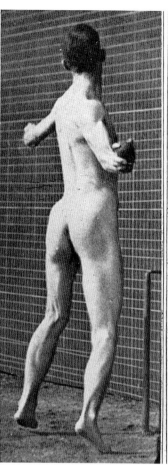
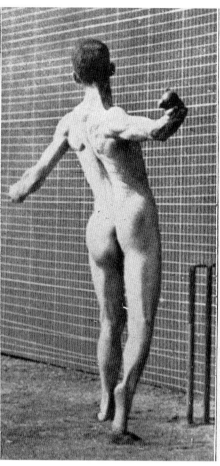
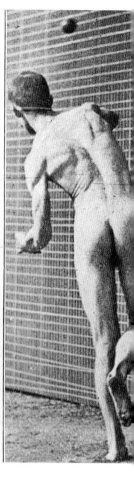

37 EADWEARD MUYBRIDGE
(1830–1904), Man Bowling
and Batting *(from Animal
Locomotion, 1887). These
sequential photographs of nude
figures in motion disproved many
of the most cherished tenets of
academic art.*

particular standard, often at variance with the results of direct observation. The body, in neo-Classical art works – paintings, drawings and sculptures – is often not merely idealized but also abstracted. It becomes a collection of conceptual forms, obviously different from, yet intellectually akin to, the conceptualization seen in Greek Archaic art. This process can be seen at work, not merely in Flaxman's outline engravings, inspired both by Winckelmann's theories and by the paintings on Greek vases, but in the work of Flaxman's much greater contemporary and friend, William Blake (1757–1827). It comes as no great surprise to discover that Blake almost never drew directly from life, but was, on the contrary, often inspired by reproductive engravings which were made after works by other artists.

Though the impulse towards idealization of the body continued to be strongly upheld in the academies of art where nearly all painters and sculptors were trained, it was challenged by the scientific developments of the nineteenth century, particularly by the invention of photography – the first practical photographic process, the daguerreotype, was announced to the world in 1839.

The photograph impressed the nineteenth-century audience not merely because such a way of making images had been long awaited for purely practical reasons – people had in this case been able to imagine quite clearly what they could not as yet practically accomplish – but also

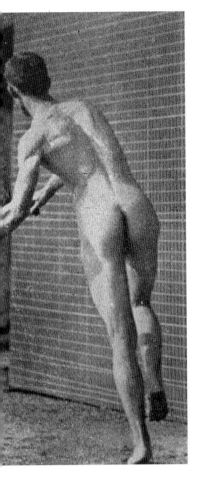

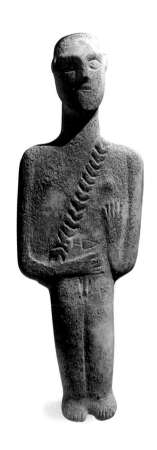

because it seemed to pre-empt the activity of the artist. The natural world, it was felt, was now free to imprint itself on the photographic plate, independent of the human hand or brain. Artistic subjectivity was therefore at an end. To some extent this was true. The experiments of pioneer scientific photographers such as Eadweard Muybridge (1830–1904) showed that the human figure had hitherto been represented in ways that often bore little relationship to the facts. Muybridge's portfolio *Animal Locomotion, An Electro-Photographic Investigation of Consecutive Phases of Animal Movement* (1887), contained many studies of humans clothed and unclothed. These images often flatly contradicted the rules laid down by the classical ideal.

Long before this, however, photographers realized their medium was subject to artistic control. As in art, nudes – male and female – became standard photographic subject matter. Photographers who provided 'photographic references for artists', like the prolific Italian, Gaudenzio Marconi (at work in the 1870s), often posed their models as well-known classical statues. However, there were several elements of ambiguity in this. Firstly, while artists did use these pictures as reference, a fierce battle was being fought between traditional art forms and the camera. Photography was relegated to the position of a lower form of expression; to call a painting 'photographic' was to condemn it.

Another ambiguity was that these images also addressed themselves to quite a different audience – one looking for erotic stimulation rather than artistic reference. It is one of the special qualities of photography that it stresses both the voyeurism of the photographs and of the person who looks at the finished product. The photographic image guaranteed that a certain individual had stripped naked for the camera – in other words, had stripped in the presence of at least one other person. There was no possibility that the nude figure had simply been imagined.

Nineteenth-century society could deal with the emotions aroused by this when the model was female, but found it more difficult to do so when the model was a man. A photograph of a nude male, however traditional the pose, raised the spectre of homosexuality. Representations of the male, in the hands of any photographer, whatever his declared intentions, moved into new and dangerous territory.

38 Hunter-Warrior, *Early Cycladic II* (2800–2300 BC). *At this stage in the development of Greek art, mother-goddess figures occur much more often than males. This represents the very beginning of the Greek* kouros *or 'beautiful male'. As yet the proportions have not been worked out.*

The Heroic Nude

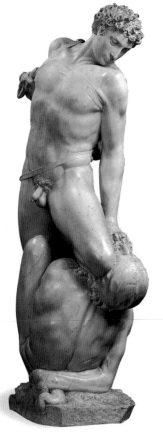

39 VINCENZO DANTI (1530–76),
Truth Conquering Falsehood.
*This Mannerist allegorical group
shows how Michelangelo's heroic
style was adapted by later
Florentine artists (above).*

40 LIN JAMMET, Untitled (1989).
*This pastel by a contemporary
British artist records his memories
of childhood – being lifted on to a
horse's back by his stepfather, when
he was still too small to mount by
himself (right).*

THE IDEA OF THE HERO — *a word which the* Concise Oxford Dictionary *defines as 'a man of superhuman qualities, favoured by the gods; a demigod' – is closely associated with Greek mythology, and therefore with Greek religion and civilization as a whole. The concept itself, however, antedates the Greeks. The first heroic myth known to us in some detail comes from ancient Mesopotamia, and concerns Gilgamesh. At his beginnings, Gilgamesh may have been a real person – a king who reigned at Uruk in southern Mesopotamia sometime during the first half of the third millennium BC.*

In Gilgamesh's legendary guise, he is a great builder and warrior, part divine, part human. He battles with, but then becomes the companion of, Enkidu, a wild man who lives among animals, who accepts civilized life for the sake of Gilgamesh. After Enkidu dies, Gilgamesh makes a dangerous journey to learn how to escape death. He obtains the remedy, but loses it, and returns unhappily to his city of Uruk. There, the spirit of Enkidu rises from the dead to visit him, and gives a grim report of conditions in the underworld inhabited by the spirits.

What one sees here, in early outline, is the image of the human being who is supremely gifted, both mentally and physically, yet fated at last to fall, and suffer the doom that awaits all humankind. This doom, the Greeks thought, was often accelerated by *hubris* – an excessive pride towards, or defiance of, the gods. That is, the hero is both a demigod himself, and also a vulnerable

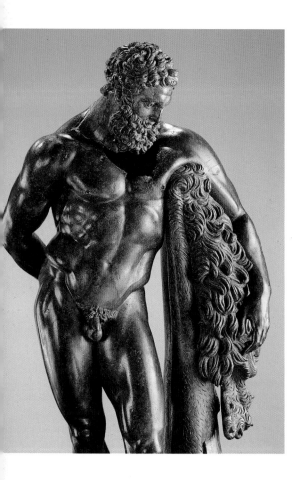

41 Hercules Resting (detail). This fine Roman bronze statuette from Curino, near Sulmona in Italy, is one of the best surviving records of the so-called 'Farnese Hercules' type invented by the fourth-century Greek sculptor Lysippus.

42 TONY BUTCHER, Torso (1996). A close up torso study of an athlete showing how contemporary photographers continue to be influenced by the forms of classical art (right).

representative of human pride, who sets himself up in opposition to divine power and is duly punished.

Though women figure in heroic myths, the main protagonists are almost invariably men. It is man the wanderer and fighter, glorying in his own physical strength, who is the paradigm of heroic qualities. The heroic male is one of the central subjects of ancient Greek art, and one of the ways of representing this heroic quality is through nudity. The Greek Archaic kouroi, when they are commemorative, served as memorials to warriors and successful athletes. Similarly, in later times, it became customary to commemorate those who were successful in the Olympic games. Grateful compatriots would set up a statue of the victor, usually nude, in one of the great Greek sanctuaries.

The battle scenes that adorned Greek sanctuaries also tended to show the combatants completely nude – except, that is, for their shields and weapons. The idea that the ideal warrior fought nude and unprotected had a curious influence on the design of Greek armour, where breastplate and back-plate would often be shaped to resemble a muscular nude torso. This conceit proved so attractive that it survived into much later epochs. Roman armour also used it, and the 'classical' parade armour worn in Renaissance pageants was designed in the same fashion.

The warriors in battle seen in the temple friezes of the fifth and early-fourth centuries BC conform to the same physical type as other representations of male nudity made in the same epoch. The differentiation of roles seems to have begun in the age of Alexander the Great. Its evolution had a lot to do with the cult of the hero Heracles, who, like Gilgamesh, was probably originally a real man – a chieftain-vassal of the kingdom of Argos. In mythology, he was the son of Zeus, the ruler of the gods, and the mortal Alcmene, granddaughter of another Greek hero, Perseus. Heracles, famous for his enormous strength, was already popular in Archaic and Classical times, but his cult began to grow rapidly in the late fourth century. Alexander commissioned his favourite sculptor, Lysippus, to make a small sculpture of a seated Heracles, the Heracles Epitrapezos, as an ornament for a banqueting table, and the same artist also seems to have been responsible for the original from which the Farnese Hercules, now in Naples, derives. Another copy, in the Pitti Palace in Florence, actually has an inscription naming Lysippus as the original artist.

Whereas most of the sculptures attributed to Lysippus, and known to us now through copies, have small heads, slender bodies and elongated limbs, the Farnese Hercules is exaggeratedly massive and muscular. Its rediscovery during Renaissance times was to have an enormous impact on representations of the male nude in art. Even before that, however, this new masculine type had

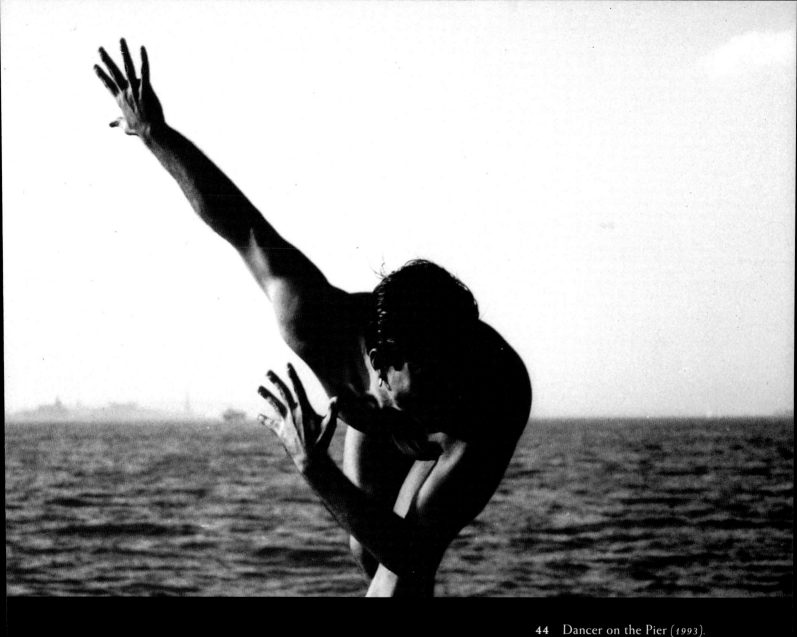

BALY HINTER WIPFLINGER, The Boy from the
Temple Next Door (1996). This image by
the contemporary Italian photographer shows the
influence of the turn of the century photographer
Wilhelm von Gloeden (left).

44 Dancer on the Pier (1993).
Another, very different, image by Baly
Hinter Wipflinger takes advantage of
the capacity of the modern camera to
capture movement. The figure becomes a
faded silhouette against a broad sky —
a symbol of modern athleticism (above).

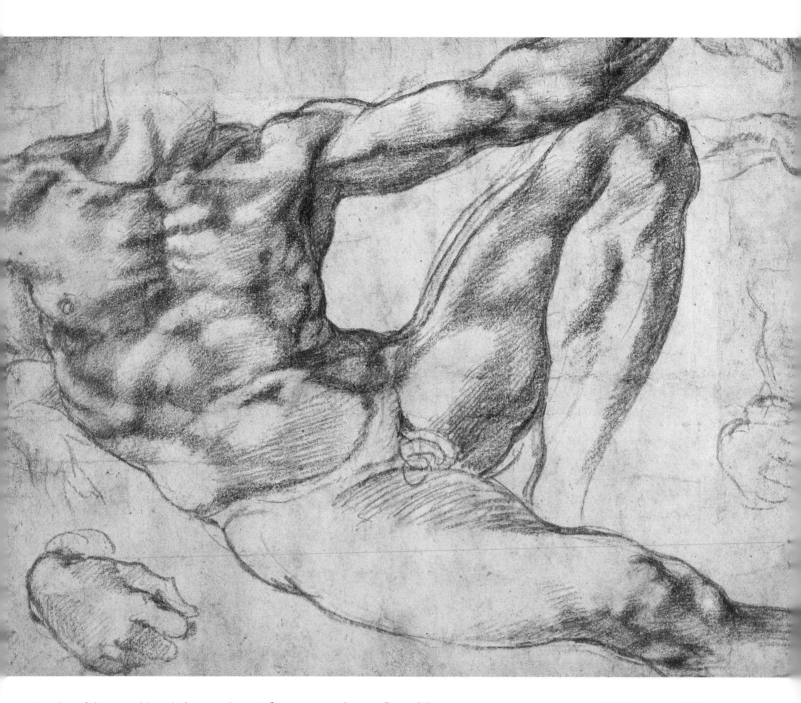

45 *One of the most celebrated of all Michelangelo's drawings, for the* Creation of Adam *on the ceiling of the Sistine Chapel. Adam is heroic but languid, leaning back as God touches his finger to bring him to life.*

an influence on sculptors. One of the more curious customs among Hellenistic and Roman sculptors was that of creating portrait statues in which a strongly characterized head was joined to a heroically idealized nude body. One of the best-known examples of this is a late Hellenistic statue of a man with a lance, supposedly representing Demetrius I of Syria, found at Pompeii. Sculptures of this type often exaggerate the musculature as a metaphor for the worldly power of the subject. In a more general way, Hellenistic sculptors tended to exaggerate the musculature of heroic male figures because this was a way of increasing their dramatic impact. The gods and giants of the *Great Altar of Zeus* at Pergamon owe their effect to this as much as they do to their overwhelming scale.

One of the Renaissance artists upon whom this particular tendency had the most effect was Michelangelo (1475–1564). It was the *Belvedere Torso*, which is closely related in its style and proportions to the *Farnese Hercules*, which seems to have encouraged him to increase the bulk of his male figures. The celebrated *Ignudi* of the Sistine Ceiling, heroic youths with no apparent role in the iconographic programme of Michelangelo's elaborate composition, were particularly influential in promoting the form. Their direct descendants include both the similar youths on the ceiling of the Farnese Gallery, painted by Annibale Carracci (1560–1609), and the heroic male nudes painted by Peter Paul Rubens (1577–1640).

An influential factor in the transmission of this particular image of the male was the parallels that Christian scholars discerned between certain stories in the Old Testament, notably that of Samson, and also the classical accounts of Heracles. Giovanni da Bologna's (1529–1608) Mannerist group sculpture of *Samson Slaying the Philistine* (1567), for example, simply presents Heracles in another guise.

The influence even extended itself to New Testament imagery, and in particular to certain presentations of the figure of Christ. For example, to make the figure of the dead Christ into a massively muscular figure emphasized the heroic nature of the Redeemer's sacrifice for mankind.

The artists of the nineteenth century, in their usual eclectic fashion, took over a whole repertoire of types from their predecessors, the heroic nude among them. Towards the end of the nineteenth century there was a new development, when nature began to imitate art. Many primitive societies have, or had, contests that feature competitive feats of strength – the lifting or throwing of heavy objects – among the males of the community. The Highland Scottish sport of tossing the caber – a caber being a roughly trimmed tree trunk – is one relic of these male competitions.

In the eighteenth century there was a fashion for professional strongmen who exhibited themselves at fairs, and later at circuses and in theatres, sometimes challenging all-comers to equal their feats. This fashion persisted into the following century. The strongmen, though often featured in popular prints, seem to have been admired primarily for what they did, rather than for their actual physical appearance, though those who appeared in fairs often wore special costumes which emphasized their claims to possess exceptional physical strength. Some even appeared wearing a lionskin costume, which was a direct allusion to the myth of Heracles. However, the prudery of the times generally dictated that this should be worn over some kind of close-fitting leotard. Where male nudity remained, up to a point at least, acceptable in art, the rules for public nudity in life were complex and often contradictory.

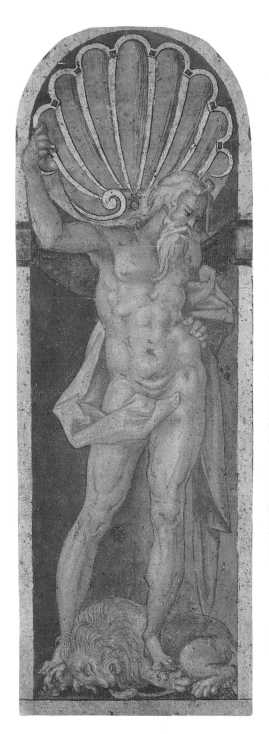

46 BARTHOLOMAEUS SPRANGER (1546–1611), Hercules. *Spranger was one of the northern Mannerist artists who worked for the Emperor Rudolph II in Prague. The elongated proportions and swaying pose belie Hercules' reputation as a vigorous hero.*

47

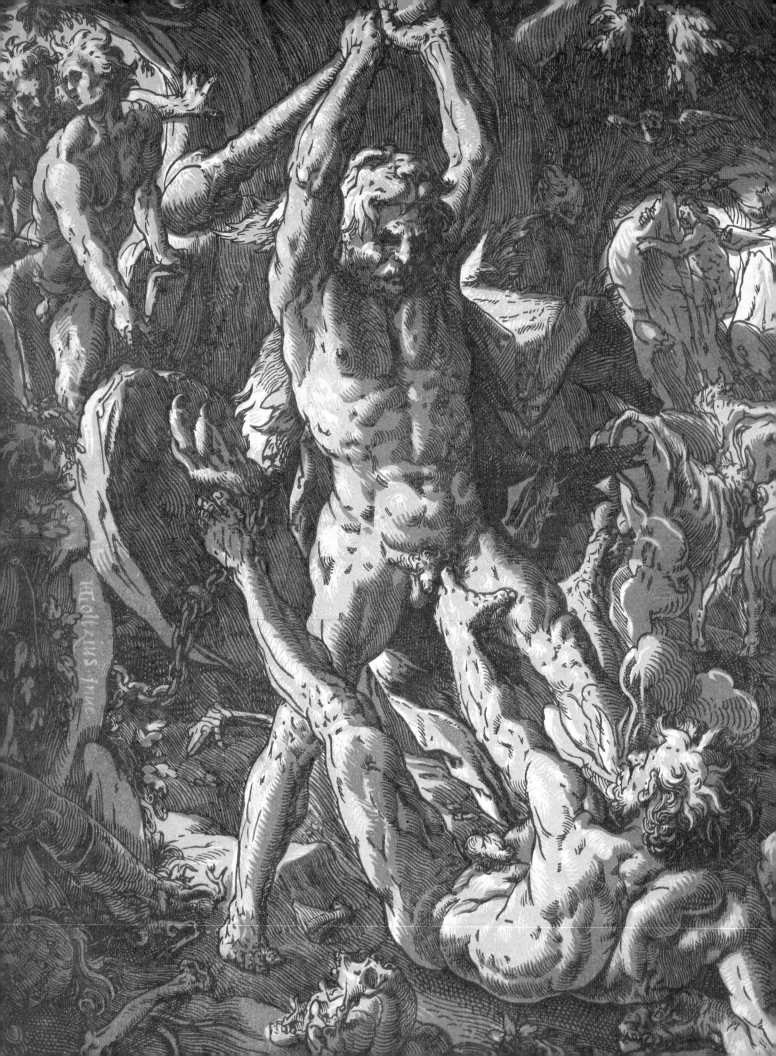

HENDRIK GOLTZIUS
(1558–1617), Hercules Killing
Cacus. *A chiaroscuro woodcut,
made from several blocks to give a
relief effect. Goltzius uses the
technique to exaggerate Hercules'
musculature to the uttermost as he
batters his helpless opponent (left).*

HENRY FUSELI (1741–1825),
Ulysses between Charybdis
and Scylla (1803). *A major
figure in the early part of the
Romantic Movement, Fuseli looks
back to Mannerist prototypes in
depicting the perilous situation
of the hero of Homer's* Odyssey
(right).

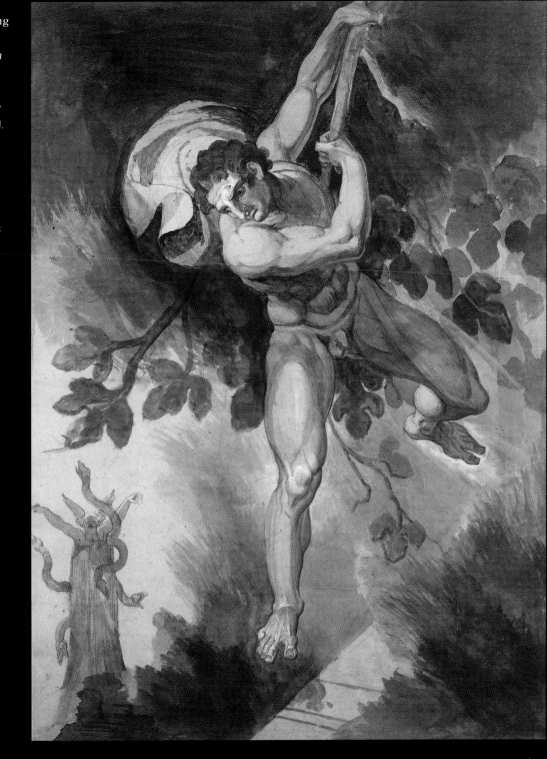

49 TOM BIANCHI (*b. 1949*), Untitled 7.
*Choosing a low viewpoint and raking
illumination from one side, the contemporary*

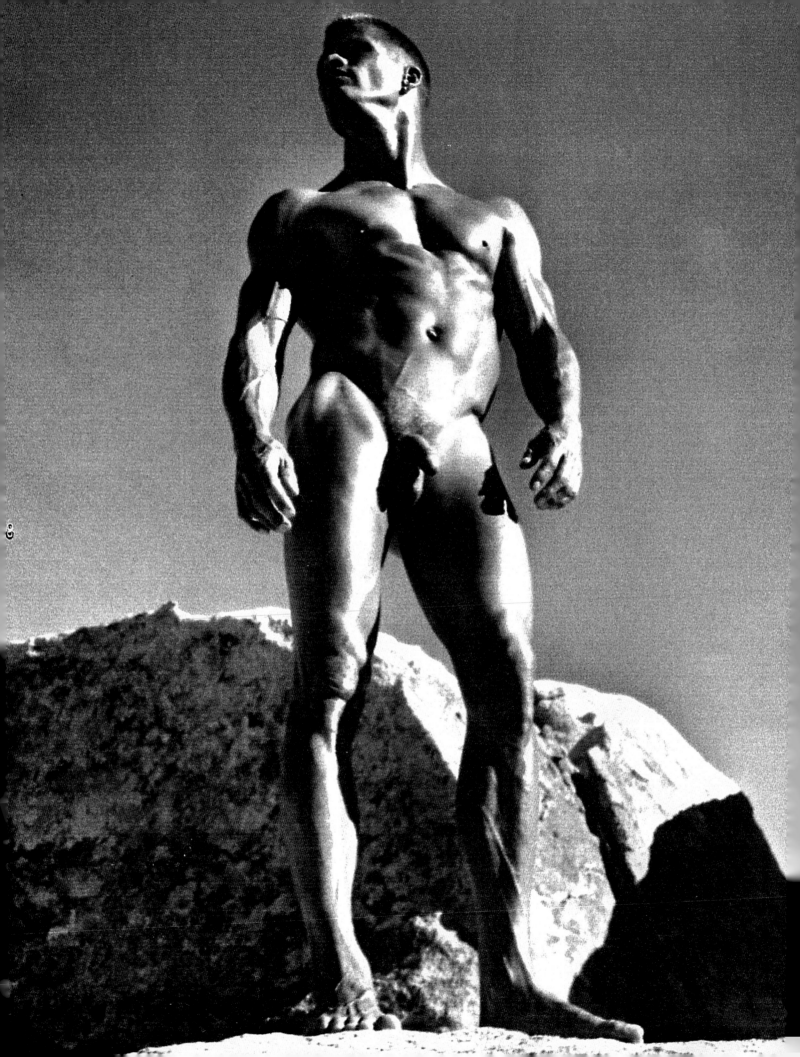

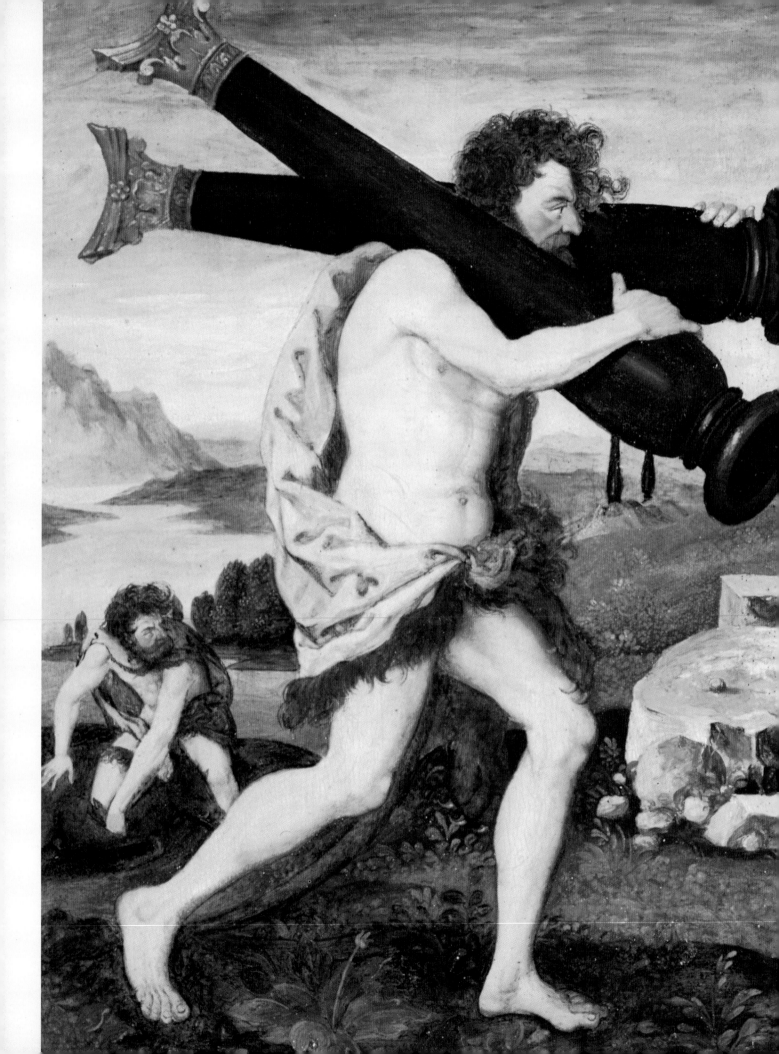

The man who played the largest part in changing this situation was the German-born strongman Eugene Sandow (1867–1925). Sandow is seen as one of the fathers of modern competitive weight-lifting. He was also the prime originator of the modern sport – or cult – of bodybuilding. He became so famous for the perfection of his physique that he used to display himself with the emphasis on this, rather than upon any feats of strength that he might have been capable of performing. Sometimes, in more private circumstances, he would appear completely nude, seen in silhouette, with his shadow thrown upon a sheet. Like other late Victorian celebrities – famous sportsmen, society beauties, freaks of nature like the dwarf General Tom Thumb – Sandow's appearance was recorded in many photographs. These formed part of his professional publicity, and often show him wearing the bare minimum – sometimes only a large artificial fig-leaf. Today these likenesses, far from resembling the kind of classical statuary which they were obviously intended to evoke in the minds of Sandow's admiring contemporaries, have an intriguingly period air. Part of this effect is due to minor details, such as the subject's upturned waxed mustachios. A good deal of it is due to Sandow's actual body-type, and the nature of his musculature.

If one looks at pictures of successive generations of bodybuilders, from Sandow's time to the present day, one is aware of the way taste has shaped the male body, just as it appears to have shaped and reshaped the female body during the same period of time. The first bodybuilding contest took place in New York in 1903, when the ideal male body was still a physique closely resembling that of Sandow. The bodybuilders of the 1920s and 1930s, however, were lithe and streamlined compared with Sandow and other members of the same generation. This was true even of the slightly different physical types who starred in various movies featuring the jungle hero Tarzan of the Apes. The champion swimmer Johnny Weissmuller (1904–84) is perhaps the best-remembered of those who took the role of Tarzan. Having won three Olympic gold medals for swimming in 1924 and two more in 1928, he starred in twelve Tarzan movies between 1932 and 1948.

After World War II however, there was an increasing emphasis on bulk and musculature, but bulk and musculature of a different sort from that displayed by Sandow. In the 1950s, the bodybuilder who best exemplified this new standard of admiration was the American, Steve Reeves,

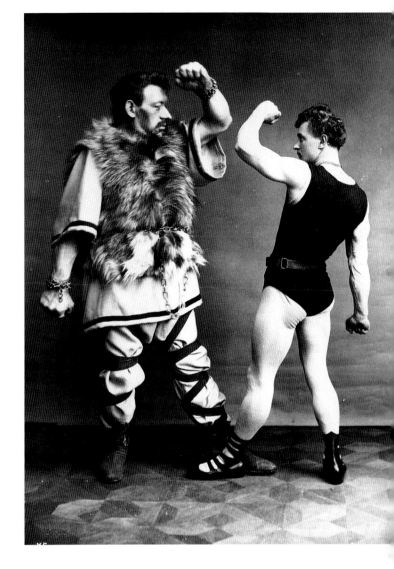

50 *Anonymous Flemish,*
Hercules carrying the Pillars
*(mid-sixteenth century). In this
slightly naive representation,
Hercules is shown carrying the
columns intended to mark the
entrance to the Straits of Gibraltar
(left).*

51 Sandow and Goliath. *In this
photograph taken at the beginning
of his career, the young Eugene
Sandow (1867–1925) poses
with an old-fashioned Victorian
strongman much taller and bulkier
than himself. An acrobat, wrestler
and a weightlifter, Sandow became
famous for his looks as well as his
physical feats (above).*

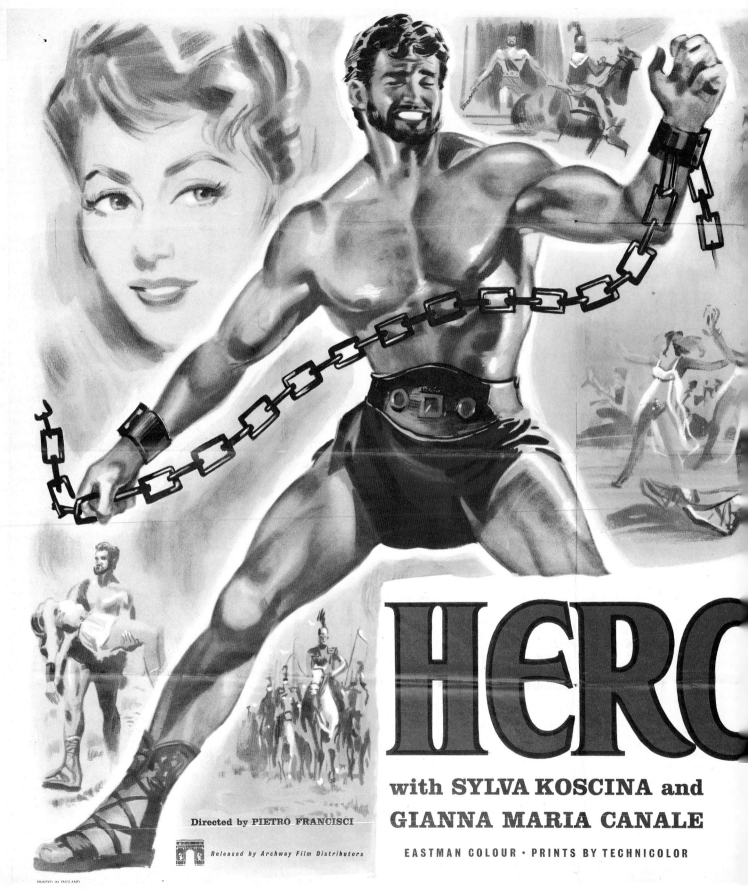

HERC

with **SYLVA KOSCINA** and

GIANNA MARIA CANALE

EASTMAN COLOUR · PRINTS BY TECHNICOLOR

Directed by PIETRO FRANCISCI

Released by Archway Film Distributors

PRINTED IN ENGLAND

STUDIO SEVEN

eve **REEVES**
(Mr. Universe)

JLES

Ⓤ

Stafford & Co., Ltd., Netherfield, Nottingham; and London

52 *This poster for* Hercules (1958),
*starring the American bodybuilder
Steve Reeves, illustrates the enduring
appeal of the Hercules legend. Issued
about three years before the emergence
of Pop Art in the United States, it is*
masterpiece of uninhibited Pop design

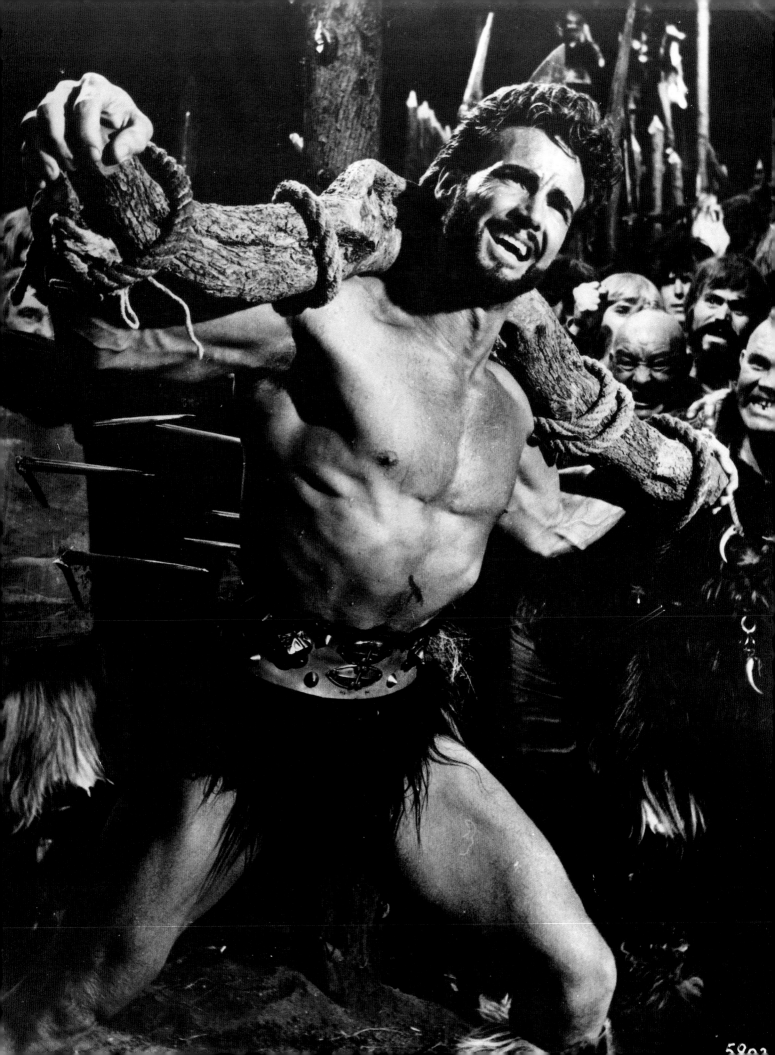

winner of the Mr Universe contest, who graduated from bodybuilder to movie-star in a series of cheerfully ridiculous films based chiefly on Greek and Roman legends. The first and most celebrated was the worldwide success, *Hercules* (1958), made cheaply in Italy as *Le Fatiche di Ercole*, but successfully promoted in the United States. In this, Reeves, having grown the requisite beard, directly challenged the viewer's recollection of Hellenistic and Roman representations of the hero. The success of this film illustrates the enduring appeal of this and other classical legends.

The triumph of *Hercules* led to the making of a whole cycle of similar films – sometimes called 'peplum pictures' because of their abbreviated male costumes – starring Reeves and other champion bodybuilders, such as the Englishman Reg Park. This cycle, which petered out in the late 1960s, was later revived for the benefit of a new generation of bulky bodybuilders, chief among them the Austrian-born American, Arnold Schwarzenegger, who was seven times winner of the Mr Olympia contest (1970–5 and 1980), before going on to make a highly successful career in the movies. One of his first successes was *Conan the Barbarian* (1982). Subsequent bodybuilding champions, local, national and international, have been content to follow the example set by Reeves, Schwarzenegger and their peers.

A striking aspect of the modern cult of the bodybuilder is that the physiques on display in bodybuilding contests are not a refinement or incremental improvement on the norm, but in many respects a deliberate departure from it. For example, bodybuilders improve on nature in various ways. One such way is through the taking of anabolic steroids to increase muscle growth. Though banned in both amateur and professional bodybuilding because of their side-effects, these anabolic steroids are known to be very widely used by contestants. Others methods of self-improvement are less deleterious. Contestants shave all body hair and deprive themselves of fluids immediately before a competitive event to increase the visibility and clear definition of muscle groups.

All this implies a very different attitude towards the body from the one that prevailed among the ancient Greeks. There, admiration for the perfect male physique was an admiration for what was assumed to be the norm. Contemporary bodybuilders and their fans, in contrast to this, fix their sights on what is clearly exceptional. Both the ancients and their successors in the Renaissance and Baroque periods were largely content to imagine heroic physiques. Ours may be the first age which has insisted on making the demigods into reality.

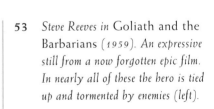

53 *Steve Reeves in* Goliath and the Barbarians *(1959). An expressive still from a now forgotten epic film. In nearly all of these the hero is tied up and tormented by enemies (left).*

54 *Arnold Schwarzenegger in* Conan the Barbarian *(1982). In this popular pulp-fiction series* Conan *was the vehicle for Schwarzenegger's transition from a career as champion bodybuilder to successful movie-star (above).*

The Child, Youth and the Feminized Male

55 BENVENUTO CELLINI (1500-71), Narcissus. *This statue sums up the attraction Renaissance artists often seem to have felt for pubescent boys. Cellini was under house-arrest for a homosexual offence when he died.*

56 HIPPOLYTE FLANDRIN (1809-64), Boy Sitting by the Sea (1856). *Flandrin applies the style Ingres invented for portraying nude women to a male adolescent. Ingres lived a generation earlier (right).*

HE HEROIC MALE, *with exaggeratedly masculine characteristics, is balanced in art by the pliant, feminized youth. However, the iconography of this type is much more complex than that of its opposite and counterpart. Western art recognizes at least three different versions of the anti-masculine male. There is the naked child, before the onset of puberty. There is the ephebe, or pubescent youth. And there is the androgyne, who has some of the characteristics of both genders. In art, the second and third of these categories sometimes shade into one another.*

It was the sculptors of the Hellenistic age who finally mastered the representation of children. Before this, artists, and in this case especially the Greek vase-painters, had understood how to represent pubescent boys, as opposed to mature males, but had paid little attention to the very young. Hellenistic sculptors invented a new type, primarily for representations of the god of love, Eros, son of Aphrodite. With their interest in genre subjects, they also used versions of this type for decorative sculptures of children at play. The children could be female as well as male, but it was the males who interested them more. The Romans sometimes used multiple representations of male children, or *erotes* as they came to be called, for purely decorative purposes.

Greek and Roman representations of playful children turned out to have a particular attraction for the artists of the Renaissance, for several reasons. In their original form, now called *putti* rather

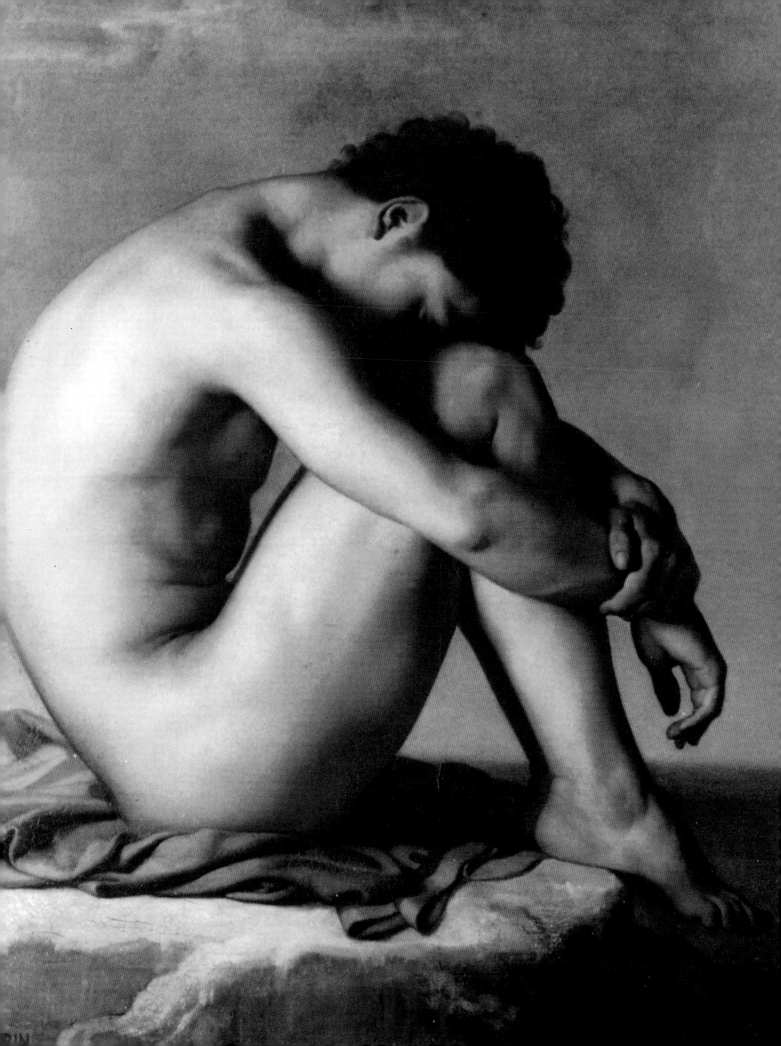

than *erotes*, they offered a harmless, playful aspect of antiquity, a hedonism free of threatening sexual overtones. They also turned out to be of use for religious compositions. One of the things that these artists wished to do was to humanize the relationship between the Madonna and the Christ Child. The laughing, chubby babies portrayed by Raphael and his contemporaries have their origins in the representations of children found in Hellenistic and Roman art. So, too, do the winged child angels who throng the religious compositions of the Renaissance and the Baroque. Sometimes the sexuality of these child angels, already minimal, is further reduced by abbreviating the representation, so that the angel becomes simply a child's head, framed by a pair of wings. This is the convention used by Raphael (1483–1520) in the *Sistine Madonna* (1513), which transforms the cherubim of the Old Testament (originally powerful winged beings who could take human, bird-like or animal forms) into playful attendants for the Virgin and her Son.

The question of sexuality does, nevertheless, enter into some of these religious representations of children in a wholly unexpected way. As a recent study by Leo Steinberg demonstrates (*The Sexuality of Christ in Renaissance Art and in Modern Oblivion*, 2nd ed. 1996), Renaissance Madonna and Child compositions often contain explicit sexual symbolism. Either the Madonna points to her child's penis, as the emblem of his manhood, or else the child's genitalia are concealed by a large knot of drapery which takes an unmistakably phallic form.

57 Youth from Marathon (*Greek, 340–300 BC*). *This is a Greek bronze dredged from the sea, the work of a follower of Praxiteles. Its air of dreamy melancholy makes it typical of its period.*

The one celebrated work of the late Renaissance/early Baroque period that seems to offer a child as an object of erotic desire is Caravaggio's (1571–1610) notorious *Amore Vincitore*. Here the victorious God of Love, triumphing over the emblems of the arts and sciences, is represented as a knowing Roman urchin, equipped with a pair of property wings. Contemporary sources, which hint, and often rather more than hint, at Caravaggio's bisexuality, describe the model as '*il suo Caravaggino*', and imply that we are looking at a likeness of a boy who served both as the artist's studio assistant and as his bedmate. The patron

58 JEAN HONORÉ FRAGONARD (1732–1806), *detail from* The Fountain of Love (c. 1784). *The child angels are asexual, despite the erotic subject matter of the painting.*

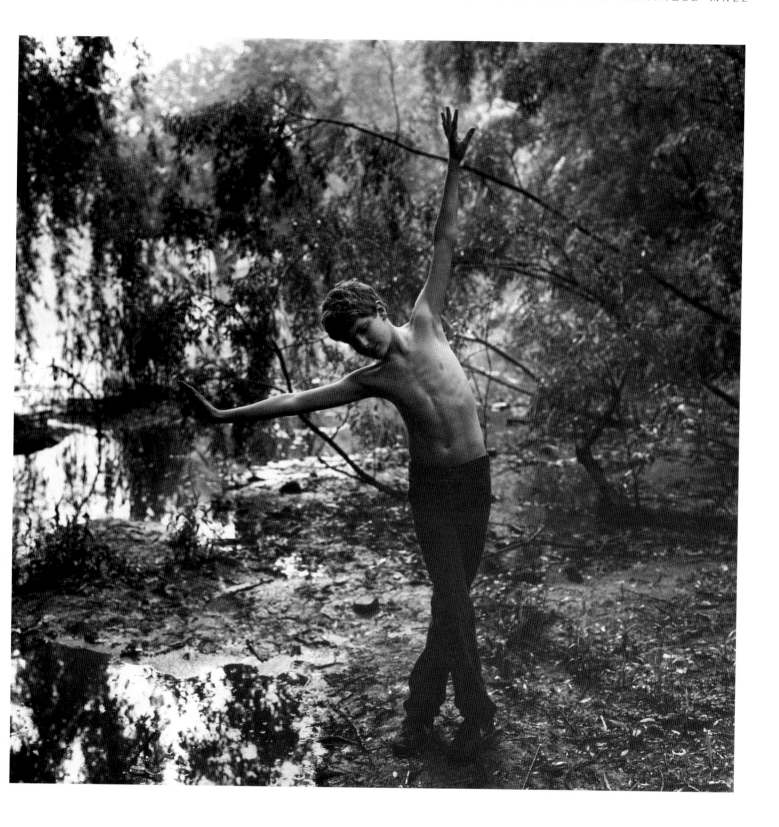

59 ARTHUR TRESS (*b. 1940*), My Brother, Adam in Central Park (*1982*). *An exquisitely tender fraternal image by a well-known American photographer.*

who commissioned the work, Marchese Giustiniani, seems to have belonged to a circle of homosexual nobles and clerics living in Rome. It is known that he kept the painting hidden behind a curtain, and showed it only to favoured intimates.

The ephebe, or adolescent, has a much longer history in Western art. The youths represented by Greek Archaic statues of *kouroi* are barely into the first flush of their sexual maturity, and, as has already been noted, Greek vase-painters often represented courting scenes between mature men and youths, which reflect the homoerotic culture of Greek society of this period. Both black- and red-figure vase-painters also represented beautiful youths as a subject in their own right, often with *kalos* inscriptions praising their beauty, and we are probably not far from the truth if we think of these images as the pin-ups of their day.

In the fourth century BC, as sculptors began to evolve new types, they turned not only to the hyper-masculine Heracles, but also to deities such as Eros, Apollo and Dionysus, who could be depicted as beautiful, rather effeminate adolescents. An influential example of this development is Praxiteles' *Apollo Sauroctonos* ('Apollo the Lizardslayer') in which the god is a youth leaning sinuously against the trunk of a tree, about to kill a lizard on the tree trunk with the point of one of his own arrows. Many copies of the statue are known, so the subject clearly had a great appeal to Hellenistic and Roman taste.

The great painters and sculptors of the Renaissance, often themselves homosexually inclined, sometimes explored the attraction of male adolescent beauty. Examples are Donatello's bronze statue of a youthful *David* (before 1469), Michelangelo's *Drunken Bacchus* (1496–7), and Parmigianino's painting of *Cupid Carving A Bow* (1533–54). The deliberately provocative pose of the last of these, with Cupid seen from the back, bending forward while glancing behind him, makes the erotic intention plain.

The increasing importance of the female nude, from the beginning of the seventeenth century onwards, tended to displace the adolescent male as the subject of choice for erotic representations. It was to surface again, after a long period in limbo, as a theme for photography at the end of the nineteenth and at the beginning of the present century. In particular, the photographs made in Sicily by Wilhelm von Gloeden (1856–1931) attempted to revive the Greek dream of perfect youth, with a literalism which today seems both touching and slightly ludicrous.

There is a subtle, but nevertheless real distinction to be made between these images of adolescent boys, whatever their epoch, and a related series which portrays androgynous or feminized males, who may or may not be adolescents. Greek myth made room for the concept of the androgyne in the form of the legend of Hermaphroditus – the idea was

60 EDWARD LUCIE-SMITH, Kouros (1997). *This study of an Archaic Greek torso found in Cyprus deliberately emphasizes the softness of the modelling (left).*

61 DONATELLO (1386–1466). *Considering its fame, it is surprising that the precise date of Donatello's* David *is unknown. The extreme youth of the Jewish hero is here emphasized, in a work which was certainly the first large-scale free-standing nude to be produced by a Renaissance sculptor (below).*

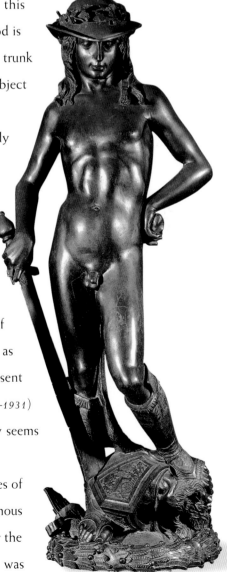

63

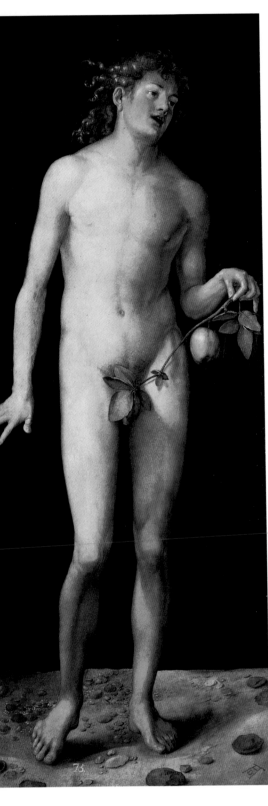

originally imported from the dualistic religions of the Near East. The concept also, somewhat surprisingly, left its traces on Talmudic interpretations of the Bible. Despite Judaism's traditional opposition to dualism, some Jewish scholars asserted that Adam was a hermaphrodite because Genesis 1:27 says of God's creation, 'Male and female he created them.'

For the Greeks, Hermaphroditus was originally a beautiful youth, the son of Hermes and Aphrodite, who was transformed when the nymph Salmacis fell in love with him and entreated that she be forever united with her lover. Hellenistic sculptors, with their taste for the outré and the bizarre, made representations of hermaphrodites – the most famous version, where the man-woman reclines in sleep, female breasts and male genitalia just visible thanks to a subtle twist in his/her body, was paraphrased by the leading neo-Classical sculptor Antonio Canova (1757–1822).

In the post-Classical epoch the rise in popularity of this version of the male began in the Renaissance, with the androgynous representations of males painted by artists such as Leonardo da Vinci (1452–1519) (notably his disturbing image of *St John the Baptist* in the Louvre, 1514–15), but did not finally triumph until the Rococo. The Rococo style not only made ample room for images of nude females – this was the moment at which the female nude displaced the male nude from its central place in Western art – it also tended to feminize representations of males. If one looks, for example, at the preparatory drawings of nude men made by the painter and designer François Boucher (1703–70), whose work is the perfect expression of French taste in the Rococo period, one notices how much more vigorous and muscular these are than the same figures when they are incorporated into Boucher's paintings. Boucher and his younger counterpart Jean-Honoré Fragonard (1732–1806) elaborated a make-believe world where plump adolescent lovers are forever in amorous pursuit of one another, and where the males are scarcely distinguishable from the females. A perfect exemplification of this trend is the series of large canvases on the theme of *The Fountain of Love*, which Fragonard painted in 1770 for Mme du Barry's pavilion at Louveciennes, and which are now in the Yurik Collection in New York.

Neo-Classicism revolutionized the arts, but surprisingly enough did not alter this particular tendency. Most of the major neo-Classical artists represented males in this way – Jacques-Louis David (1748–1825) in his unfinished painting of the dying *Joseph Bara*, a drummer-boy shot by the royalists; Anne-Louis Girodet-Trioson (1767–1824) in his *Sleep of Endymion* (1792); Pierre-Paul Prud'hon (1758–1823) in representations of Cupid and Psyche.

62 ALBRECHT DÜRER (1471–1528), *Adam* (1507). *Of later date than his famous Adam and Eve print, this Adam is hipshot with a protruding stomach.*

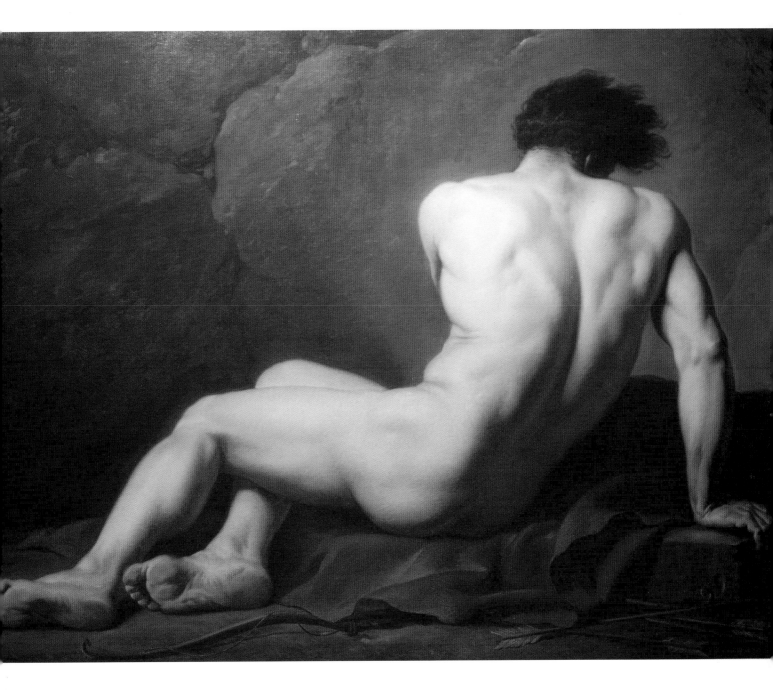

63 JACQUES-LOUIS DAVID (1748–1825), *Study of a Nude* (1780). *Painted at the beginning of David's career, this is one of the very few purely academic studies known by the re-founder of academic art.*

64 Sleeping Hermaphrodite
(*Roman copy of a Hellenistic
original of c.* 200 BC). *With the
Hermaphrodite, Hellenistic art
pushed the theme of androgyny to
an extreme, creating a combination
of male and female. The head is
influenced by the effeminate type
already used for representation of
the god Apollo in the late fourth
century* BC.

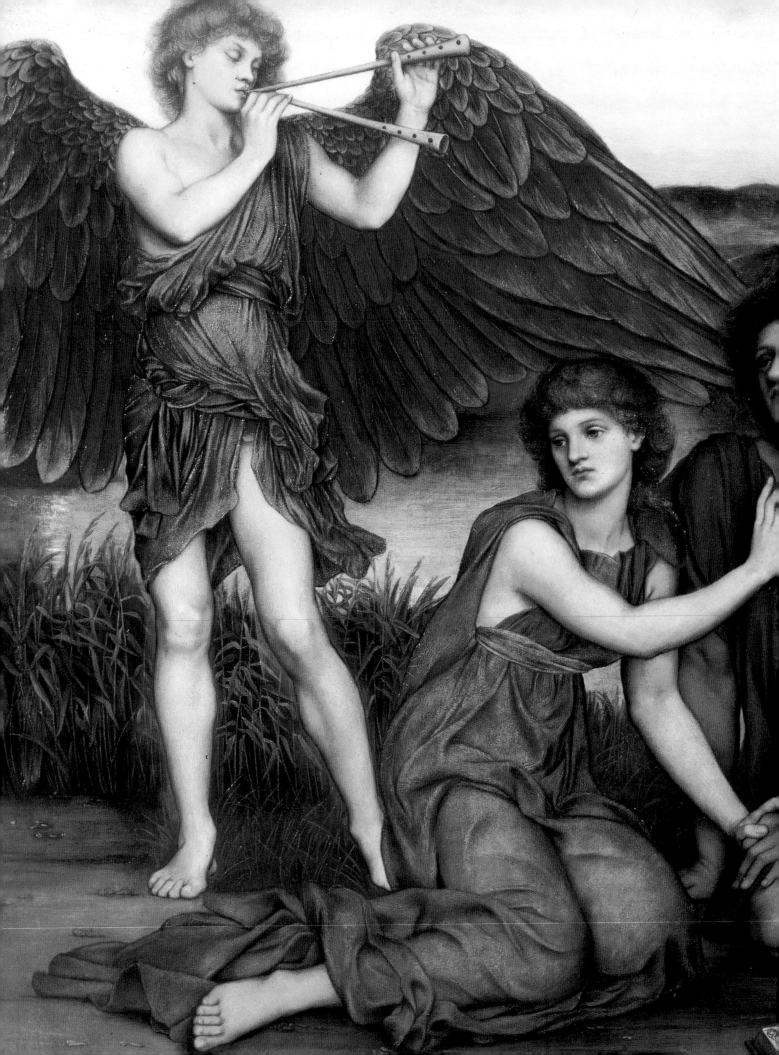

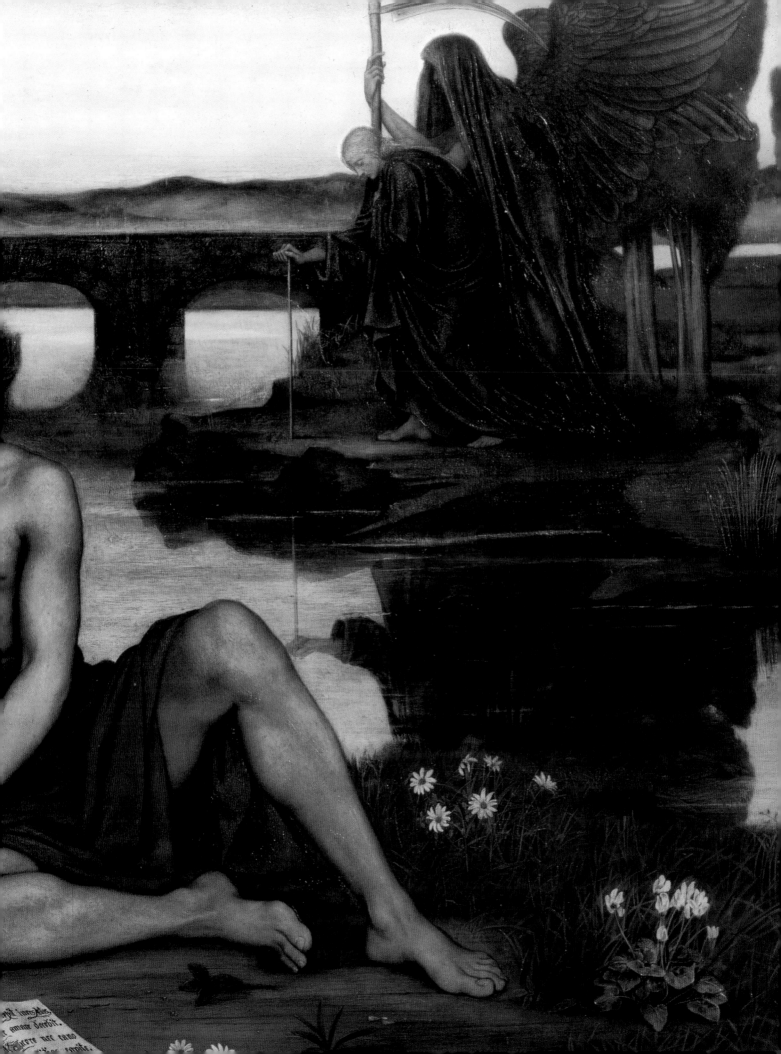

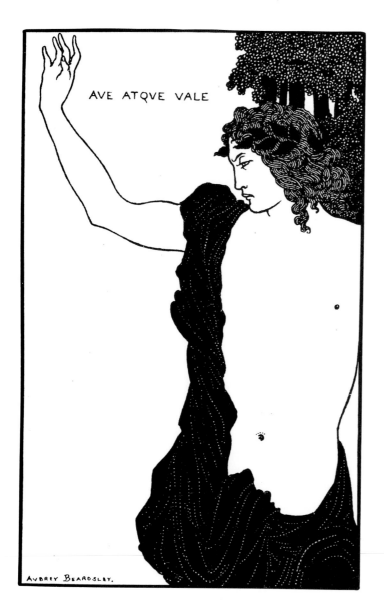

AVE ATQVE VALE

AVBREY BEARDSLEY.

The scientific materialism of the mid-nineteenth century tended to approach the subject of androgyny in a different and distinctly more earthy way, as can be seen from a group of unsubtle photographs taken by Nadar (Gaspard-Félix Tournachon, 1820–1910) of physical anomalies. To record these was to certify their existence, hitherto largely a matter of scandalized rumour.

A more poetic fascination with this specialized physical type reappeared in the work of the Symbolists. Images of androgynous males abound in the work of Gustave Moreau (1826–98), Edward Burne-Jones (1833–98) and also in that of the influential illustrator, Aubrey Beardsley (1872–98).

Though successive generations of artists represent male figures whose total masculinity is in one way or another questioned by the manner in which they are presented, there is nevertheless a wide variety of physical types. The amorous juveniles painted by Boucher and Fragonard are short and chubby. With males as well as females there is often an emphasis on the attractions of the human posterior – a theme which attracted the erotic authors of the eighteenth century just as much as it did the artists of the time.

Posteriors are not necessarily gender specific, and Rococo nudes therefore exude a kind of joyous pan-sexuality. Neo-Classical androgynes are more sinuous and elongated than their Rococo predecessors – their physiology is male but their gestures and deportment often seem female. Those depicted by Symbolist artists carry these characteristics further still, often in imitation of Renaissance artists such as Botticelli (1445–1510). The sexual overtones are more directly homosexual than those of their Rococo predecessors, but many neo-Classical and Symbolist nudes also suggest a kind of weariness with sex, even a will to renounce all sexual characteristics. In the work of Edward Burne-Jones, the two genders have often come so close as to be almost indistinguishable, but neither seems particularly attracted to the other, even when they are actually clinging together.

The most recent incarnations of the androgyne do, however, carry a strong sexual charge. They have manifested themselves not in art, but in the world of popular music. Rock stars like Mick Jagger, David Bowie, Marc Bolan, Alice Cooper, Freddie Mercury and Boy George have all

66 AUBREY BEARDSLEY (1872–98), Ave Atque Vale (1896–8). In this illustration to Catullus' poem of farewell to his dead brother, the atmosphere of the nineteenth-century fin de siècle is caught. The precisely placed details of nipple and navel help to give the image its disturbingly erotic quality (above).

65 EVELYN DE MORGAN (1850–1919), Love's Passing (1883–4). This allegorical composition is typical of late Pre-Raphaelite art in the way in which it creates types for males and females which are almost indistinguishable (previous page).

67 PIERRE PUVIS DE CHAVANNES (1824–98), **The Little Fisherman**. *One of the leading French Symbolist painters, Puvis de Chavannes sometimes comes close to the English Pre-Raphaelites in style.*

68 This anonymous image from the
 1930s can be referred to as the cult
 of 'healthy outdoor life' which
 flourished at that time. Its repetitive
 patterning evokes some forms of
 German National Socialist art, but
 the photograph is probably British.

69 HENRI-EDMOND CROSS (1856–1910), The Bather at St Tropez (1843).
*A work by a follower of Seurat which is an early example of the celebration of
carefree physical life on the Mediterranean coast. The total nudity of the young
bather may also illustrate the curious late-Victorian and early-Edwardian
double standard where male nakedness in public was concerned.*

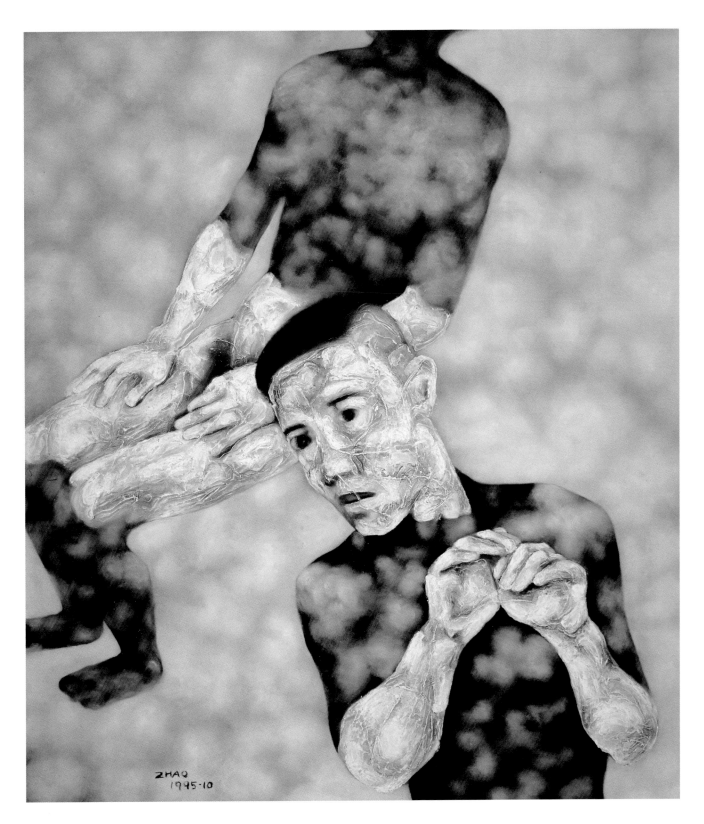

70 ZHAO NENG-ZI (b. 1968), An Encounter (1995). A
modern Chinese artist here skilfully evokes the awkwardness of
adolescent social intercourse. Despite the use of a Western
medium, oil on canvas, the lack of idealization also illustrates
the difference between Eastern and Western artistic traditions.

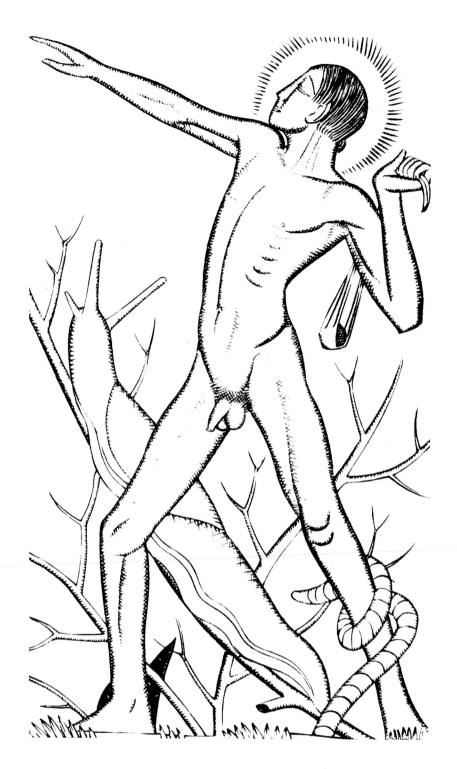

71 ERIC GILL (1882–1940), David (illustration from Gill's That Which Pleases the Sight (Id Quod Visum Placet), 1926). The coiling serpent round David's leg seems to suggest that this totally nude adolescent is to be regarded as a source of temptation.

in their various ways flirted with the idea of androgyny. Sometimes this was simply a matter of costume – singers like Alice Cooper and Boy George used cross-dressing as a way of unsettling the perceptions of the audience and (certainly in the case of Boy George) of expressing their sexual orientation while making it the subject of their own ironic commentary.

With Jagger and Bowie, two major rock personalities, the situation is more complicated. Both have immense sexual charisma, both appeal successfully to a mainstream audience. Jagger's bisexuality has often been rumoured, Bowie's has been openly admitted. Their tendency to present

themselves in androgynous guise intensifies their allure – they are sexually available, they imply, to both men and women. It is also, perhaps paradoxically, the androgynous guise that makes Jagger and Bowie seem less threatening to that part of their audience – the very young – who are only just beginning to experiment with sex.

Bowie's trajectory, inventing and reinventing himself from album to album, has been especially fascinating. When his second major album, *The Man Who Sold The World*, was released in 1970, he was a slender figure of indeterminate gender, wearing elaborate make-up. He continued to play variations of this theme for quite a while, inventing substitute personalities for himself – Aladdin Sane or Ziggy Stardust. In a profile published in the British periodical *Melody Maker* on 22 January 1972, for example, the singer was characterized as follows: 'The expression of his sexual ambivalence establishes a fascinating game, is he or isn't he? In a period of conflicting sexual identity he shrewdly exploits the confusion surrounding the male and female roles. "Why are you wearing your girl's dress today?" I said to him (he has no monopoly of tongue-in-cheek humour)."Oh dear," he replied. "You must understand that it's not a woman's. It's a man's dress."'

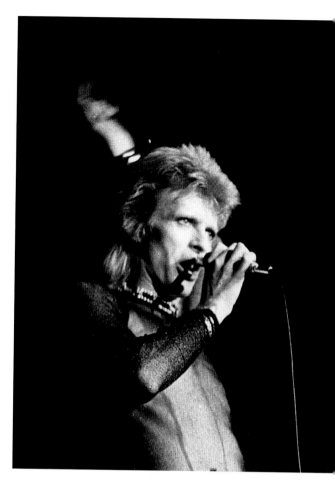

72 *During his early career as a rock-star, David Bowie frequently made play with androgynous images.*

There was always the implication that Bowie's sexual ambiguity sprang from a still deeper source of alienation: that he was, quite literally, not an earthly being, but someone from another planet. This aspect of his personality was cleverly exploited in his first movie, *The Man Who Fell To Earth* (1976), in which Bowie played an alien from another planet. Bowie's background is in the visual arts and in the avant-garde theatre – he worked as a commercial artist and performed as a member of a mime troupe before finding success as a singer – and there is no doubt that the way he has shaped his public persona has been a matter of deliberate choice. The kind of attraction he radiates – or at least radiated in some of his incarnations of the 1970s – may be close to that felt by their contemporaries for the castrati of the eighteenth century.

These singers often took heroic masculine roles in the operas of Handel and his contemporaries, and were rewarded with the adoration of both men and women. The range, power and flexibility of their voices seemed both to quash the accusation of effeminacy and at the same time set them a little apart from the human sphere. Unearthliness seems to be the quality which separates the genuine androgyne, at least in our imaginations, from the merely effeminate male. Because of this the androgyne is powerful, alluring and sometimes, though not always, as threatening as the exaggeratedly muscular hero whose antonym he forms.

Naked Victims

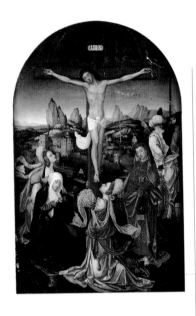

73 Attributed to CORNELIS ENGELBRECHTZ THE ELDER (1488–1533), The Crucifixion. Painted in the early sixteenth century in a Netherlandish workshop, this contrasts the near nude body of Christ with the extravagant costume worn by the mourning women (above).

74 ROBERTO MARQUEZ (b. 1959), El Vuido (1995). A self-portrait by a young Mexican artist, based on images of Christ as the Man of Sorrows. The jumbled inscription, plus the marks of the stigmata on the hands, make it clear that art itself is a form of martyrdom (right).

*T*HE IDEA OF THE MALE NUDE *as a vehicle for the expression of suffering did not originate with the Christian religion, though it was greatly enhanced and elaborated by it. The turbulent battle scenes favoured by Greek artists — Lapiths against centaurs, Greek warriors against Amazons — were initially almost emotionless, just as the battle scenes depicted by Egyptian artists on their temples had been. In the great battle scenes that show the victory of the Nineteenth Dynasty pharaoh Ramses II (1279–1213 BC) over the Hittites at the battle of Kadesh (c. 1274 BC), the Egyptian monarch towers over his opponents with a completely expressionless face, while they run away from him like so many fleeing ants. Even after the Greeks obtained a complete mastery over the representation of the nude male body in every possible position, the faces of their warriors remained expressionless, as can be seen, for example, in the metopes from the Parthenon.*

The situation began to change at the end of the fourth century BC, with the work, not of Lysippus or Praxiteles, but of Scopas (fl. 395–350 BC). Scopas has been badly treated by the accidents of time. We know that he worked on the Mausoleum of Halicarnassus, where one of the combat friezes has been attributed to him, and also on the temple of Athena Alea at Tegea. From this some battered heads survive, which show warriors in the grip of strong emotion. Another work

75 PIERRE-PAUL PRUD'HON (1758–1823), Justice and Divine Vengeance pursuing Crime (1803). *The body of the victim here conforms to a feminized type of male nude which enjoyed surprising popularity with leading neo-Classical artists – surprising because neo-Classicism also subscribed to a cult of virility, as can be seen from the famous* Oath of the Horatii *by Prud'hon's contemporary Jacques-Louis David.*

attributed to Scopas is a figure of an ecstatic maenad, a copy of which exists in Dresden. Here too, the head of the figure is badly battered, but it was clearly the pose of the body just as much as the expression of the face which showed that the maenad figure was in the grip of overpowering passion. The choice of subject is also significant – not because, in this case, we are dealing with a female rather than a male, but because maenads were followers of the Greek god Dionysus, and were therefore votaries of one of the chief mystery cults in Greek religion. The ecstatic drunkenness of the maenads was emotional as well as physical – in the grip of the cult, they were beings whose emotions had overcome their reason.

Scopas seems to have been the chief source for the so-called 'baroque' phase of Hellenistic art, which is particularly associated with the city of Pergamon. In the Great Altar of Zeus, previously mentioned, with its frieze of gods battling against giants, the faces of the giants, in particular, express the anguish of their defeat, and heads and bodies form a seamless emotional whole. The city declared its independence from the Seleucid kings of Syria in 263 BC, and its second ruler under this dispensation, Attalus I, who succeeded in 243 BC, successfully beat off an invasion by wandering Galatian tribes, otherwise called Gauls. This feat was commemorated with a monument showing the defeated tribesmen. The chief relic of this is a superb Roman copy of a dying Gallic trumpeter, long known as the *Dying Gladiator*. In this, the possibilities of the heroic male figure as a vehicle for emotion, in this case tragic pathos, are fully exploited. The sculptor who created the original commented not only on Attalus' victory, but on the fallibility of human strength and the brevity of human life.

The theme was pursued in other Hellenistic sculptures. One was a group showing the *Flaying of Marsyas*. Marsyas was a satyr who found a pipe that Athena had invented and let fall. Marsyas grew skilled in playing it and he rashly challenged Apollo, god of music, to a contest. When he lost, Apollo condemned him to be flayed alive. The group showed Marsyas suspended, ready for the knife, Apollo idly watching his victim, and a kneeling Scythian executioner sharpening his blade. Versions of all three figures survive in the form of Roman copies, but the image of Marsyas himself was by far the most popular component and exists in multiple versions. Two things about it seem to have appealed to the Romans: the virtuoso display of musculature in Marsyas' body, which makes him look as if he has already been flayed, and the terror and anguish which the victim displays. In post-Classical times the figure was to supply source-material for depictions of Christian martyrdoms, and particularly for the *Flaying of St Bartholomew*.

Another ancient sculpture which uses the male nude to express dramatic emotion is the group of three figures known as the *Laocoön*. In Greek legend, *Laocoön* was a Trojan seer and a priest of the god Apollo. He offended the god by breaking his oath of celibacy and begetting children.

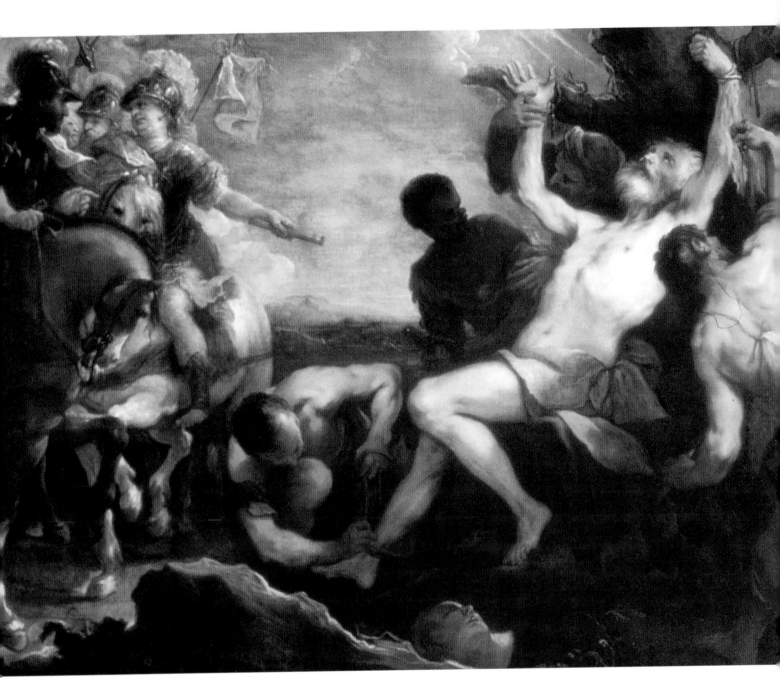

76 JUAN CARREÑO DE MIRANDA
(1614–85), The Martyrdom of
St Bartholomew. *This particularly
cruel subject owes something to classical
representations of the flaying of Marsyas.*

While preparing to sacrifice a bull on the altar of the god Poseidon, he and his twin sons were crushed to death by two great sea serpents. His fate is represented in a celebrated sculptural group signed by three Greek artists, Agesander, Polydorus, and Athenodorus. Though the group is often attributed to the second century BC, an inscription found on his native Rhodes shows that Agesander was alive between 43 and 21 BC. The sculpture is therefore a late derivative of the Pergamene style established 150 years earlier. It shows a skilful use of anatomical exaggeration, particularly in the muscles of Laocoön's torso, to heighten the tragic and pathetic effect. Its rediscovery in the ruins of the Roman palaces of the Palatine, in the very location where the writer Pliny the Elder (AD 23–79) had described seeing it in his *Natural History*, had an enormous impact on Renaissance and later art. It was greatly admired both by Michelangelo and by Winckelmann, and the German dramatist and philosopher Gotthold Ephraim Lessing (1729–81) made it the subject of an important aesthetic analysis, *Laokoon: oder über die Grenzen der Malerei und Poesie* ('Laocoön; or, On the Limits of Painting and Poetry'), published in 1766.

The coming of Christianity led to a sharp reaction against any display of nudity, disapproved of both by traditional Jewish religion and by the theology of the new church, which associated nakedness with pagan rites of an orgiastic character. Deeply entwined with these ideas was the Biblical legend of the first man and the first woman, Adam and Eve. According to the most fully elaborated version of this, found in Genesis 2:5–7; 2:15–4:1, and 4:25, God, or Yahweh, created Adam at a time when the earth was still void, forming him from the earth's dust and breathing 'into his nostrils the breath of life'. Adam was given the Garden of Eden to tend but was also commanded not to eat the fruit of the 'tree of knowledge of good and evil'. To provide Adam with a companion, God later put him to sleep. As Adam slept, God removed one of his ribs, and created Eve. It was Eve who yielded to the blandishments of the evil serpent and then persuaded Adam to join her in eating the forbidden fruit from the tree. The result of this was that the couple lost their innocence, recognized their own nakedness, and out of shame donned fig-leaves as

77 AGESANDER, POLYDORUS AND ATHENODORUS, Laocoön and His Sons (c. 50 BC). *This celebrated group shows the Trojan priest Laocoön and his twin sons being crushed to death by two sea serpents, as a punishment after having offended the god Apollo.*

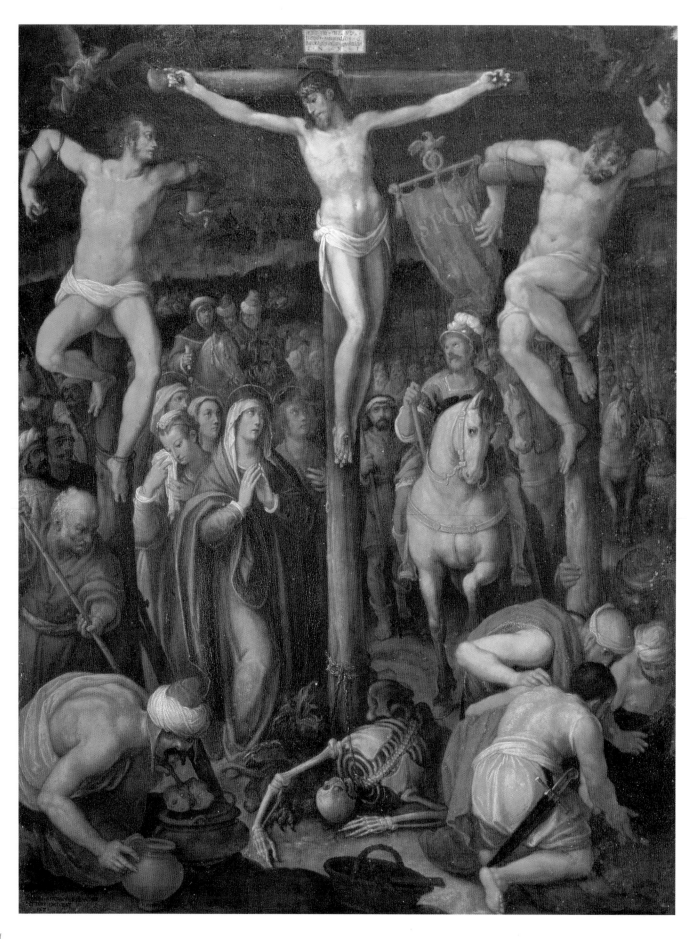

garments. Nudity was thus directly associated with the idea of sin, and of disobedience to divine commandments.

Though Christianity at first simply took over the existing forms of pagan art, it modified these to get rid of things which did not accord with its own tenets, the display of nudity, whether male or female, being one of them. However, when artists wanted to illustrate aspects of both the Old and the New Testament, they found themselves in a dilemma. It was impossible, for example, to portray the Fall without showing the nudity of Adam and Eve, and the Christian Redemption, in turn, was rooted in the idea of fallen humankind, for whom Christ made his sacrifice. Showing the phases of that sacrifice, for example in the traditional Fourteen Stations of the Cross, also involved a display of male nudity or semi-nudity, as Christ was whipped, stripped of his garments and finally crucified. Though the Stations were not established in their present form until a comparatively late date, in the early sixteenth century, the New Testament narrative on which they were based was of course known and illustrated from the very earliest periods of Christianity.

The prohibition against nudity was, however, so strong that in the earlier Christian centuries the crucified Christ was often portrayed almost fully clothed, wearing a long robe that fell almost to his feet. When Adam and Eve were depicted, every effort was made to play down the fleshliness of their bodies.

The situation began to alter soon after the year 1200. One powerful influence in this was the teaching of the new Franciscan order. St Francis of Assisi (1181/2–1226) preached a doctrine of physical identification with Christ, and of Christ's own full humanity. The force of the message was greatly reinforced because Francis was known to have received the stigmata – the wounds in hands, feet and side which Christ sustained as a result of crucifixion – on his own body. St Francis' contemporary, the Holy Roman Emperor Frederick II of Hohenstaufen (1194–1250), generally resident in his southern territories of Apulia and Sicily, and anxious to revive the glories of the original Roman Empire, encouraged a regeneration of classical forms which long anticipated the Renaissance, and this too encouraged artists to take a closer look at the male nude than had been possible for centuries.

It is significant that one of the major steps towards a new form of art should have been Masaccio's fresco of *The Expulsion* (c. 1424–8) in the Brancacci Chapel in Florence. His depictions

78 JOHANNES STRADANUS (*Jan van der Straet, 1523–1605*), The Crucifixion (*1581*). *In this depiction of Christ, he is accompanied by the Good Thief (left) and the Bad Thief (right). Their contorted attitudes allow the artist to give a virtuoso display of anatomical knowledge (left).*

79 STEVE HAWLEY, Male Nude (*1980–1*). *In this study by a contemporary American realist painter, the model is posed as if crucified, but it is evident that his arms are not in fact carrying his weight (above).*

80 FRANCESCO CLEMENTE (b. 1952),
The Fourteen Stations, No. VIII
(1981–2). *The traditional Fourteen
Stations of the Cross were first
established as a devotional sequence at
the beginning of the sixteenth century.
The eighth Station shows the women
of Jerusalem (here symbolized by their
shoes) weeping over Christ as he
follows the road to Calvary.*

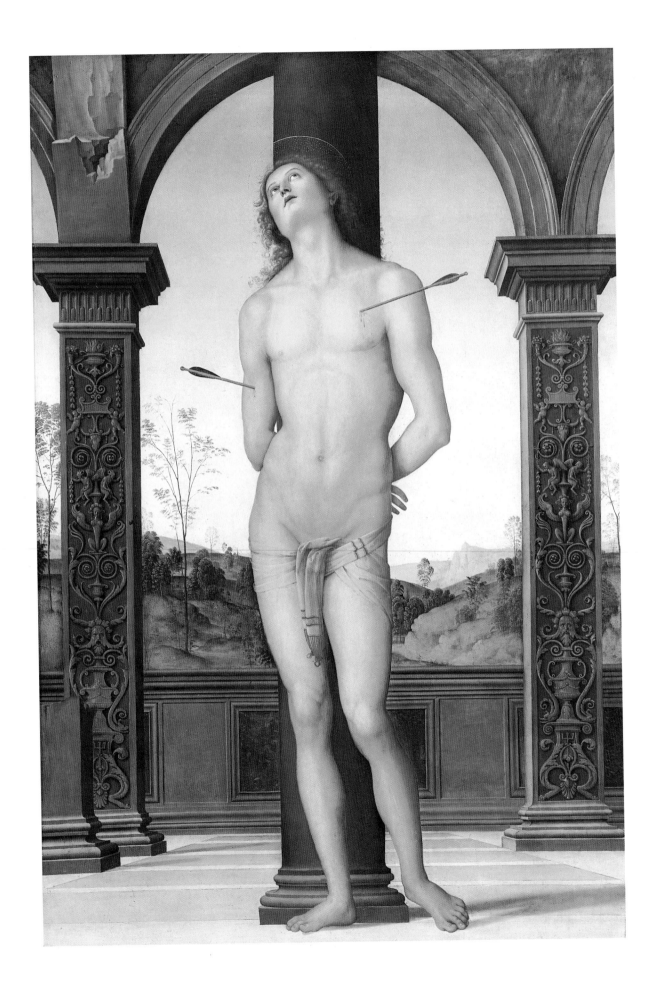

of the nude Adam and the nude Eve driven howling from Paradise were a revolutionary attempt to depict the naked human body in a realistic way.

The overall condition of fifteenth-century society meant, however, that the figure of Adam was to have far greater influence on artists than the figure of Eve. As artists rediscovered the art of antiquity they started to look for ways to incorporate their discoveries into the works of art they were asked to produce for religious purposes. One of the obvious ways in which to do this was to show the suffering Christ as an antique hero. The emotional sculptures of the Hellenistic age provided exemplars for Christ Crucified, Christ at the Column, and also for the Deposition and the dead Christ lamented by holy women or by weeping angels.

In addition to depicting episodes from the life of Christ that required them to portray nudity or semi-nudity, Renaissance painters were also required to give visible form to the lives, and in particular the martyrdoms, of the saints. Here too, male nudity was often unavoidable. It is, for example, obviously impossible to portray the martyrdom of St Lawrence, roasted alive on a gridiron, if the main figure is clothed.

One especially popular saint was St Sebastian, who was tied to a column or tree trunk and pierced with arrows, tended when almost lifeless by women, and finally beaten to death and flung into a sewer. Of these episodes, by far the most popular with the devotional audience was the first, and in his altarpieces the saint is almost always depicted bound and pierced with numerous arrows. This gave classicizing artists such as Andrea Mantegna (1431–1506) the opportunity to show a beautiful youth, almost entirely naked, sometimes stoically enduring the agony inflicted upon him, sometimes (as in Mantegna's painting of the subject now in the Ca d'Oro in Venice) writhing in agony.

It has been suggested that St Sebastian was in fact raped by his persecutors, and that the arrows were a metaphor for this. Certainly many depictions of the martyrdom of this saint carry a strong homoerotic charge.

The *St Sebastian* in the Ca d'Oro is unusual for its period because of its empathy with the sufferings of the victim. This situation was to change with the appearance of the Baroque style at the end of the sixteenth century. In Catholic countries the religious art of the Baroque was an expression of the Counter-Reformation spirit – the counter-attack against the inroads made by

81 PERUGINO (1450–1523). St Sebastian (1518). *The gentle Umbrian artist minimizes the saint's suffering, choosing instead to make him a tranquilly beautiful youth. The semi-transparent scarf round his loins allows a surprising glimpse of his – rather inadequate – genitalia (left).*

82 RICARDO CINALLI (b. 1948), St Sebastian (1989). *The contemporary Argentinian artist Ricardo Cinalli violently compresses and foreshortens his subject in order to monumentalize it. The lamenting Virgin with Christ in her lap, seen in the background to the right, is a quotation from the Italian Renaissance master Sebastiano del Piombo (1485–1547) (above).*

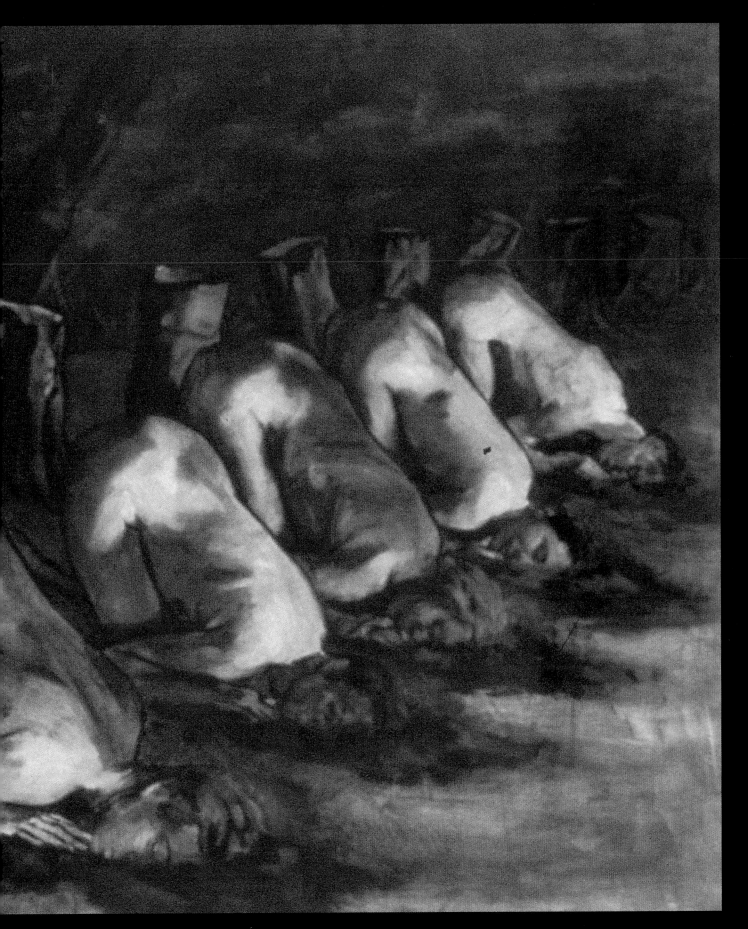

84 LUIS CABALLERO (1943–85),
Untitled (1979). *In making drawings
of this kind Caballero was influenced
by pictures of fatal road accidents and
assassinations he found in the
Colombian newspapers, but he also
wanted them to have an erotic charge.*

83 PATTY WICKMAN (b. 1959),
Taken (1991). *A contemporary
fantasy about captivity, with affinities
to the Orientalist paintings of the
nineteenth century (previous page).*

Protestantism. A major factor in this was the teachings of a saint whose influence over the development of Catholicism rivals that of St Francis – the Spaniard, St Ignatius of Loyola (1491–1556). The Jesuits of St Ignatius were to be the intellectual shock troops of the Church. In addition to this, his *Spiritual Exercises*, first drafted in 1522–3 and published in 1548, were to have a lasting effect on the devout. In this text, Ignatius encourages the worshipper to identify as closely as possible with the sufferings of Christ and his saints, to project himself or herself into the full reality of the sacred event. Baroque artists rejoiced in the fleshiness of their figures and the unrestrained violence of the events they depicted. A good example of this is *The Flagellation* by the Bolognese artist Ludovico Carracci (1555–1619) now in Douai.

The taste for violent physicality was mitigated in the eighteenth century by the essential frivolity and worldliness of the Rococo, but was then revived by Romanticism. There are, for example, a number of drawings by the French artist Théodore Géricault (1791–1824) which show sadistic execution scenes featuring nude male figures. In addition to this, Géricault liked to depict in his paintings episodes of suffering and death taken from real life. His most famous composition, *The Raft of the Brig 'Medusa'* (1818–19), depicts the aftermath of a contemporary French shipwreck which was a political scandal of the day, whose survivors embarked on a raft and were decimated by starvation before being rescued.

In the twentieth century, the taste for the male nude seen as an empathetic focus for episodes of pain and violence has mostly taken refuge in popular art forms such as the cycle of 'peplum' movies already referred to in Chapter Two. No movie starring Steve Reeves was complete without a scene in which the hero is seen bound or chained, and threatened by physical torments of one kind or another. The centrality of these scenes to the narrative indicates that they were one of the chief reasons why films of this type became so popular.

Similar images can be found in the world of news and sports photography – in the latter case, the focus is on the moments when competitors are pushing themselves almost beyond the limits of their own physical powers. It is interesting to note how often, when dealing with either war photography or sports photography, picture editors seem to choose images that echo compositions already established by long use in Christian art.

One contemporary artist who spotted this tendency and made use of it was the Colombian painter, Luis Caballero (1943–95). A powerful draftsman with a strong academic training, his source materials included Spanish colonial religious art, the graphic news pictures of assassinations and auto-wrecks which appear in Colombian newspapers, and homosexual pornography. These he blended together to produce images which speak eloquently, but also with deliberate ambiguity, of the bond between sex and death.

The Noble Savage

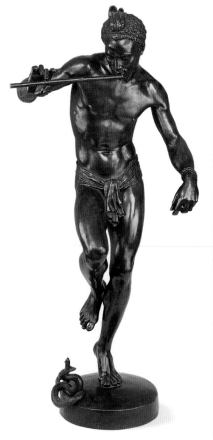

85 CHARLES ARTHUR BOURGEOIS (*1838–86*), The Snake Charmer (*1862*). *This represents mid-nineteenth century eroticism, at a time when Europeans were carving out colonial empires (above).*

86 THÉODORE GÉRICAULT (*1791–1824*), Nude Man Pulling on a Rope. *Géricault could not resist giving an academic life study an air of wildness (right).*

FOR THE GREEKS, *the willingness of the male to go naked was often a mark of civilization as opposed to barbarism. In battle scenes showing combats between Greeks and Persians, it is the Greek warriors who are nude and their opponents who wear their national costume, including the trousers that the Greeks found so ridiculous. Both Hellenistic rulers and Roman emperors were willing to be represented entirely nude, as a mark of their semi-divine status.*

Since the triumph of Christianity, the situation has been the opposite. Nakedness, in the eyes of the Church, became the sign of uncivilized ignorance, and therefore of sin. The Christian missionaries who operated in the South Seas during the nineteenth century spent a great deal of time and effort trying to get their converts to wear more clothing, preferably the all-concealing garment called a 'Mother Hubbard'. Though they probably objected to female nakedness even more than they did to the male variety, because it seemed a direct invitation to sexual sin, the missionaries urged males to clothe themselves as well. They particularly disliked forms of adornment, such as the penis-sheath worn in New Guinea, which seemed to combine almost total nudity with sexual boasting.

Given the history of European costume, the objection to penis-sheaths was a little ironic, as there had already been periods when male dress, though in theory preserving the modesty of the wearer, laid great stress on his sexual attributes. In the fifteenth century young gallants wore short tunics over tight-fitting parti-coloured hose, which accentuated the buttocks, and especially the

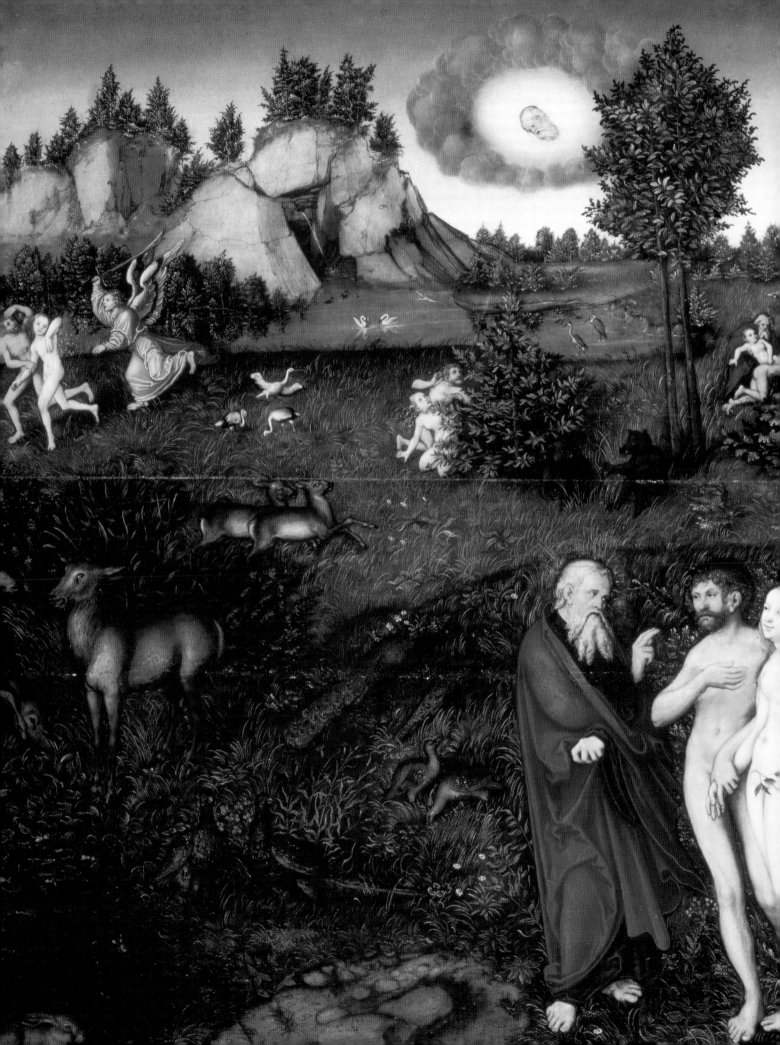

87 LUCAS CRANACH THE ELDER
(1472–1553), Adam and Eve
in the Garden of Eden (1530).
*The idea of natural 'innocence'
appears in the Bible in the account
of Adam and Eve. In the foreground
they are being instructed by God
the Father. In the background to the
right Eve persuades Adam to eat the
apple, while to the left an angel
drives the pair out of the Garden.*

division between them. In front, the gap between tunic and hose was filled by an item called a codpiece, a small bag which covered the genitals. The word 'cod' is an archaic term for scrotum. In the early-sixteenth century a new male fashion developed, and the codpiece was padded until it resembled the male genitalia in a state of excitation, and was often adorned with embroidery and jewels. So essential did this strange adornment seem that it was even copied in metal and added to suits of armour. Metal codpieces form part of some of the suits of armour made for Henry VIII and preserved by the armouries of the Tower of London. Here essential protection is combined with blatant sexual advertisement.

The fashion for extremely close-fitting nether garments died out around 1580, but returned in the eighteenth century with the rise of neo-Classicism and persisted throughout the whole period of the Napoleonic Wars. It was especially favoured for military uniform, and in this guise has survived until the present day. The white buckskin breeches which form part of the ceremonial uniform of the British Life Guards are worn so tight that the wearer is said to need assistance in actually getting into them. Two comrades pick him up, and drop him bodily into the garment, which a third holds open. A number of modern sports uniforms for men, made of brightly coloured stretch fabrics such as Lycra, operate on much the same principle. Protective shields or

padding for the genitalia play much the same role in these garments as the sixteenth-century codpiece, drawing attention to the part of the body they conceal, and at the same time emphasizing the wearer's virility.

By the eighteenth century, however, the Christian concept of original sin was already meeting competition from another set of ideas, summed up in the familiar phrase 'the noble savage'. Despite their conviction that they were superior to all other races, the ancient Greeks had already made a place for this concept in their ideology. Homer, and after him Xenophon and Pliny the Elder, idealized the Arcadians and other primitive groups, especially the Scythians. A Scythian prince called Anacharsis was included in some Greek lists as one of the legendary Seven Wise Men and was praised by Herodotus as an example of primitive virtue.

The idea reappeared in the late seventeenth century. The actual phrase 'noble savage' was first used in John Dryden's play *The Conquest of Granada* (1672) and the notion was further developed

88 *Swiss armorial stained-glass window (early sixteenth century). The coat of arms of the canton of Uri is sustained on either side by two landsknechts. Prominent (in all senses) features of their costume are the codpieces fashionable at the time (left).*

89 Jack Fritscher (b. 1939), Actual Body-builder, American Man (1989). *The subject wears tight-fitting lycra sportswear, boxing gloves, a helmet – and a padded crotch-protector (above).*

CHRISTOPHER JAMES (b. 1947),
Wrestlers: India (1985). These
all-but-nude figures, with their
primitive training equipment
correspond closely to the European
idea of the 'noble savage', despite
the fact that India's civilization is
in fact so ancient.

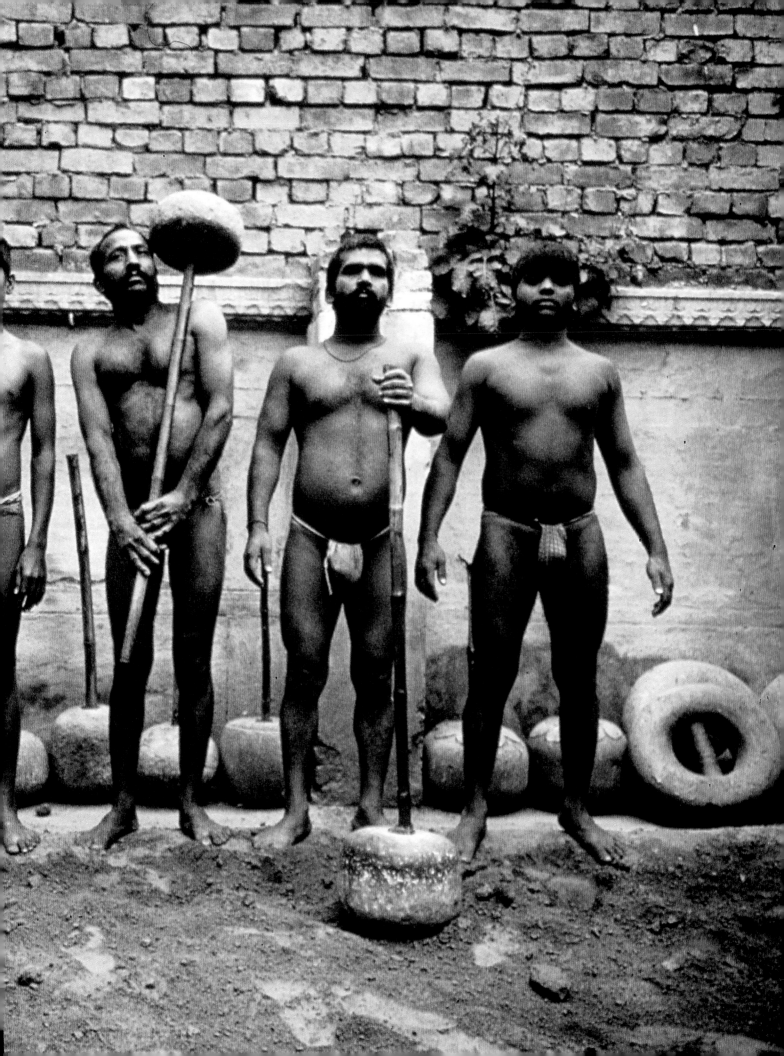

in another English drama, Thomas Southern's *Oronooko* (1696, based on a novel by Aphra Behn), which concerns an African prince enslaved in the Dutch colony of Suriname, on the tropical shores of South America.

The most influential advocate of man's original nobility was the French philosopher, Jean-Jacques Rousseau (1712–78). In his first major publication, *Discours sur les sciences et les arts* (1750), written as a prize essay, Rousseau announced a theme which was to obsess him for the rest of his life: that man is innately good by nature, and has been spoilt by civilization – a proposition that turns the doctrine of Original Sin on its head. In his *Discours sur l'Inégalité* (1755), he attempts to construct the earliest phases of humankind's life on earth, and argues that, while the first men were perhaps solitary, they were also happy, good and free. It was only when they came together to create societies that their nascent passions, and especially the passions of envy and jealousy, led them into vice. In *Emile, ou De l'Education* (1762) he denounces the corrupting effect of traditional educational methods, and he re-affirms his belief in man's basic goodness in his *Confessions*, written in 1765–70. Rousseau's attitudes inspired much of the fiction of the Romantic Movement, notably the novels of François-René de

91 *Lithograph after* GEORGE CATLIN *(1794–1872),* The Sioux Ball Player We-Chush-Ta-Doo-Ta. *Catlin's romantic depictions of native American braves seem to have been influenced by writers such as Chateaubriand and James Fenimore Cooper (above).*

92 JAMES STRACHAN, Vanuatu, Tanna Island: Tribesman and Two Children by a Tree in the Jungle *(1994). No doubt intended to be a completely objective ethnographical document, this photograph conveys the photographer's feeling that the 'uncivilized' life has something idyllic about it (right).*

Chateaubriand: *Atala* (1801); *René* (1802) and *Les Natchez* (1826), in which he sentimentalizes the life of the North American Indians.

Cheateaubriand's work, in turn, inspired a large number of enormously popular novels on the same theme in English. Early examples include the *Leatherstocking Tales* (1823–41) of James Fenimore Cooper. These in turn have had numerous descendants, among them the Tarzan stories of Edgar Rice Burroughs (1875–1950), in which the hero is the son of an English nobleman, abandoned in the jungles of Africa, where he is rescued and raised by apes. Burroughs' original novel, *Tarzan of the Apes* (1914), and a series of 24 successful sequels, are reported to have sold 25 million copies between them. They have been translated into more than 56 languages. In Burroughs' fiction the influence of Rousseau is mingled with that of Charles Darwin (1809–82).

Rousseau's attempt to determine the 'scientific' origins of man was taken up in a more determined way in the nineteenth century. The first major public step in this quest was Darwin's *On the Origin of Species by Means of Natural Selection*, published, after a long gestation, in 1859. Since it so flatly

contradicted the Biblical account of the Creation given in the Book of Genesis, and suggested that humans were in fact the direct descendants of apes, the book caused immediate and long-lasting controversy. In 1871 Darwin added fuel to the flames with *The Descent of Man*, tackling the question of human origins directly. He argued that humans had psychological as well as physiological similarities to the great apes, predicting that 'the time will before long come when it will be thought wonderful that naturalists, who were well acquainted with the comparative structure and development of man and other animals, should have believed that each was the work of a separate act of creation.'

His influence has continued until the present day. Recently it was announced that, thanks to modern research into the Y chromosome, a chromosome that sons only inherit from their fathers, all men can trace their ancestry back to one individual, who lived 150,000 years ago in Africa[1]. His closest living relatives are members of the small Khosian tribe in contemporary South Africa, which is believed to have emigrated to its present territory from the Rift Valley in East Africa where *Homo sapiens* is thought to have evolved. The myth of a single male ancestor, Adam, thus paradoxically becomes the subject of scientific proof.

The new doctrine that man was not unique, but simply a mutation from a 'lower' species, naturally affected the way in which artists looked at the male body. The process of idealizing it, which is, in a certain sense, also a process of ridding it of its animality, became infinitely more complicated. There were other effects as well. One was a fascination with the way in which members of primitive societies decorated their bodies. Though decoration of this kind was already known from European contact with the Indian tribes of North America, it had acquired, in an epoch just prior to that of Darwin, a much more elaborate cultural context than it had previously possessed. The study of this decoration became a part of the science of anthropology.

The birth of anthropology, which divides into physical and cultural branches, can be traced in a general sense to the impact made by the great voyages of the Age of Discovery, from the fifteenth to the early nineteenth century. However, the most influential of these, simply because the time was intellectually ripe for what they found, were eighteenth-century maritime explorations, most of all the expeditions led by Captain James Cook (1728–79). Cook's three voyages to the Pacific in the 1770s aroused great interest in Europe concerning the tribal societies he found, and especially about the physical appearance of their members.

William Hodges, the artist who accompanied Cook's second Pacific voyage in 1772–5, made drawings, which were subsequently published as engravings in the handsome illustrated work which described what Cook had achieved. These showed not only the scenery of the Pacific Islands, but also the costumes, or lack of them, of the inhabitants and details of the elaborate

[1] The Times, London, 9 November 1997, p.24.

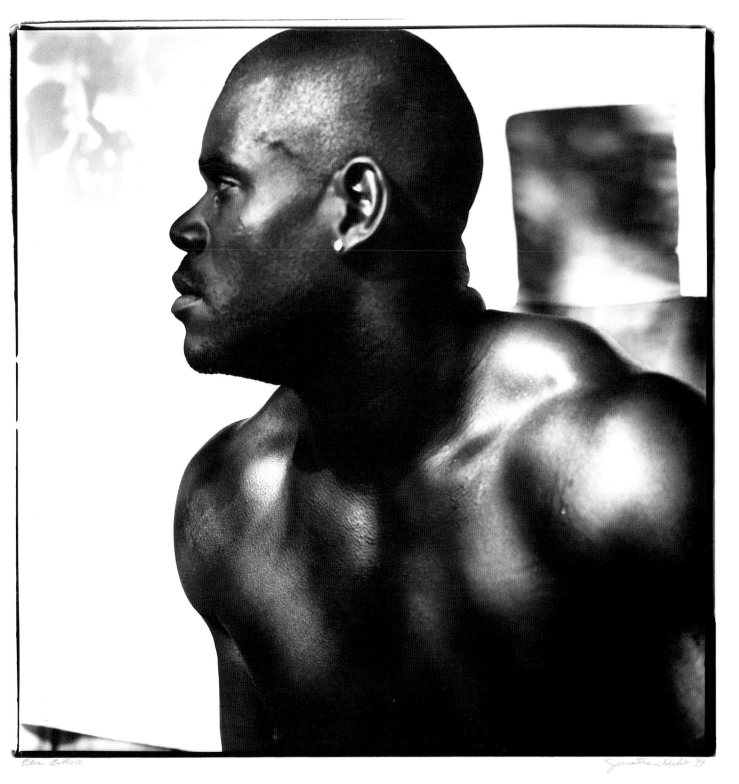

93 JONATHAN WEBB (*b. 1955*), Otis Bathiste
(*1997*). *Jonathan Webb has here chosen
to concentrate on the primitive strength of
Otis' profile. Another New Orleans
photographer, George Dureau, has made
numerous images of the same model.*

94 GEORGE DUREAU (b. 1930),
Chico Rodrigues (1979).
*Here Dureau photographs a
street hustler in a variant of a
classical pose.*

way in which they tattooed and decorated their bodies. Other books that recorded the great voyages of discovery in the late eighteenth and early nineteenth centuries were illustrated in a similar fashion. Subsequent explorations, into regions as widespread as Amazonia, Tierra del Fuego and various parts of Africa, revealed that the custom of decorating the body was not in fact confined to Pacific regions alone.

These bodily decorations were used by women almost as frequently as they were used by men, and they often had specific meanings which were directly to do with gender. Tattooing or scarification, for example, was often used to record a rite of passage – the moment when a youth was recognized as a man. Some of these rites, like the widespread practice of circumcision, relate directly to male sexuality. A youth not yet circumcised was often regarded as ritually 'unclean', and therefore forbidden to procreate. In addition, there were other reasons for a man to decorate his body. For example, he might aim to emphasize his aggressiveness and power as a warrior. Many male adornments were designed primarily to frighten the enemy – or alternatively to frighten away evil spirits. Or they might simply stress the man's status within the community.

One tribe at least, the Nuba of the central Sudan, paint themselves with elaborate decorations simply out of admiration for their own bodies. For example, when a man has a pair of giraffes painted on his back, it is because he thinks that these designs enhance his own elegant shape. Nuba men, who often go naked, are intensely body conscious. Their language has words to refer to every muscle in the body, and even to the divisions between the muscles. There are also words for the different kinds of movement – walking, skipping or prancing – associated with a Nuba warrior. Equally, this language makes fine distinctions between different kinds of abrasion to the skin. This means that a man who has even a minor skin blemish will not paint his body or call attention to it in any way. In this case, the male body is not simply the inspiration for art, as it was with the Greeks, but is a work of art in its own right.

95 Wrestler Stretching a Steel Chain Bow (*Mogul miniature from the Clive Album, 1700). Indian artists working in traditional fashion also seem to have felt the attraction of the 'natural man'.*

96 DAVID HISER, Western Samoa:
Man with Traditional Tattoo
(1992). *While tattoos are found
all over the world, they are
particularly associated with the
tribal societies of the Pacific. Here
the elaborate tattoo serves as a
kind of substitute nether garment.*

Tattooing – the insertion of pigment under the skin – is a more permanent form of decorating the body than the simple use of paint. The word comes from the Tahitian *tatu*, meaning 'to strike', and was introduced into the English language thanks to Captain Cook's voyages of exploration. Tattoos, however, were known from the earliest times. A celebrated example is the embalmed body of a heavily tattooed man found in one of the Scythian burial mounds at Pazyryk in Kazakhstan. The burials date from the fifth to the third century BC. Even earlier instances have been found in ancient Egyptian burials from c. 2000 BC, and the practice was widely known in antiquity. Classical authors mention it in connection with the Thracians, Greeks, Gauls, ancient Germans, and ancient Britons. After the advent of Christianity, tattooing was increasingly discouraged in Europe as an assault on the god-given integrity of the body, and was finally banned on religious grounds by Pope Hadrian II in AD 787. It nevertheless persisted in non-Christian cultures. Marco Polo, for example, gives a clear description of the process in his account of his travels. In the early nineteenth century, after Cook's discoveries had made their impact, heavily tattooed men, like the harpooner, Queeqeg, in Herman Melville's novel *Moby Dick* (1851), were considered to be prototypes of the 'noble savage' whose intellectual genesis has been discussed above.

After an American naval squadron led by Commodore Matthew C. Perry opened Japan to foreign trade in 1853, the extremely elaborate and skilful tattooing done by the Japanese attracted the attention of Europeans. By the end of the century tattooed designs of a greater or lesser degree of elaboration had become popular with sailors and with individuals in general, especially members of the working class, who wished to present themselves as thoroughly masculine. During the present century the practice has gone through phases both of favour and disfavour. Among the reasons given for discouraging the tattooist's art are the questions of hygiene, and, still more so, the fact that tattoos have often been the chosen insignia of defiantly marginal groups, such as members of outlaw biker gangs and convicts, who relieve the boredom of imprisonment by adorning themselves with crude amateur tattoos.

Recently, tattooing has experienced a remarkable rise in popularity. There seem to be several reasons for this. One has already been given: a tattoo, or better still, an elaborate series of tattoos, is perceived as an insignia of masculinity, and of the stoic capacity to endure discomfort. It is one of the few ritualized ordeals to which a modern man can now subject himself. In addition to this, there is in our society an increasing emphasis on the culture of the body, accompanied by the willingness to expose large areas of flesh to the public gaze. A heavily tattooed man can indulge

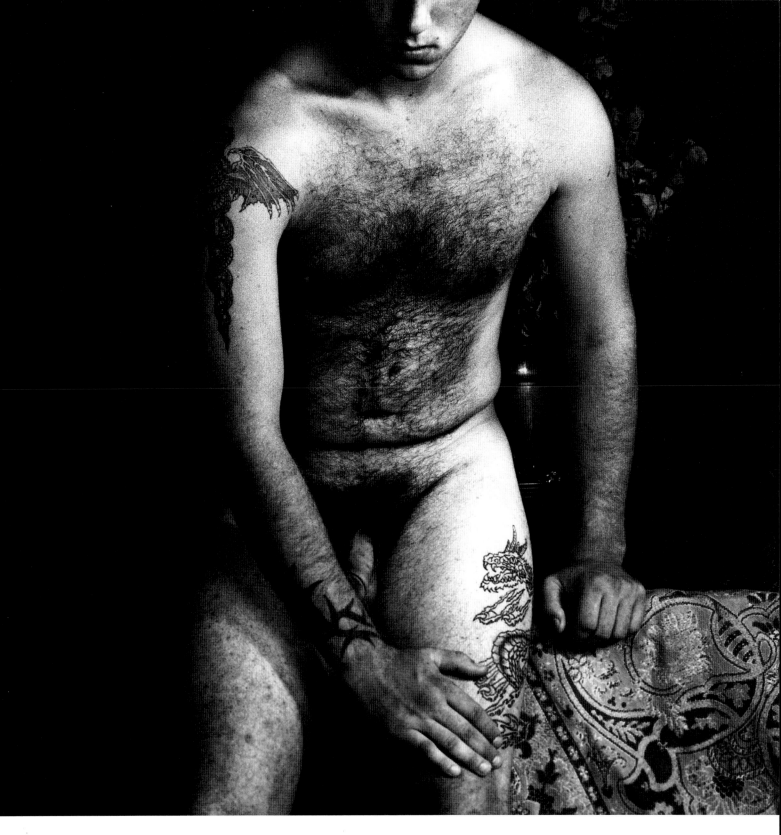

97 ROBERTO RINCÓN (*b. 1967*),
Nude Male (*1993*). *The
photographer cleverly links the
patterns on the subject's nude
body to those on the tablecloth.*

in the decorative impulse without in any way appearing to be effeminate. The more clothes he sheds the more he emphasizes his own essential maleness.

Finally, there is no doubt that tattoos eroticize the body as well as simply decorating it. The professional tattooist Spider Webb classifies the subject as follows in his book, *Pushing Ink*: 'Eroticism in tattooing can be divided into four general categories. The first involves tattoos which are intended to make the body more attractive in general, to create a nonspecific sensual appeal. The second concerns tattoos with specific erotic placement and/or content. The third takes in the notion of a tattoo subculture – people who form sociosexual alliances and communities on the basis of tattooing. And the fourth deals with the very process of tattooing as an erotic activity independent of design, placement or motivation.'[2]

Tattooing, for example, often goes contrary to the idealizing impulse that insists we look at the male body as a unity rather than as a collection of parts by calling attention to specific areas, and to the erogenous zones in particular. A tattoo on the penis makes a very specific reference to the idea of sexual activity. Spider Webb recounts that one man had the face of a demon placed on his belly and he had his penis made into a forked tongue. Another had his penis made into a whip handle, with the lashes of the whip spreading out over his belly and chest. The required discomfort involved in having one's body tattooed necessarily links the procedure to much cruder forms of erotic sado-masochism.

In their most recent manifestations, elaborate tattoos have often been part of a specifically gay subculture. Though this sometimes involves females, its appeal in general has been to males. Once again, there are several related reasons. In the first place it allows the male to attract the masculine gaze without compromising his own masculinity. As has already been suggested, such tattoos allow the wearer to focus attention not just on the body itself but also, if he wishes, on specifically sexual areas. As an alternative, they allow him to draw attention to characteristics that intensify an aura of maleness – a broad chest or big biceps. They suggest, in addition, that he is someone who has survived some kind of ordeal or rite of passage. Finally, they hint (through the 'noble savage' metaphor or – nearer to home – the convict/biker comparison) that this is someone who is prepared to defy the rules which modern society attempts to impose.

Above all, elaborate tattoos imply a willingness to go naked – what is the point of having them if they cannot be seen? Their revival in recent years is part of radically changing attitudes towards the whole question of masculine nudity. The reverberations of tattoos will be explored in the second part of this book.

Spider Webb, with Marco Vassi, Pushing Ink: The Fine Art of Tattooing (Simon & Schuster, 1979), p.76.

98 EDWARD LUCIE-SMITH, Olin, Truth-or-Consequences (1997). *Olin is an artist-craftsman living in a small town in central New Mexico. His numerous tattoos allude to his keen interest in and self-identification with the North American Indians (left).*

Naked
not
Nude

99 Ancient Greek Boxers (*from a Panathenaic amphora, c. 336 BC*). *The Greek custom of men participating in sports totally unclothed gave a very different nuance to the idea of nudity and nakedness in Ancient Greek society.*

100 E.F. KITCHEN (*b.1951*), Mors in Lutetia (*1997*). *We instinctively think of the subject here as 'naked' not 'nude' because of the transitory nature of the action shown (pointing a pistol directly at the photographer, as if to ward him off) and the cluttered domestic setting, whose details are repeated in the mirror behind the figure (right).*

A RADICAL SHIFT IN PERCEPTION *takes place when we begin to think of the individual who is represented as a work of art as being naked (that is, conspicuously without clothing), rather than as nude (without clothing, but somehow translated into an ideal sphere). Before the invention of photography, artists were usually able to avoid this dilemma, though there were occasions when they were confronted with it.*

The broadening of artistic range which took place in Hellenistic times, and especially the Hellenistic taste for a new sort of realism, involved the representation of physical types at both ends of the spectrum of age which had not been tackled previously. Old men and women as well as very young children became subjects for the artist. For the Hellenistic public, representations of physical decrepitude carried with them implications of poverty and misery, conditions to which this public was not necessarily sympathetic. A case in point was a statue of an old fisherman, an artistic creation very popular with the Hellenistic Greeks and the Romans if one is to judge from the number of extant copies, which was later transformed by the imagination of Renaissance savants into an image of the poet-philosopher Seneca (*c. 4 BC–AD 65*) committing suicide on the orders of the Emperor Nero. Here the fidelity with which the sagging, wrinkled flesh of the subject is rendered overcomes all pretext at idealization and makes us very conscious of his lack of clothing. It took the compassionate doctrines of Christianity to take coldly objective representations of this sort and turn them into something with which the viewer could empathize,

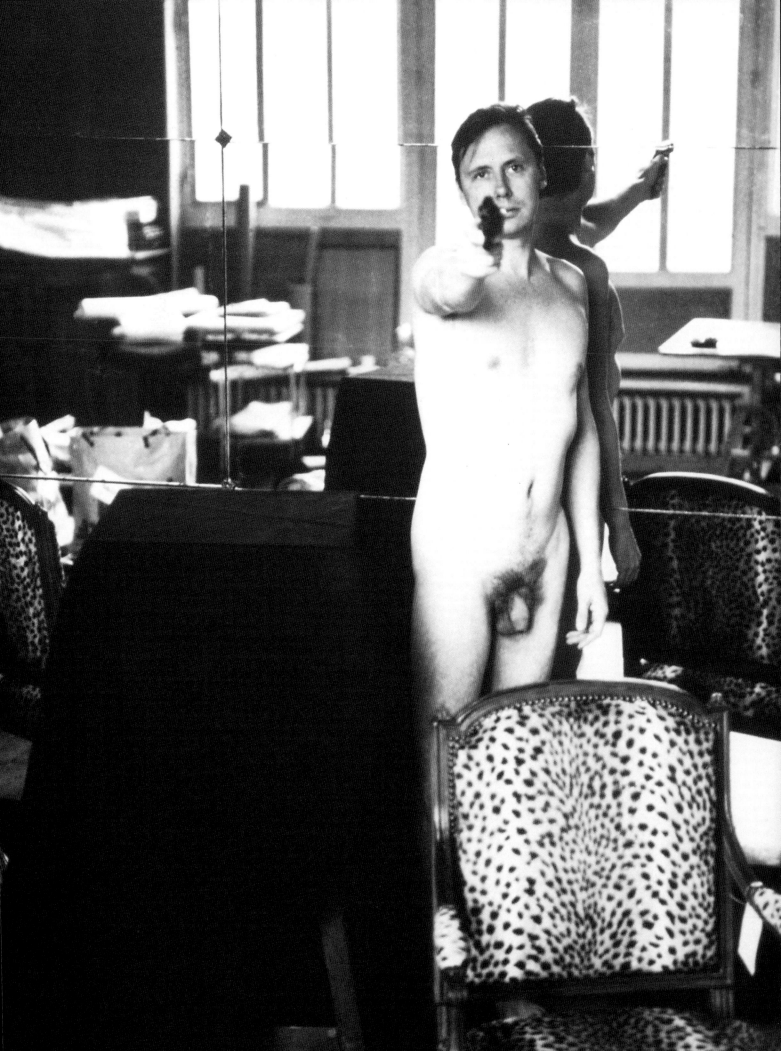

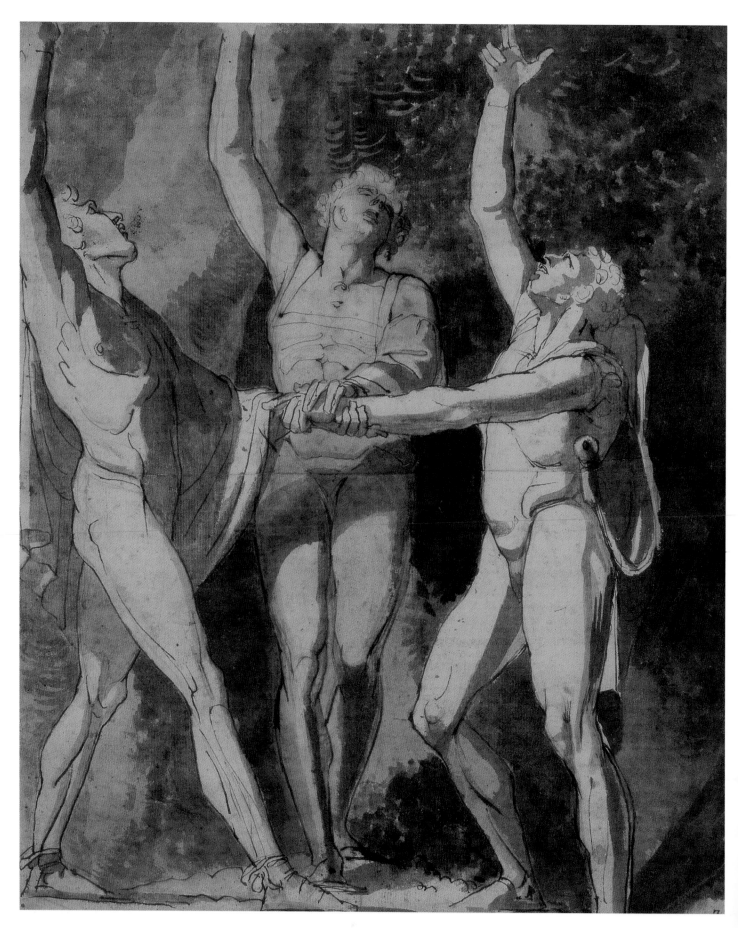

in the persons of St Jerome praying and fasting in the desert of Chalcis, or of Job dealing patiently with his afflictions.

The invention of photography turned art back towards realism and had a particularly drastic effect on attitudes to the nude. The camera's objectivity was apparently unimpeachable, and when the lens was turned on the human body it tended to reveal very clearly just how far the body usually departed from the ideal proportions which artistic academies were at pains to instil in their pupils. In addition, it called attention to the fact that the subjects being photographed were individual human beings who had violated social canons of modesty by stripping off their clothing and presenting themselves to the gaze of another human being. That is, there could be no pretence that this was an imaginary event, which had taken place only in the artist's head. The action of light on photographic emulsion offered an objective guarantee that the event in question really had taken place.

It might be supposed that a naked female exposing herself to the gaze of a male photographer (it was presumed that the photographer would in this case be male, though many females entered the profession) would produce a more shocking effect than a male doing the same thing to a photographer of the same gender. This was not, in fact, the case, for more than one reason. The points of sexual focus on a female body are the breasts and the vagina. Breasts had been represented in art so frequently, and were often revealed so fully by fashionable costume, that they had, by the second quarter of the nineteenth century, lost a good deal of their shock value. The vagina, a woman's most private and secret part, was not the most conspicuous aspect of her anatomy. Photographers could get rid of both vagina and pubic hair with a minimum of retouching, and without producing a disturbingly incomplete effect.

The genitals, the main point of sexual attention in the male body, presented an entirely different case. Western art had never devised a satisfactory convention for dealing with them, even at moments when the idealizing impulse was at its strongest. The Greeks consistently diminished their size in relationship to the rest of the body, except in some rare erotic representations. Before the Renaissance, art of the Christian era found it almost impossible to represent male genitalia. After the Renaissance, artists still often contrived to fudge the issue, using strategically placed wisps of drapery or conventionalized fig-leaves. It is noticeable that, when called upon to make preparatory drawings of full-frontal nudes in the privacy of their own studios, academic artists often left this particular detail blurred or undeveloped.

While photographers might adopt some of these strategies, draping the model's loins with a scarf or putting him in poses where his penis and testicles were hidden by the position of his

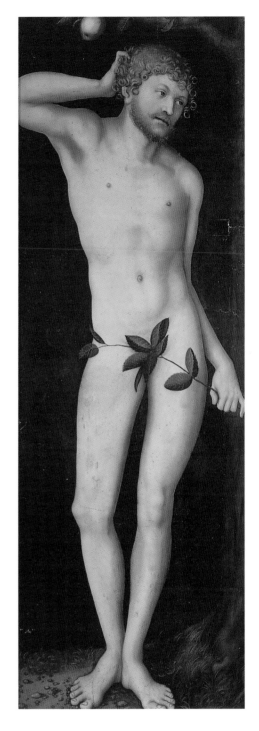

101 HENRY FUSELI, Conspirators Swearing an Oath at Rütli (1779). *Fuseli heroizes the oath marking the Swiss confederation by showing the oath-makers nude (left).*

102 LUCAS CRANACH THE ELDER (1472–1553), Adam (1528). *A contemporary of Dürer, Cranach was little affected by Renaissance classicism (above).*

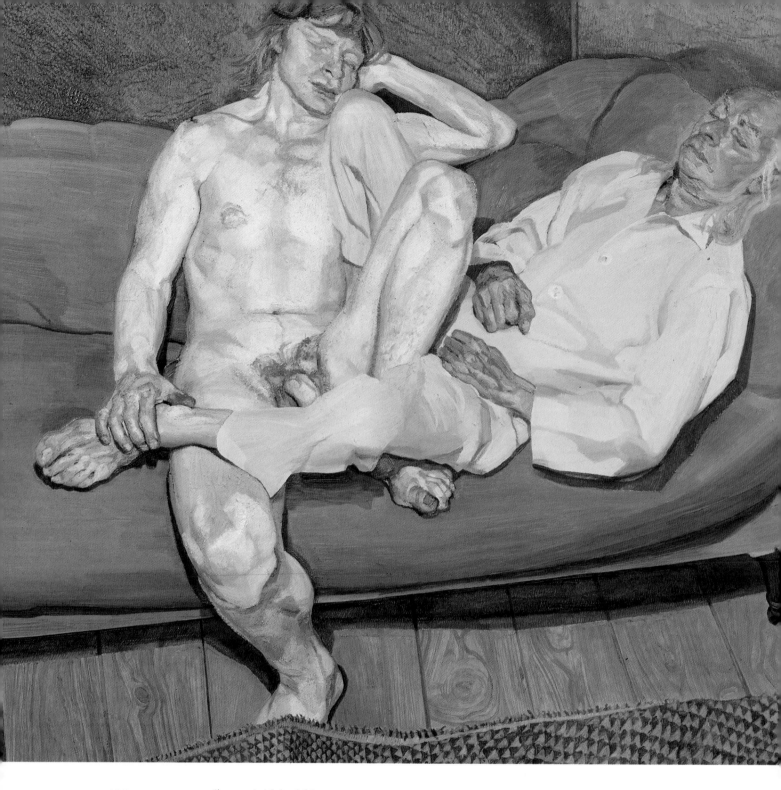

103 LUCIAN FREUD (*b. 1922*), Naked Man
with his Friend (*1978–80*). *The candid,
tender representation of a relationship between
an older and a younger man shown here has
no overtones of academic idealism.*

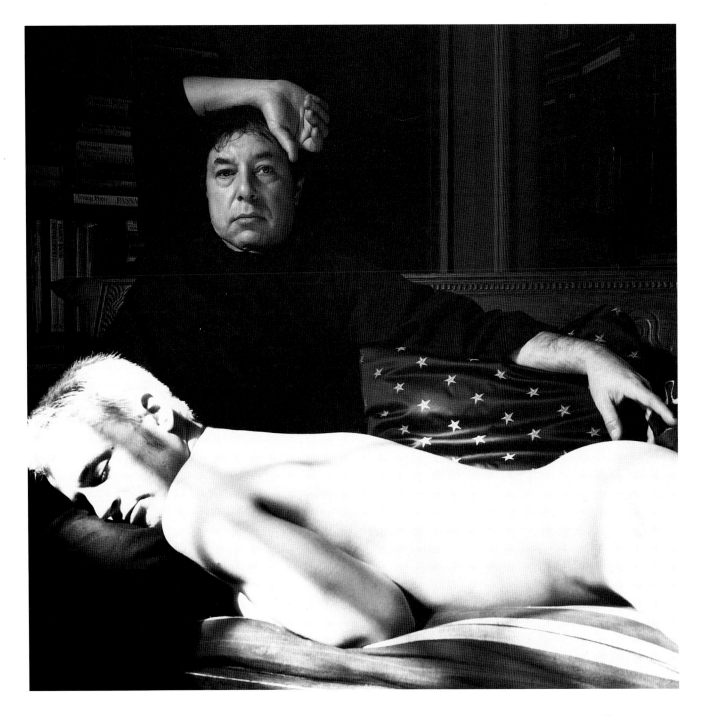

104 JONATHAN WEBB (*b. 1955*), The Apparition (*1996*). *An image, not of nudity, but of a human relationship, though the dramatic lighting of the nude figure apparently asleep in the foreground does suggest a degree of idealization.*

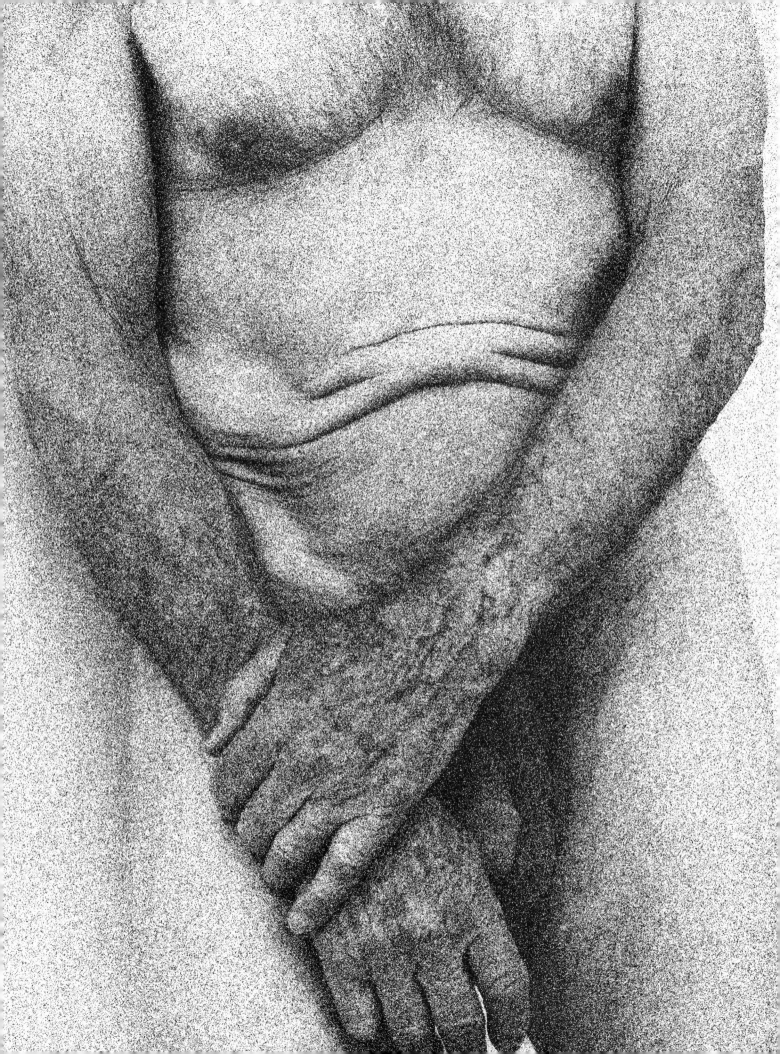

limbs, the whole nature of the process they were using tended to make such gestures counterproductive. What they were photographing remained fully physical, in the most brutal and down-to-earth sense of that adjective. Naive gestures of concealment merely drew attention to the fact that something was being hidden. When, on the other hand, photographers made full-frontal photographs of males, the genitals, even when not erect, attracted a disproportionate amount of the spectator's attention – both their size and the unsparing particularity of the camera's way of representation seemed to make this feature the chief subject of the picture.

In addition to this, the fact of a male photographing another male generated a peculiar frisson. Very early in its career the photograph was seen primarily in a sexual context, and photographs of naked males immediately prompted the idea that homosexual feeling was in some way involved. Even Muybridge's sequence of photographs of naked males in action seem, to carry a sexual charge which is absent from his very similar photographs of naked women – even though sexual content was in this instance demonstrably not part of the photographer's intention. The sexual aura of Muybridge's pictures of wrestlers was the reason they fascinated the painter Francis Bacon (1909–92).

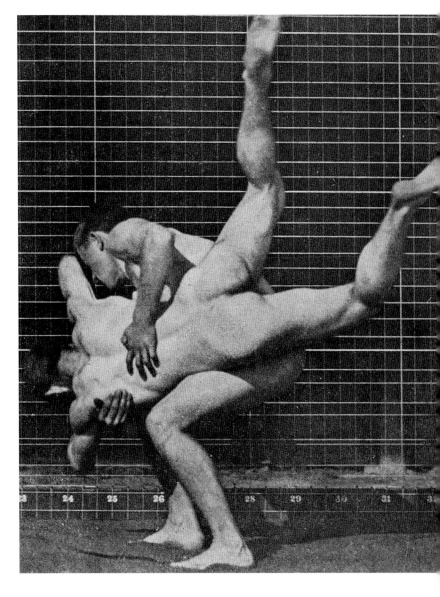

One consequence of the triumph of photography was that it became more and more difficult to depict unclothed males in a purely detached way. If, for example, one looks at the long sequence of academic nude studies produced by students at the Ecole des Beaux-Arts in Paris, who followed a course of study founded on the intense scrutiny of the human body, what one notices is that these drawings and paintings, mostly images of males rather than females (though the use of female models was now permitted), gradually become more and more clearly individualized. By the 1880s, the more gifted students at the Ecole were producing sharply characterized naked portraits of the models – soldiers, labourers and vagrants, intermingled with some Italian professionals whose business in life was modelling – who were recruited to pose for them. This development remained to some extent veiled because few of these students had any wish to

105 DONALD WOODMAN (b. 1945), *Jack at 83* (1997). *Woodman photographed a model who came to pose for his wife, Judy Chicago. He says, 'It gave me a chance to look at the aging of the male body and to reflect the effect of age on male virility' (left).*

106 EADWEARD MUYBRIDGE (1830–1904), *Men Wrestling. A single image from one of the most famous sequences in* Animal Locomotion (1887). *As with all Muybridge's pictures of this sort, it tends to reveal a gap between what really exists and what artists previously imagined to be true (above).*

continue turning out images of naked males once they had graduated. They launched themselves into painting what was accepted and profitable – portraits and genre scenes, in which the figures were of course clothed; and the kind of sanitized, discreetly erotic female nudes which found favour at the official Salon. Meanwhile the popular image of the artist – as propagated by books like Henri Murger's *Scènes de la Vie de Bohème* (published in parts, 1847–9) – was that of a carefree young man of healthy sexual appetites, who cheerfully slept with his female model or models, but never spared a thought for the male ones – if indeed there were any.

The special nature of photography – the supposed objectivity with which the lens of the camera viewed and recorded the visible world – made it especially suitable for a task which came to the fore both with the development of scientific method and the impulse towards physical exploration which were important aspects of the mid-and later nineteenth century. This was the depiction of the 'other'. The 'other', in this sense, may be defined as the person who is not, and never can be, oneself. The tribesman of the forests of New Guinea or of the Amazonian or African jungle falls into the category of 'other'; various freaks and deformities of nature fall into the same category. It has been argued by twentieth-century sociologists that awareness of the presence of this 'other' has a crucial effect on the way human beings define both what is internal and what is external. The stress, in this case, is on forming relationships with other entities, and being modified through contact with them.

There is, however, another situation, which is almost the mirror-image of this one, in which human beings define their relationship with a particular group, or, even more precisely, a particular norm, by examining what seems to fall totally outside the parameters of that norm. Essentially, this is what the ancient Greeks were doing when they compared themselves to people whom they considered to be barbarians. As we have already seen, one of the crucial comparisons they made was in terms of attitudes to male nudity. However, one does not have to look far in Greek art to find representations of human 'otherness' in the sense in which I am now using that term. In particular, images of pygmies and blacks appear in the art of fifth-century Greece, most frequently painted on vases. Interestingly enough, the Greeks seem to have inherited some of these attitudes from the ancient Egyptians, as can be seen from the representations on the walls of Queen Hatshepsut's mortuary temple at Deir el-Bahri of a maritime expedition to Punt – the African coast at the southern end of the Red Sea. Among the personages represented is the steatopygous queen of the pygmies who then inhabited the region. Blacks from the Sudan ranked among the four traditional 'enemies of Egypt', and were sometimes depicted bound and helpless on items of royal furniture.

107 MARTHA MAYER ERLEBACHER (b. 1937), Man with an Earring (1992). *A gifted artist in the classical tradition, Erlebacher seems to define her idea of 'otherness' by giving her sitter a restless, uneasy air.*

108 PABLO PICASSO (1881–1973),
The Three Ages of Man (1942).
*In this late work, Picasso continues
to explore his lifelong fascination
with classical forms, simplifying
and deliberately distorting them, but
still retaining their essence.*

109 ASHLEY, Crouching Figure (1997).
*The submissive pose of the figure here,
with his arms wrapped defensively
around his legs, suggests not power but*

110 MARIO CRAVO NETO (b. 1947), Voodoo
Figure (1988). *A male nude portrayed by a
Brazilian photographer in a totally different
crouching pose to the one seen opposite
suggests savagery about to be unleashed.
These contrasting images have much to say*

Study for "Wishing it were true"

111 JUDY CHICAGO (*b. 1939*),
 Study for 'Wishing it were
 true' (*1983*). *A preparatory
 drawing for the artist's sequence*
 Powerplay *in which she
 meditates on male vulnerability
 and also on male denial of
 vulnerability.*

112 GEORGE DUREAU (*b. 1930*), Stanley Hurd (*1981*).
Dureau has always been fascinated by dwarfs, or, as
they prefer to call themselves, 'little people'. Many of them
used to come to New Orleans as entertainers, especially as
wrestlers. Though small, they were also extremely athletic.
Dureau presents his subject as a miniature Hercules.

126

When Greek art fused with late Egyptian art under the Ptolemies, one result was a plentiful production of small grotesque figures, often deformed and with grossly enlarged phalluses. These, perhaps simply because of their contrast with the more fortunate, seem to have been regarded as talismans to ensure good luck. Another speciality of the Hellenistic art of Alexandria was bronze statuettes of young blacks, in this case often very sympathetically depicted. It is always made clear, nevertheless, that these youths are either servants or beggars – in the former case, they were also in all probability slaves. It is perhaps unnecessary to stress the gap between the free man and the slave in the ancient world. One could hardly hope to find a better example, within its context, of the 'otherness' I have been talking about.

In the Middle Ages, the European sense of 'otherness' was chiefly directed at the Islamic world. It was intensified in the sixteenth century by the Spanish conquest of the Aztec and the Inca empires; and then, later still, by European encounters in North America with nomadic Native American tribesmen; Captain Cook's explorations in the South Seas; and events like Lord Macartney's embassy to China (1792). It then found a different and fuller flowering in the pitiless nineteenth-century scientific attitudes – typified by Muybridge's studies of a crippled child and by Nadar's photographs of hermaphrodites. Yet it is photography, rather than other art forms, which continues to explore this area. It is interesting to note that photographers in search of the alienated, separated 'other' tend to choose male not female subjects. This is not necessarily true of Diane Arbus (1923–71), but it is of her successors, Robert Mapplethorpe (1946–89) and George Dureau (b. 1930). Perhaps the reason is that male subjects allow them to combine images of power with equal, opposite images of impotence, in the same photograph.

Mapplethorpe made his reputation with a series of startling pictures of the male sado-masochistic community in America, and confirmed it with icily impersonal studies of blacks – the latent racism of the latter has seldom been analyzed. Dureau also photographs blacks, often nude and frequently crippled or mutilated. He also turned his lens on white amputees and dwarfs, or 'little people'. These images are close to the edge of the current frontiers of acceptability, but they are extraordinary in that they stress the gulf between the spectator and the particular subject portrayed, and also build a bridge of sympathy between them. Dureau does not idealize the human body, but it could be said that through the medium of crippled and stunted male bodies he idealizes the human condition.

113 GEORGE DUREAU (b. 1930), Craig Blanchette (1992). *Dureau also has a fascination with amputees. Here a legless man poses on a column, like a fragment of classical statuary. The image jolts our perceptions because we suddenly realize that the truncated figure is in fact alive.*

JAVIER MARIN (b. 1962), Torso de Hombre Amarillo (1993). Mexican sculptor Javier Marin's expressive figures look back to the tradition of baroque art in Latin America. They also refer to the Hellenistic baroque of 300–200 BC (left).

115 JORGE TACLA (b. 1958), Claustrofobia (1986). The Chilean Tacla is an Expressionist, who uses nude human images as a vehicle for violent emotion. His purpose is the same as Javier Marin's, but the actual result is very different (above).

The Triumph of the Female

STEPHANIE RUSHTON,
Black Man and White Woman
Embracing (1994). Here it is the
woman who is the active party.

117 HENRY FUSELI (1741–1825),
Adam and Eve (aquatint). Here
Fuseli abandons the exaggerated
masculinity of the majority of his
other images, and makes Adam seem
almost as feminine as the Eve whom
he embraces (right).

WHILE BOTTICELLI'S FEMALE NUDE *in the* **Birth of** **Venus** (*c.* 1485) *presents herself as a daring deviation from the expected norm, the early sixteenth century witnessed an upsurge of interest in the depiction of naked females of a kind not experienced in art since the overwhelming success of Praxiteles'* **Aphrodite of Cnidus** *in the fourth century BC. The typology of these sixteenth-century nudes, the majority of them paintings rather than sculptures, is, however, not uniform.*

On the one hand were the fleshy nudes favoured by the leading Venetian artists, invented by Giorgione (*c.* 1477–1510), and developed by Titian (1488/90–1576) and Palma Vecchio (1480–1528). These correspond to the rather thick-waisted proportions established in the Hellenistic period by statues like the *Venus de Milo* (*second century BC*) and inherited by Roman artists.

On the other hand there was the physical type favoured both by northern artists such as Lucas Cranach the Elder (1472–1553) and by Italian artists working north of the Alps as members of the School of Fontainebleau. This type is elongated, with small breasts and a high waist, but also a rounded stomach and broad hips. It corresponds to a late medieval canon of female beauty, not to anything that can be considered classical. The voluminous garments of the late medieval period are stripped away to reveal the form beneath, which was itself – and this is a paradox – very

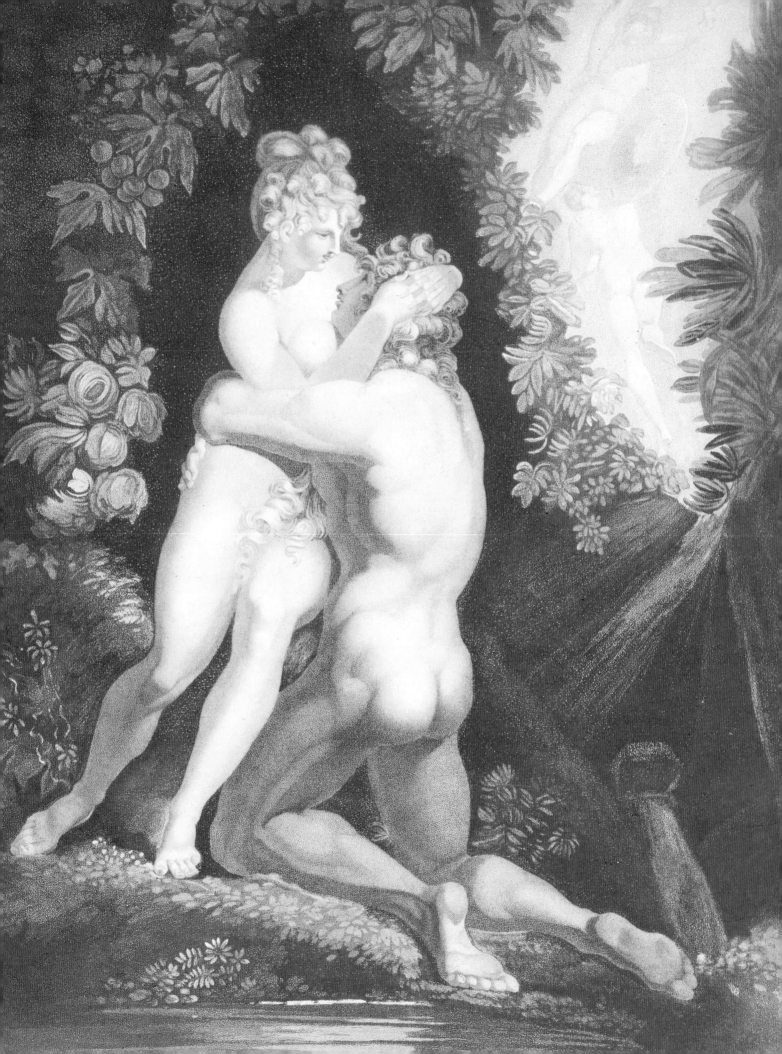

118 ROBERTO RINCÓN (*b. 1967*), Steve Reclining (*1992*). *In this photograph Rincón has posed his model in an odalisque-like pose which recalls some of the photographs of prostitutes made by E. J. Bellocq in New Orleans brothels in the early 1900s.*

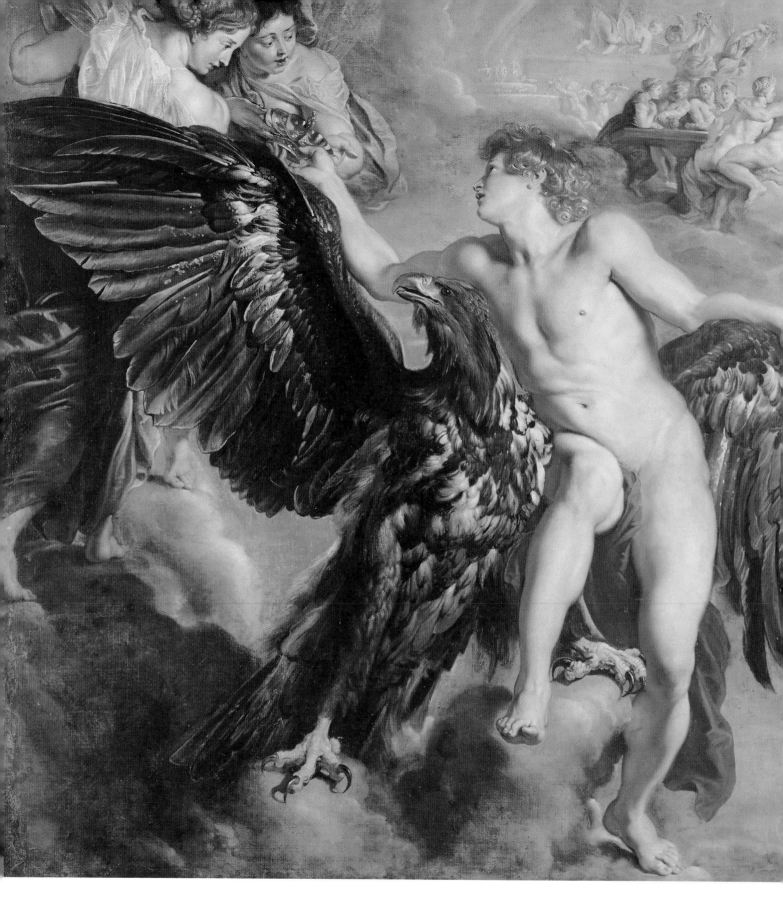

119 SIR PETER PAUL RUBENS (1577–1640),
The Rape of Ganymede. *Rubens' preference*
for the female body expresses itself here through
his feminization of the youth carried off to
Olympus by Zeus in the guise of an eagle.

134

much a product of the then prevailing fashions in dress. For example, women who were not pregnant sometimes actually padded their stomachs to look as if they were.

These early and mid-sixteenth century nudes do not appear in art without a social context. They were often produced in circumstances where they could be read as a tacit gesture of rebellion against the Church. Venice was notoriously secular and hedonistic in atmosphere compared to other parts of Italy, and was correspondingly resistant to papal attempts at control. The French monarchy, though Catholic, also pursued a policy of resistance to papal interference. Cranach worked for Protestant patrons, the Elector Frederick the Wise of Saxony and his successors, and based himself in Wittenberg, the university town which was also Martin Luther's headquarters. He painted portraits of Luther and his wife, and also of other leaders of the Reformation.

But Protestantism, or even simple anti-papalism, was not a *sine qua non*. The female nudes which all of these artists produced carried a freight of social meanings which were much more important than any purely religious ones. One of the most appreciative collectors of Titian's nudes was the fiercely Catholic and pious Philip II of Spain. Like Philip, the patrons who acquired such works were either ruling sovereigns or members of their immediate entourage, and possession of such images was a statement about the way in which these patrons differed from the common herd, and could allow themselves to cross boundaries which still constrained those who were in a lower social position. These nudes do indeed indicate a movement towards secularism, but it was a movement that began at the very top.

There is a third type of female nude from this period that also deserves consideration. It is one chiefly associated with Michelangelo, who devised a type of female nude which, it has often been remarked, resembles a muscular youth with breasts rather unconvincingly attached to the upper part of his torso. An example is the figure of *Night*, which forms part of the Medici tombs in San Lorenzo (*built 1419*) in Florence. On occasions, this sort of nude becomes intermingled with the Fontainebleau version and recovers its eroticism, as can be seen in Bronzino's allegory, *Venus, Cupid, Folly and Time* (c. 1546). Michelangelo's female nudes can perhaps be seen as a very personal restatement of the theme of the androgyne – a being in whom masculine and feminine characteristics are fused.

The art of the Baroque period witnesses a struggle for primacy between strongly characterized males and equally strongly characterized females. In paintings by Peter Paul Rubens (1577–1640), for example, males acquired muscles piled upon muscles – they are approximations of a physical type that does not seem to have existed in reality until the appearance of the mid-twentieth century steroid-fed bodybuilder. Rubens' females, on the other hand, exaggerate the imagery already discovered by Titian. The emphasis is on voluptuousness and maternal fecundity. Modern taste,

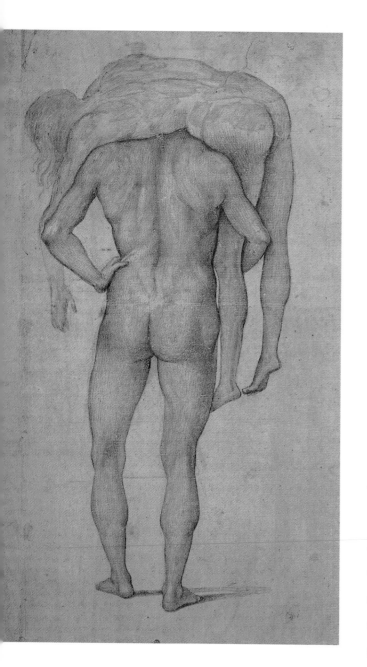

with its emphasis on slenderness as a desirable quality in women, finds these Baroque nudes grossly overweight.

The French Rococo style, which developed out of the pan-European Baroque of the seventeeth century has significant features of its own. These are once more closely linked to the social background. Taste in the visual arts is now for the first time strongly influenced by women. It was Louis XV's mistresses, in particular the highly intelligent Mme de Pompadour (1721–64) and the coterie of artists and taste-makers who surrounded her, who now shaped the direction being taken by the visual arts. Erotic subjects, often mythological themes such as the *Bath of Diana*, featuring a whole bevy of female nudes, were much in favour.

Yet at this time there was also at least the beginning of a feeling that eroticism must be bridled in some fashion, just as it was thought that male passions must now be placed under female control. One way of doing this was to stress the youth of all the participants in scenes in which a number of nudes appeared. In addition, as has already been noted, artists feminized male participants so that their presence among the females could be perceived as less threatening.

Nevertheless, the art of the eighteenth century has a darker side. Louis XV himself is reputed, especially in his later years, to have had a taste for deflowering very young girls. This taste was widespread amongst his contemporaries, in fact and in imagination, as the erotic fiction of the time attests. If François Boucher (1703–70) manufactured playful mythologies for the court, his younger contemporary and rival Jean-Baptiste Greuze (1725–1805) produced, in addition to the moralizing genre-scenes which enchanted his champion, the encyclopaedist Denis Diderot (1713–84), a long series of slightly prurient images of pubescent girls who had just lost, or were about to lose, their sexual innocence. Greuze might portray, for example, a young peasant girl weeping prettily over a jug she had just broken. But then Diderot himself was the author of an erotic novel, *Les Bijoux Indiscrets* (1748), in which the 'indiscreet jewels' of the title are talking vaginas.

It is significant that the French painters of Greuze's generation were starting to shift their focus to a new market, based not on original paintings but on the sale of reproductive engravings. The clientele for these was not the aristocracy, nor the rich *fermiers généralux*, but the bourgeoisie. Art was undergoing a process of democratization.

120 LUCA SIGNORELLI, Male Nude Carrying Another Nude. *The figure being carried has an extraordinary pathos which springs from its limp passivity (above).*

121 SIR EDWARD BURNE-JONES (1833–98), The Call of Perseus (c. 1876). *This is a study for Burne-Jones' Perseus series, now in Stuttgart. The towering goddess Athena is considerably more powerful and masculine in appearance than the cowering nude figure she addresses (right).*

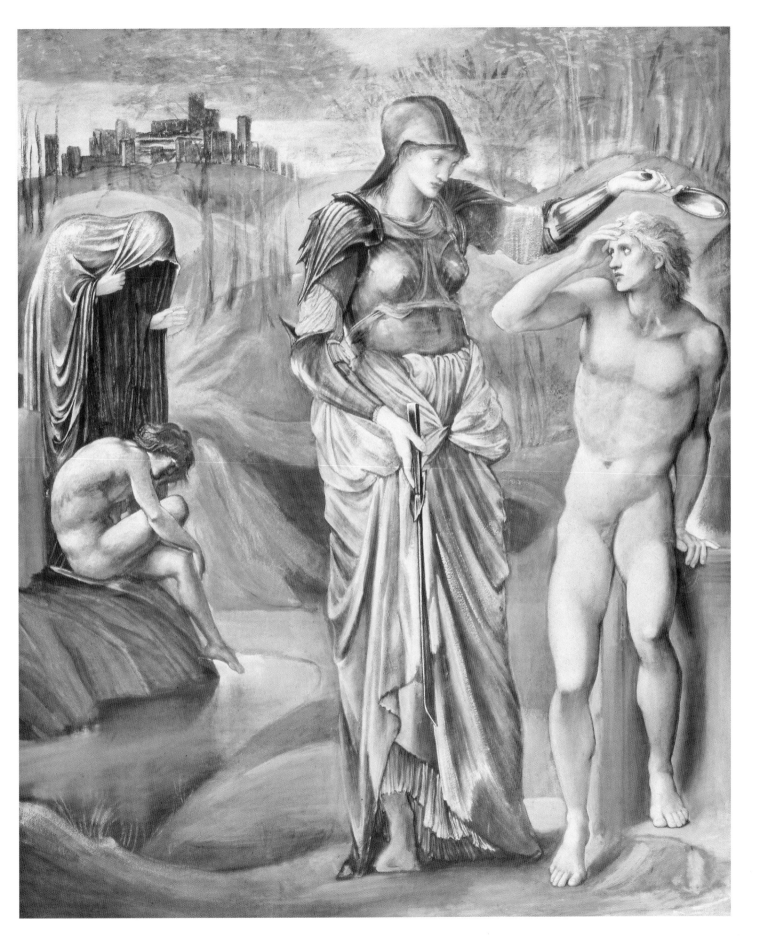

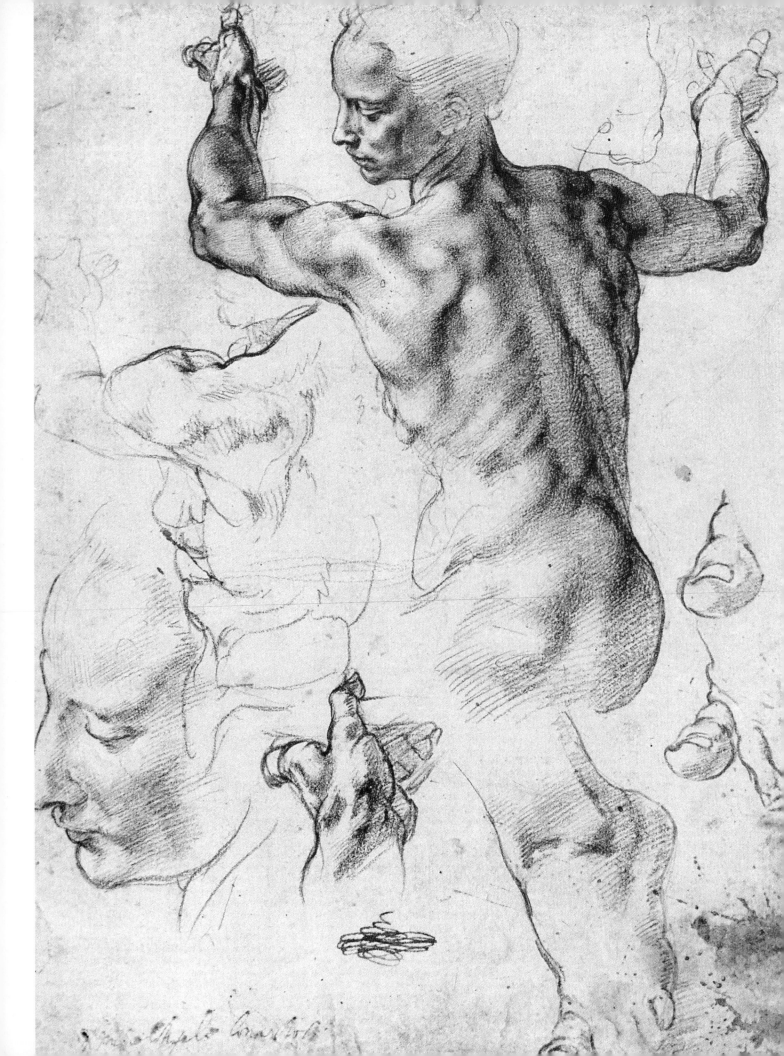

Greuze's 'innocent' models, as it happens, are seldom even partly unclothed. Faced with a new and less sophisticated public, the most the artist could allow himself was a tantalizing glimpse of a youthful breast, exposed as far as the nipple. Nevertheless, his work had an important impact on the future of the nude in art, as did the change in the nature of the audience. Painters throughout Europe increasingly followed a pattern pioneered by the Dutch artists of the seventeenth century, who no longer worked primarily on commission, but made goods for a market.

By the middle of the nineteenth century nearly all artists worked in the same fashion – major commissions became the exception for most of them, rather than the rule. As in all supposedly free markets, the economic mechanisms which now sustained art were less libertarian than they appeared to be at first sight. Artistic careers developed according to clearly understood rules. Painters looked to the annual Salons in Paris, and the equivalents of the Salon in other European capitals, both as a source of direct sales and as a means of obtaining publicity which would attract potential clients to visit their studios and see what they had in stock or in progress. They also continued to exploit an expanding and often very lucrative market for reproductive engravings. The rights to reproduce popular paintings were now often sold for large sums.

122 MICHELANGELO (1475–1564), Studies for the Libyan Sibyl. *This, one of Michelangelo's most powerful sheets of studies for the decoration of the Sistine ceiling, is a preliminary drawing for a female figure made from a male model. Michelangelo was not the only Renaissance artist whose prepared paintings show females in this way (left).*

123 JIM AMARAL (b. 1933), Aphrodite's Son, Hermaphroditus (1979). *Amaral wittily alludes to the legend of the Hermaphrodite – part man, part woman – in these profiles of mustachioed men equipped with female breasts (above).*

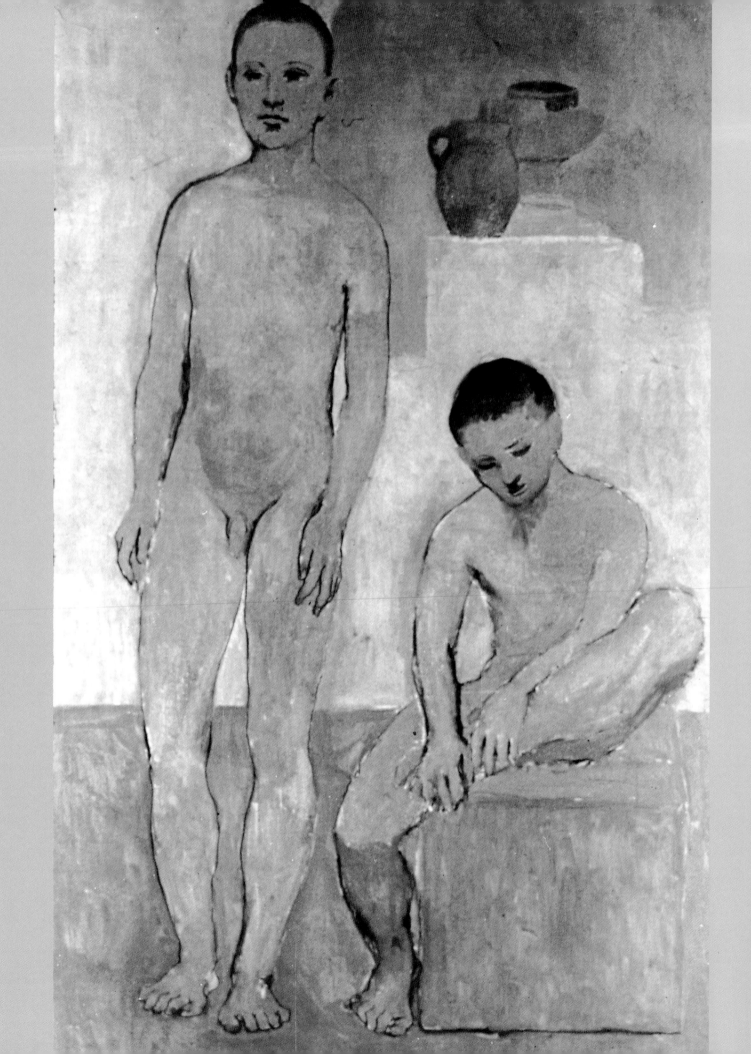

Clients were helped to make up their minds by the existence of clearly understood artistic categories. There were mythological, allegorical and historical scenes (still officially regarded as the highest form of art, but not as easy to sell as other forms of subject matter); portraits (usually, for obvious reasons, still done on commission); landscapes; still lifes; genre-scenes – and nudes.

The nude sometimes featured as part of a complex mythological or allegorical composition, but was now often painted for its own sake. The fact that the nude was the primary subject was, however, always politely disguised, and the theme was bound by a series of largely unspoken but clearly understood regulations. Naked females were to be idealized – or to put this in another way, they were not to be too flauntingly 'real' either in terms of the setting provided or in their actual appearance, which was discreetly glamorized and at the same time skilfully sanitized. Nor were they to disturb the viewer by revealing their awareness that they were both naked and observed. This was the offence committed by Manet's (1832–83) controversial *Olympia* (1863), exhibited in the Salon of 1865. Voyeurs do not like to be confronted with the fact of their own voyeurism. For the most part, female nudes were goddesses or nymphs; allegories (but with little stress on allegorical content); or else inhabitants of some ancient Roman or Oriental daydream.

These nudes were almost invariably female. The male nude almost disappeared in the mid-nineteenth century as one of the primary subjects of art – almost the sole exceptions to this being nude or near-nude male children, who were regarded in this context as being sexually neutral, nineteenth-century sentimentality about infancy having successfully allied itself with the vision of primal innocence held by Jean-Jacques Rousseau (1712–78).

In fact, as has already been hinted, the artist's decision to renounce the male nude at a certain state in his career can be regarded as a nineteenth-century rite of passage. The student was forced to portray the subject as part of his professional training; once he ceased to be a student and became a fully-fledged professional, he had the opportunity to give it up and almost invariably did so.

There were more than purely negative reasons for this. The new bourgeois public which formed the clientele for Salon painting lacked the broad cultural background which had been a mark of the older kind of aristocratic patronage. Intellectual significance meant little to them; purely sexual impact became primary. The trappings Salon painters provided enabled them to look at the female form with lascivious appreciation, but also without embarrassment. Once the idea of the nude

124 PABLO PICASSO (1881–1973), Two Youths (1905). One of the Picassos of the Rose Period which shows the lingering influence of Puvis de Chavannes and of the British Pre-Raphaelites most clearly (left).

125 WES CHRISTENSEN (b. 1949), Flaxman's Knot (1989). Once again, the pensive passivity of the pose suggests a feminine element (above).

126 DAVID HOCKNEY (*b. 1937*), Boy About
to Take a Shower (*1964*). *This early
Hockney shows the influence of Francis Bacon.
The emphasis put on the boy's buttocks stresses
his passive, feminine quality.*

JONATHAN WEBB (b. 1955), Victor (1997). There
is an obvious comparison to be made between this
photograph and the painting by Hockney opposite it.
The model's long hair, caught up in a bun, further
stresses the androgynous quality of his appearance.

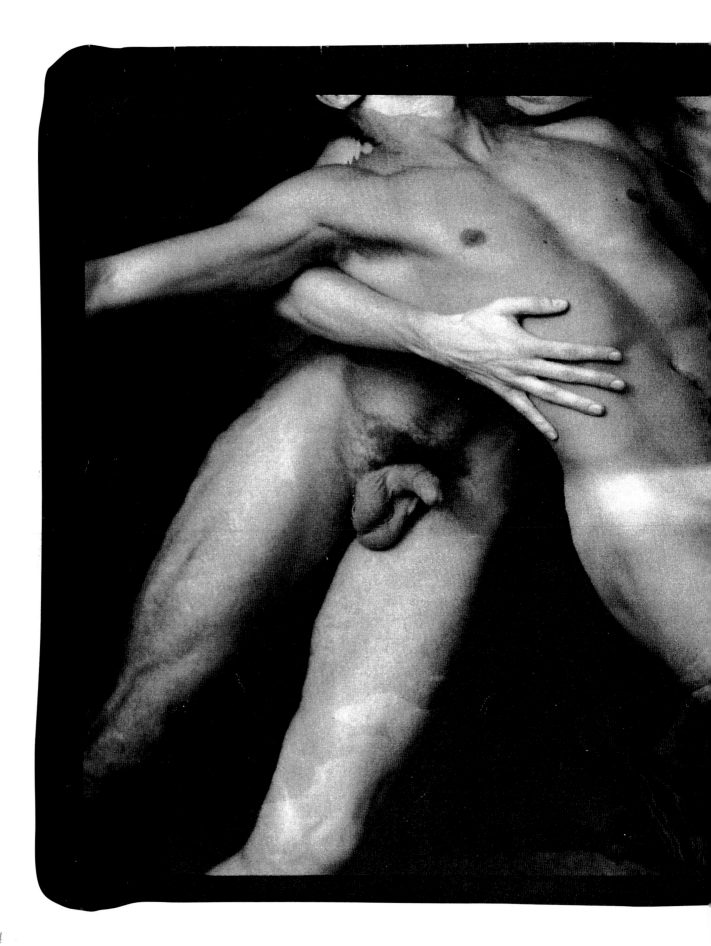

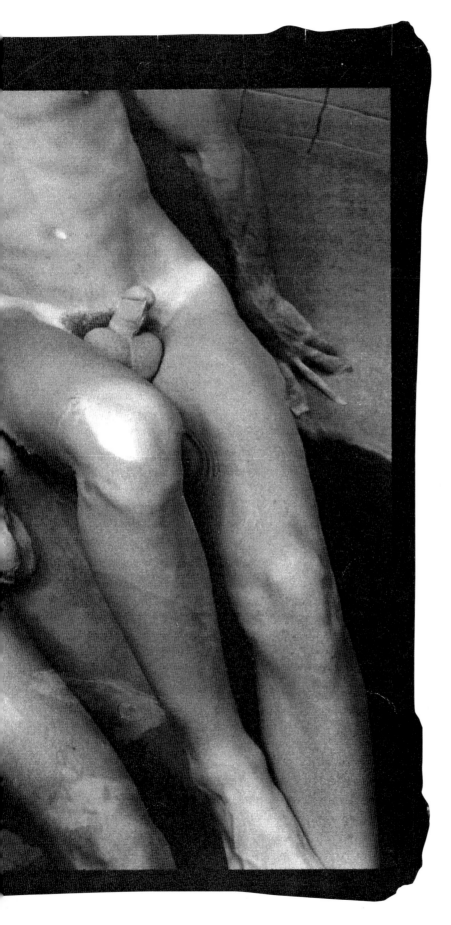

128 TOM BIANCHI (*b. 1949*), Untitled 9. *Male bodies, reclining together in a jacuzzi, take on some of the qualities of the similarly languorous female nudes in Ingres' celebrated* **Turkish Bath**.

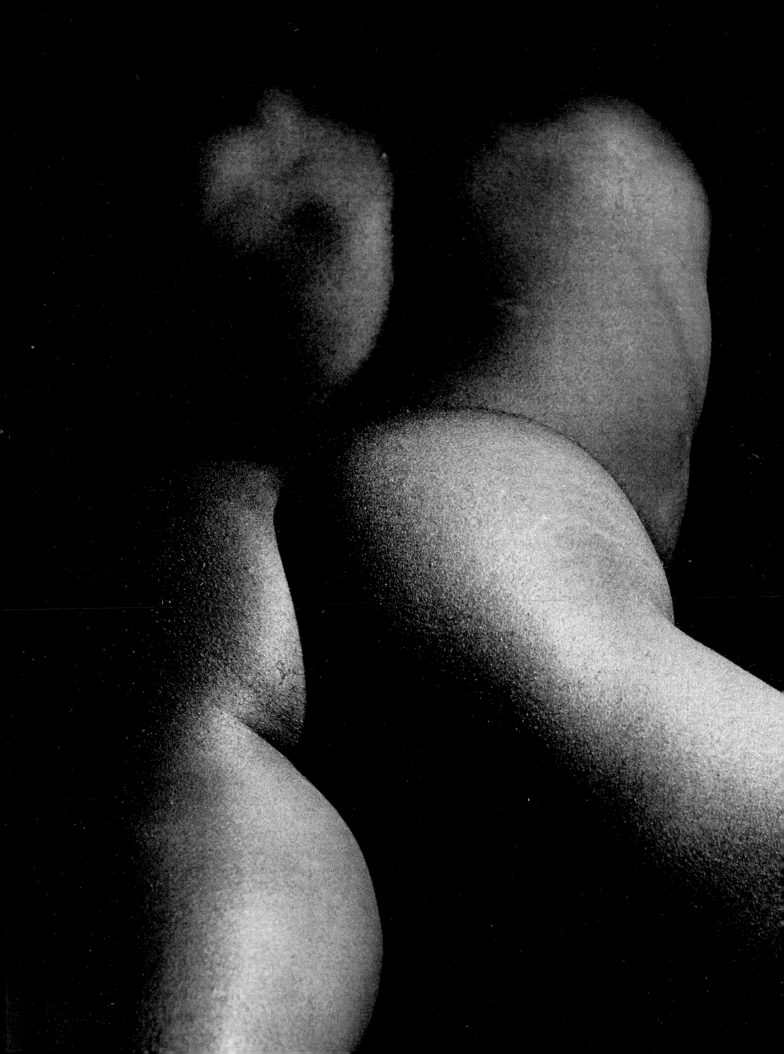

became sexualized to this extent, male nudes, especially when portrayed in isolation, and obviously for their own sake, became very difficult to deal with. The closing years of the nineteenth century saw the beginnings of a scientific interest in human sexuality, with the publication of the writings of Havelock Ellis (1859–1939), Edward Carpenter (1844–1929) and other pioneers. These brought with them a new awareness of the possibility of 'deviant' behaviour, and especially of the existence of sexual attraction between males. The study of sexuality made the portrayal of the male nude a more, rather than a less, difficult enterprise, by teasing out implications which until then had remained dormant. It is significant that the same epoch, at least in England, saw the criminalization of aspects of homosexual conduct which had previously remained outside the purview of the law. It was new, rather than old, law which led to the downfall of Oscar Wilde.

One of the few 'established' artists of this period to embark successfully upon the subject of the male nude was Frederic, Lord Leighton (1830–96) with his two sculptures, *The Sluggard* and *Man Struggling with a Python*, both made towards the end of his career. Leighton's art can perhaps be connected with the curious British Victorian cult of the Greeks, which somehow managed to blot out all awareness of the homoerotic side of Greek culture, insisting that Greek cultivation of male nudity could only spring from the purest and loftiest of impulses. However, there is also a suspicion that Leighton, who never married, had motivations not clearly known to himself when he embarked on these two ambitious sculptures.

Another leading artist of the late nineteenth century, who came to the theme of male nudity from what was in theory a very different direction, anti-classical rather than classical, was the Frenchman Auguste Rodin (1840–1917), with sculptures such as *The Age of Bronze* (1877), *St John the Baptist Preaching* (1878) and *The Thinker* (1880). Yet in Rodin's case, as in Leighton's, it is significant that the work is three-dimensional. With sculpture, but not with painting, an appeal could be made directly to ancient exemplars.

The Aesthetic Movement of the 1880s, with which Wilde was so closely associated at the beginning of his career, and the Decadent Movement which followed it in the 1890s, did, however, begin to take sidelong glances at the subject of male sexuality. One result was the evolution of a new imagery showing apparently effeminate males, not necessarily unclothed. Some of the most extreme of these can be found in the work of the short-lived but extremely influential British illustrator, Aubrey Beardsley (1872–1898).

129 TONY BUTCHER'S *photograph of a male back closely paraphrases the Greco-Roman sculpture of the* Hermaphrodite *reproduced earlier in this book, as the work appears when seen from directly above. The relaxed sinuousness of the pose gives a distinctly androgynous appearance (left).*

130 AUGUSTE RODIN (1840–1917), The Thinker (1880). *Rodin's powerful, anti-classical bronze demonstrates that inactive poses do not necessarily have to seem androgynous, or in the least feminine (below).*

147

The Male
Nude and the
Avant-Garde

131 MANDY HAVERS (b. 1953), Torso (1984). *Havers obtains disturbing effects by using a craft technique – stitched leather – to create a male figure that looks like a partly flayed anatomical model (above).*

132 GIORGIO DE CHIRICO (1888–1978), The School for Gladiators (1927). *De Chirico's* Gladiator *paintings of the 1920s represent an effort to marry avant-garde irrationality with classical tradition (right).*

SEXUALITY AND SEXUAL ALLUSIONS *very early became part of the weaponry of the twentieth-century avant-garde. In fact, the spirit of contradiction inherent in the notion of avant-gardism had begun to manifest itself long before the new century began, and often took the form of sexual gestures. Edouard Manet's (1832-83)* Olympia *and* Le Déjeuner sur l'herbe, *both painted in 1863, are a case in point. The latter painting is especially interesting in this particular context, since it contrasts female nudity with clothed male figures, seeming to imply that the males, because they are dressed, exercise a control over the situation depicted which is denied to the females.*

After the turn of the century, the sexual component returns full force in some of the key achievements of the first generation of Modernists, ranging from Matisse's (1869–1954) early female nudes to the coded brothel scene shown in Picasso's *Les Demoiselles d'Avignon* (1907). However, if one looks solely at the French contribution to the birth of Modernism, one finds few examples of the male as opposed to the female nude. There seem to have been several reasons for this imbalance. The Modernists were, in the first place, ferociously opposed to the Symbolists and to the Symbolists' allies, the Decadents. The drooping effeminates and androgynes of Aubrey Beardsley were just what they most disliked. Both the Fauves and the Italian Futurists seem to have been heterosexual misogynists, who took a loftily condescending view of women. The

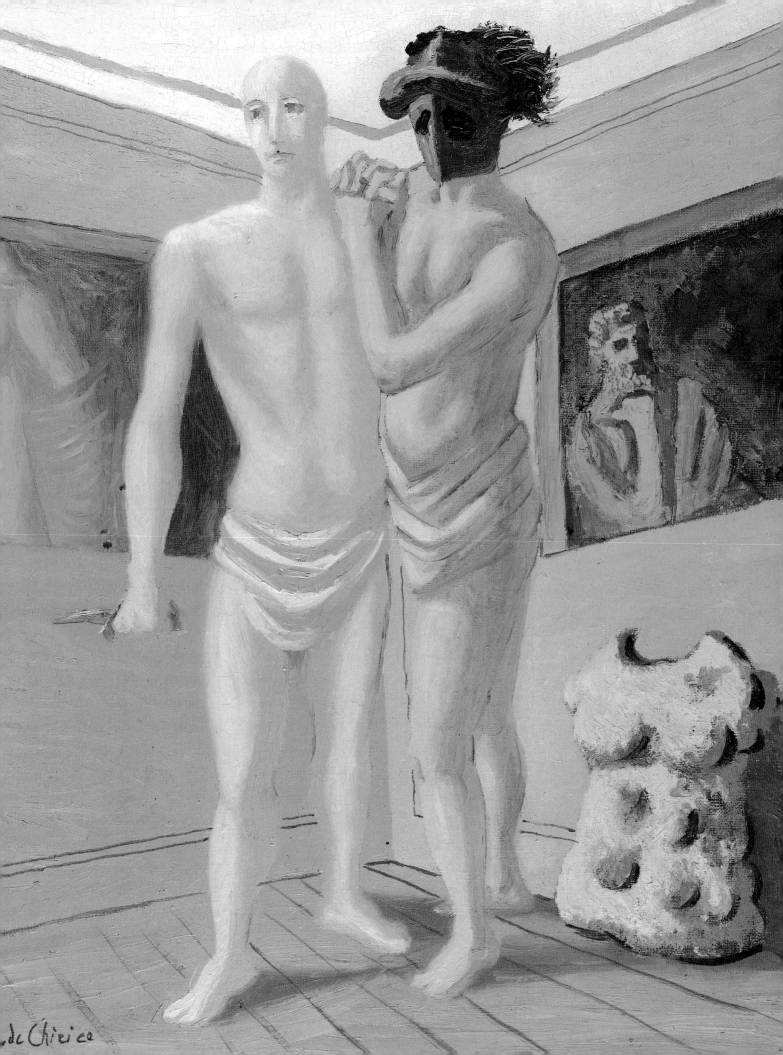

Futurists in particular were enraptured by Nietzsche's concept of an *übermensch*, or superman. But they were also curiously reluctant to portray this embodiment of intensely male qualities, perhaps thinking that the image might convey the wrong message about their own sexual proclivities.

The one School of Paris Modernist who made notable images of nude males during this period was Pablo Picasso (*1881–1973*). The touching male adolescents whom he portrayed in some of his paintings of the Blue and Rose periods were a legacy from Symbolism and also a tribute to the fascination which the idea of classicism had for him even at this very early period of his development. He was to continue his dialogue with classical imagery throughout his long career.

The only regions where attitudes to the male nude among the avant-garde were significantly different were Germany and Austria. One can advance both social and psychological reasons for this fact. Victorian attitudes to male nudity in public were curiously inconsistent. If they went sea- or river-bathing, for example, men sometimes wore elaborate bathing costumes, but also sometimes went totally nude. The choice depended on whether or not women were expected to be present. One of the best testaments to the popularity of nude bathing among men is the American painter Thomas Eakins' picture *The Swimming Hole* (*1883*) which shows his students at the Philadelphia Academy of Art disporting themselves. The informal photographs which the artist took in preparation for the composition are even more informative about this aspect of nineteenth-century male camaraderie.

In Germany, in the opening years of the new century, male behaviour which had previously been simply taken for granted began to be codified into a new philosophy – a prescription for a healthy and vital life, lived in a state of much greater closeness to nature. This owed something to Nietzsche, but perhaps a good deal more to the rapid industrialization of Germany which was then taking place. German Romanticism placed enormous stress on the importance of man's links with the natural world. The German philosopher Arthur Schopenhauer (*1788–1860*), for example, believed that the animal realm symbolizes a unity with nature which human beings have forsaken. The new German cult of nudism was an attempt to get back to a natural state of the most literal sort. The Norwegian artist Edvard Munch (*1863–1944*), one of the main precursors of German Expressionism, spent much time in Germany during the early part of his career. His *Bathers Triptych* (*1907–13*) is a tribute to the nudist beaches of the German Baltic shore.

This positive preconception about nudity – the idea that to go nude was a way of expressing a desire for closeness with nature, which in turn involved ideas about openness, honesty and lack

133 JOHN KIRBY (*b. 1949*), A Vision of God (*1986*). *Kirby takes the long tradition of the male nude in Western art and makes it the vehicle for a powerful metaphor concerning both physical and emotional claustrophobia (left).*

134 JOHN KIRBY, Virgin of Sorrows (*1991*). *The veiled, androgynous adolescent shown here has links to René Magritte's paintings of veiled heads kissing one another (above).*

135 EGON SCHIELE (1890–1918), Standing Nude, facing front (1910). *This nude self-portait by the gifted Austrian Expressionist Egon Schiele was deliberately designed to outrage conventional bourgeois feeling at the beginning of the twentieth century (right).*

of social and intellectual pretension – became linked to concepts which were more purely artistic in origin. By the time Munch began his triptych, which occupied him over a number of years at a point of crisis in his career, the German Expressionist movement already existed. The *Die Brücke* Group was founded by a circle of Dresden-based artists in 1905. Expressionism differed from the other major art movements of the time because it was less about particular stylistic ideas and more about a general attitude to art and the artist's own attitude to the world. Artists sought to express their subjective reactions to the world, rather than attempting to make an objective assessment of what they saw. In the circumstances it is not surprising that the self-portrait takes a central position in Expressionism, nor that in some of these images the artist shows himself nude. The most prolific creator of nude self-portraits among Expressionist artists was the Austrian Egon Schiele (1890–1918). Schiele was among the most gifted draughtsmen of the twentieth century, and one of his preferred subjects was himself. Through these mirror images he expressed his feelings of aggression towards the conventional bourgeois world that surrounded him, his inner anguish and, last but not least, his determination to shock. Some of these self-portraits even show the artist masturbating.

Schiele stands at the beginning of a development which has continued throughout the history of twentieth-century art. A number of modern artists have elected to portray themselves nude or nearly so, often in a most unsparing way. Examples that come to mind are Giorgio de Chirico (1888–1978), paunchy and middle-aged in a likeness inspired by the masters of the Renaissance; and the English painter Lucian Freud (b. 1922), who, in a nude self-portrait painted when he was already in his seventies, showed a scrawny figure holding a palette and clad only in a pair of unlaced boots. Undoubtedly the most prolific makers of naked self-portraits in recent decades have been the English duo, Gilbert & George (b. 1943/ b. 1942). Working in collaboration since the start of their careers, Gilbert & George view themselves as a single artistic entity. From performance work and 'postcard sculptures' they have evolved into makers of huge and ambitious photopieces – which they still classify as being essentially 'sculpture'. In effect, they perceive the sculptural element to be their own joint existence – they are self-labelled as 'living sculptures'. In these circumstances it is not surprising that the photopieces should very frequently feature the artists' own likenesses, nor is it surprising that in some of these images they are nude.

Images of this type are the artists' way of defining their own relationship to the surrounding universe, and the spectator's reciprocal relationship to themselves. In this case nudity seems to be meant chiefly as a symbol of transparency – all the meanings in the work are, for Gilbert & George, obvious meanings, statements of self-evident truths – about their situation in the world and the thoughts generated by that situation. Expressionist anguish has been banished in favour

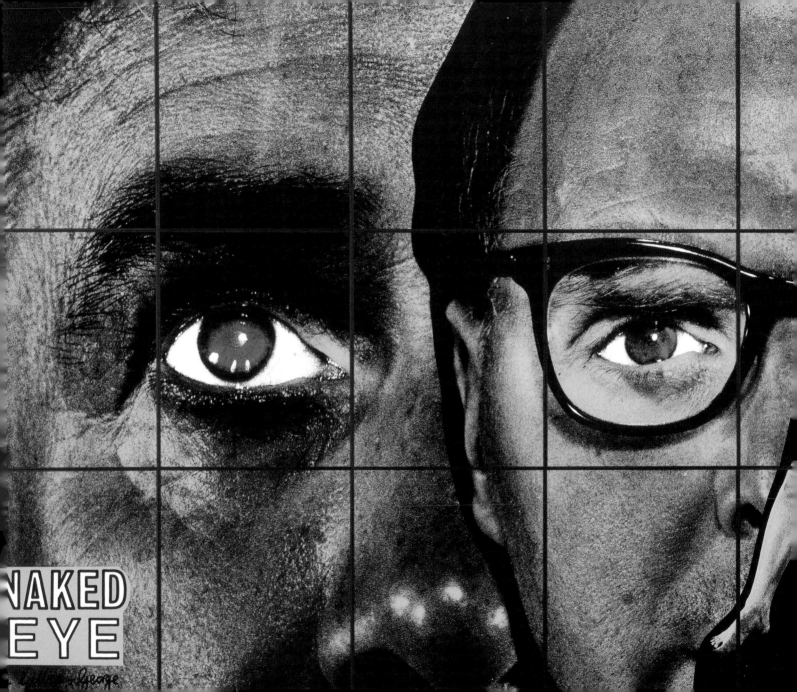

NAKED
EYE

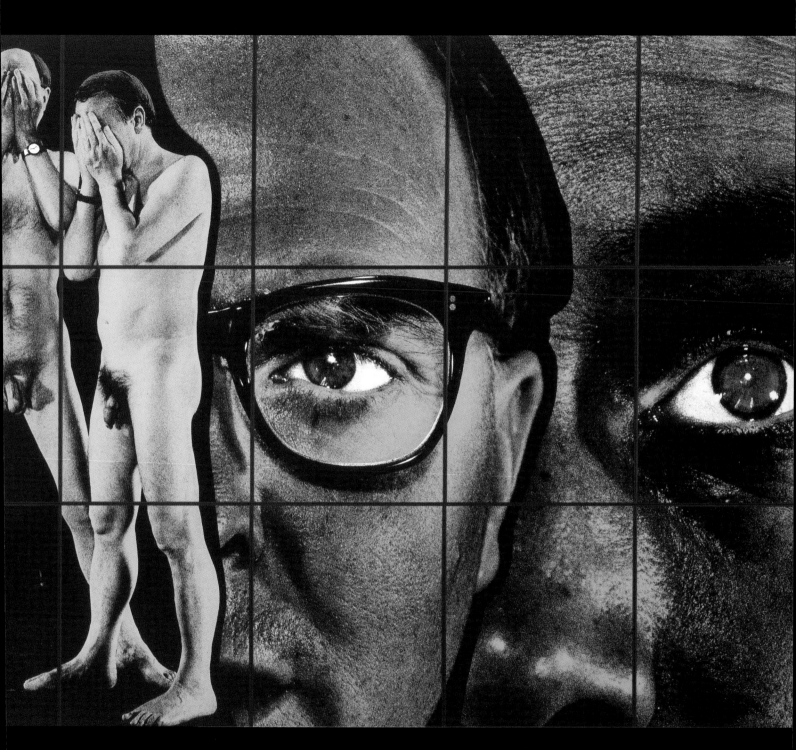

136 GILBERT AND GEORGE, **Naked Eye**
*(1994). In this huge photopiece the
artists make use of their own nude
likenesses. The work raises the question
of reality, and humanity's frequent
determination not to confront it.*

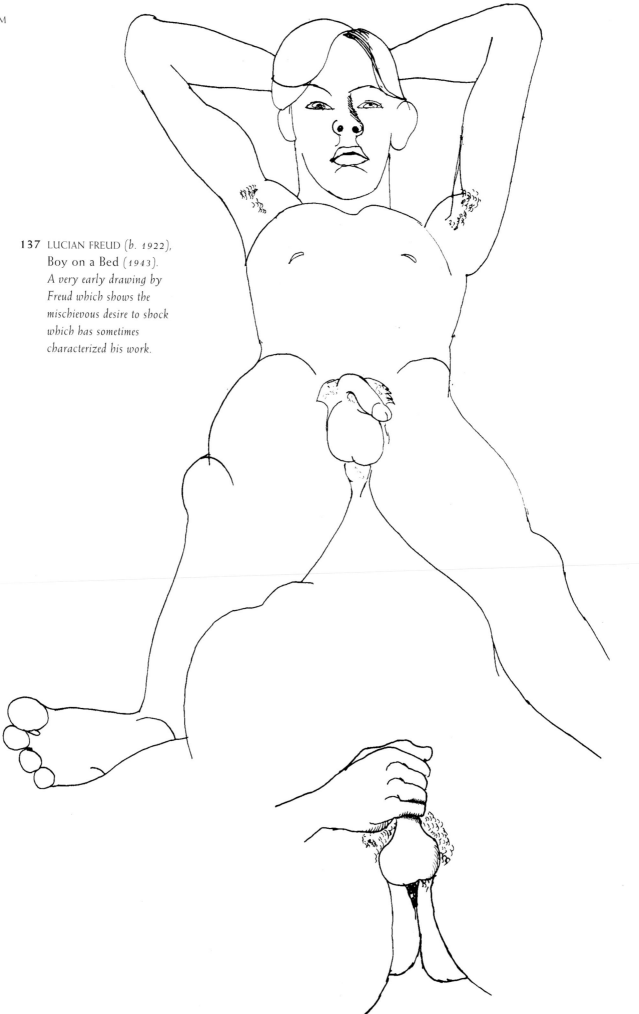

137 LUCIAN FREUD (*b. 1922*),
Boy on a Bed (*1943*).
*A very early drawing by
Freud which shows the
mischievous desire to shock
which has sometimes
characterized his work.*

of imperturbable self-confidence in their own message. When they shock, as they sometimes do, they do so not merely through the extreme nature of some of their images – a recent series of works, the *Naked Shit Pictures*, dealt with human faeces as a subject for art – but also through their assumption that the content of their work is so completely axiomatic that no-one could possibly object to it. In this sense they are the opposite of Schiele, who clearly revelled in the idea that his drawings might cause offence.

Gilbert & George stand poised between two rather different worlds. On the one hand they can be seen as slightly eccentric (though perhaps also more than usually justifiable) examples of the exhibitionism which has now become part and parcel of the fabric of late twentieth-century avant-gardism, and especially of performance work and video-art. This exhibitionism is not, of course, confined to only one of the two basic genders. It has become a convention for ambitious young artists of either sex to strip off. One recent example is the nude video made by Matthew Barney, one of the white hopes of the New York art scene of the 1990s. Basically the statement these artists are making is very close to that made by the German Expressionists at the beginning of the century – that contemporary art is about emotional honesty and that this is most directly and easily symbolized by physical nudity. There

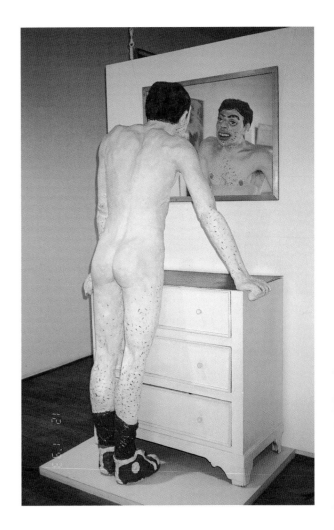

138 PABLO SUAREZ, Narciso de Matederos (1984/5). *The contemporary Argentine artist uses superrealist techniques (like the presence of a real mirror) to make a comment on male vanity.*

is also, clearly, a desire to shock, and here the law of diminishing returns has begun to operate. Public nudity is on its way to becoming a cliché in our society, with male nudity now almost as common as naked or near-naked females, who have long had a part in mass-market entertainment. Nude males are now seen frequently on the stage – even modern boulevard comedies now offer such moments of revelation. They have also made their way into the opera house – there was a moment of full-frontal male nudity in Harrison Birtwhistle's opera *Gawain*, premiered recently at Covent Garden for example.

Films have always made much of the physical appearance of the actors. Displays of masculine semi-nudity are therefore nothing new in this medium – proofs of this are the long succession of Tarzan movies and the lavish display of brawn in the 'peplum' epics of the 1950s and 1960s. What are relatively new are occasional moments of full-frontal male nudity in mainstream film entertainment, for example Richard Gere in *American Gigolo* (1980). Shots of this type are still invariably fleeting, but the availability of video-capture on the computer has given these moments an independent existence of their own, and they now form the mainstay of Internet sites such as the newsgroup 'alt.binaries.celebrities.nude.male'.

The Internet and the technological developments associated with it must certainly be considered as part of the context for any discussion of the current role of male nudity in the avant-garde visual arts. Internet binary newsgroups began the democratization of the exhibitionist impulse, and the process has been completed by the growing availability of image-scanners and, even more so, by that of affordable digital cameras.

The digital camera supplies a computer-ready image which does not have to pass through any other set of hands than those of the maker. Internet binary newsgroups offer a way of making images thus generated universally, but also, if the poster prefers, anonymously available. It has been remarked that late twentieth-century innovations in image-making – for instance, the Polaroid camera and the video camera – often seem to owe a good deal of their initial popularity to the success with which they enable consumers to satisfy their erotic impulses. By cutting out intermediary processes, these inventions empower the desire to record and celebrate moments of sexual activity, independent of both social and legal constraints.

The Internet, in combination with the digital camera as an image source, carries this situation to a logical extreme. Any sexual act can be made available to a global public. The result has been a revelation of the fact that the exhibitionist impulse among males is much more widespread than sexologists had previously thought.

Even the most casual examination of contemporary material of this sort, found in newsgroups such as 'alt.binaries.erotica.male' and 'alt.binaries.erotica.female', demonstrates that sexual exhibition is a much more typically male activity than a female one. Where females appear, they usually seem to be performing under male direction, and in conformity with male wishes and fantasies. Exhibitionist images of men, on the contrary, are usually straightforward examples of sexual display. Placed within the context offered by the Internet, avant-garde art works featuring male nudity necessarily lose much of their impact.

Another aspect of male nudity in contemporary art, and also in Internet newsgroups, is its connection with homoerotic impulses. This is not as direct as one might think at first. The male artists who strip for the delectation and edification of the avant-garde public are not necessarily making a declaration of their own homosexuality. Many – for example, Jeff Koons (b. 1955) in a series of photographs and other art works featuring himself and his former wife, La Cicciolina – do so in contexts that make it pointedly clear that their sexual preferences are heterosexual.

Where the Internet is concerned, the situation is less straightforward. Though some male exhibitionist images are labelled 'women only' by the men who post them, it seems obvious that the main impulse both for posting and retrieving these digital pictures is homosexual. Yet there

139 JAVIER MARIN (b. 1962), Hombrecito de Pie Amarillo (1997). Marin here appears to pay tribute to the folk-art which has so often been an influence on Latin American modernism (above).

140 JEAN RUSTIN (b. 1928), Homme Debout (1973). Rustin's strange figures seem to exist in a melancholic limbo. Here the unsettling effect is increased by the featurelessness of the man's face and the twisting pose which implies that he may only have one arm (right).

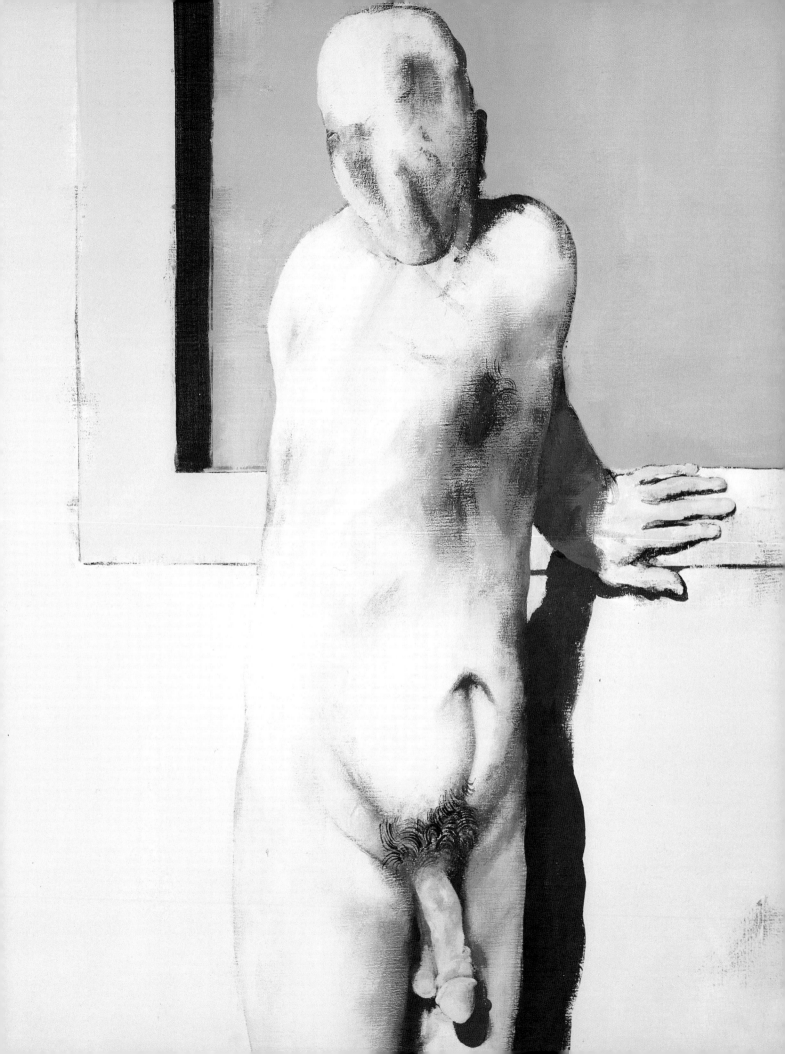

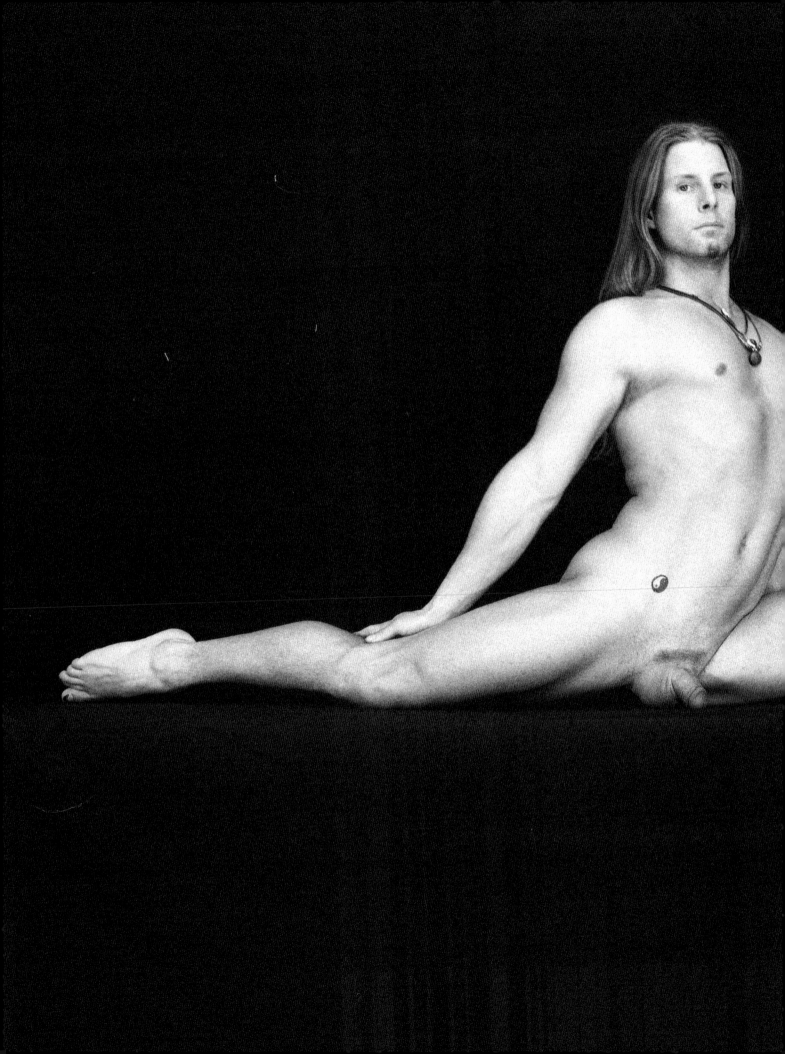

141 ROBERTO RINCÓN (*b. 1967*),
Because I Can (*1996*). *In this
striking image Rincón draws on
the tradition of modern dance,
which, from Nijinsky's* Rite of
Spring (*1913*) *onwards has been
closely linked to that of modern art.*

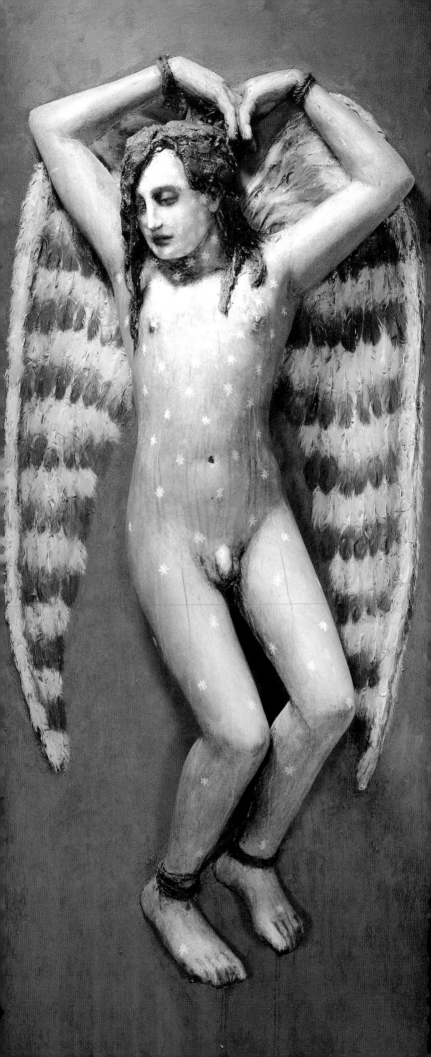

also seem to be elements of sexual boasting or teasing – men who identify themselves as heterosexuals getting a kick out of showing off to an audience which they know consists largely of members of their own gender. Added to this may be an element of contempt: the straight man who wants to demonstrate his *superiori* potency to the gay men looking on.

It is therefore necessary to be cautious about linking these developments in technology and popular culture to the increasing prominence of homosexual imagery in contemporary art. This essentially dates from the 1960s, though traces of the coming change in climate can already be found in the work of American Magic Realists of the 1930s and 1940s, notably in that of the homosexual Paul Cadmus (*b. 1904*) and the bisexual Jared French (*1905–88*).

The 1960s saw not only an overall loosening of attitudes towards sexuality in general, but a greater tolerance of homosexuality in particular. In art itself, there was a reaction against the swaggering machismo of Abstract Expressionism, a mainly American art movement of the late 1940s and early 1950s. Since Jackson Pollock's premature death in 1956, at the age of 44, his biographers have hinted, and sometimes more than hinted, that the alcoholism that plagued him

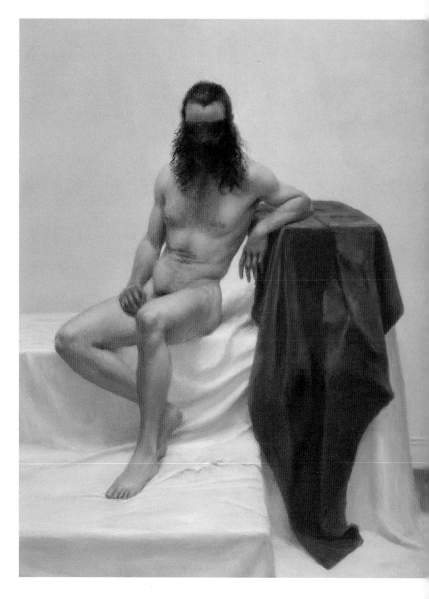

throughout his life was linked to a struggle with his own homosexual impulses. Certainly both the pattern of relationships in his family, plus other anecdotal evidence, support this. Similar, though much less decisive evidence exists in the case of another Abstract Expressionist, Franz Kline (*1910–62*). Kline, who was a good-looking man, seems to have enjoyed teasing homosexual friends with hints of his own possible availability. The general culture of Abstract Expressionism was, nevertheless, aggressively heterosexual.

Part of the opposition to Robert Rauschenberg (*b. 1925*) and Jasper Johns (*b. 1930*) in the 1950s sprang from the aesthetic challenge they issued to a now-established artistic hierarchy, which did not want to make room for newcomers. Part of it was provoked by their known homosexual orientation. Neither of these artists, however, made much use of male imagery. This was left to members of the fully developed Pop Movement, notably to David Hockney (*b. 1937*) in England and Andy Warhol (*1930–87*) in America.

142 ROBERTO MARQUEZ (*b. 1959*), Angel Vampiro (*1995*). *Like his compatriot Javier Marin, Marquez refers to the deeply rooted folk-art tradition (left).*

143 HARRY HOLLAND (*b. 1941*), Knight (*1997*). *Seeking to do a completely classical study of the male nude, Holland says that he could only persuade the model to pose if he concealed his face in some way (above).*

144 ARTHUR TRESS (*b. 1940*), Untitled.
Tress compares a version of the Pompeiian
Dancing Faun with a leaping bearded
figure in the background. The composition
closes the circle of ancient and modern
classicism (above).

145 GEORGE DUREAU (*b. 1930*), Allegorical Portrait
with Satyric Figure (*1988*). *Dureau most frequently*
paints what he will photograph the next day, many of
his paintings as here, have classical themes (right).

146 REX CHAN (b. 1958), Untitled
(1986). The delicate pencil drawings
made by this contemporary Chinese
artist attempt to incorporate elements
of Western classicism into a very
different Chinese tradition of
representing the human body (above).

147 ANDY WARHOL (1930–87),
Golden Nude (1957).
Drawn before the evolution of
Warhol's Pop style, when he was
still only a highly successful
fashion illustrator. The 'precious'
surface – gold leaf – is typical of
this phase of his work (right).

Warhol emerged into the New York art world from a visual subculture of advertising designers and commercial illustrators, many members of which were, even then, at the end of the 1950s, openly gay. Some of Warhol's early drawings, made before he discovered his identity as a Pop artist, feature naked boys seen as objects of homosexual desire. However, his early Pop work, which is his most important contribution to the development of the style, has no images of male nudity, though he was to return to the theme later in his career.

By contrast with this, Warhol's films are much more homoerotic in orientation. Not only were female roles often assigned to male transvestites, but the camera often dwells lovingly on the masculine charms of Joe d'Alessandro and other performers like him. D'Alessandro began his career as one of the models featured in the brochures of the Athletic Model Guild, one of several Los Angeles photo-studios which catered for the tastes of a gay clientele in this period.

Hockney was more systematic, also bolder, in his use of gay imagery. He used this to build up a picture of a new, hedonistic, guilt-free homosexual lifestyle. His first images celebrating homosexuality were made when he was still a student at the Royal College of Art, in 1959–62. He elaborated on them when he discovered Los Angeles, and refined his imagery further in a series of prints (1966) made as illustrations to the poems of the Greek Alexandrian writer C.P. Cavafy (1863–1933). Most of these, in keeping with the subject matter of the poems themselves, were images of naked boys, presented without reality as part of the poet's, and also of his illustrator's, quotidian reality.

Cavafy wrote most of his best work after he was forty, and he can be seen as part of a semi-clandestine, turn of the century culture which also included among its members the photographer Wilhelm von Gloeden (1856–1931). His poems were originally published in very small editions, and circulated chiefly among his friends. Hockney opened this essentially private world to general inspection by reimagining it in terms of his own time. For example, the rather naive photographs produced by the Athletic Model Guild, which Hockney discovered on his trips to California, clearly form part of the inspiration for his set of Cavafy prints. The artist plundered this and other sources in the American gay subculture in much the same way that Mel Ramos (b. 1935) and others plundered the iconography of the American pin-up in the name of Pop Art. In doing so, he suggested, perhaps without consciously meaning to do so, that homosexual erotica of this type was already making a place for itself in the development of popular culture.

Hockney's art took this idea even further. By seizing upon the male nude as an essential part of his subject matter, he made the claim that it was now, just like the female nude, a legitimate vehicle for erotic feeling, and at the same time rejected the idea that a response to its erotic appeal was anything to be ashamed of.

The Mirror of Homosexual Desire

148 BALY HINTER WIPFLINGER, Untitled (*1994*). *In this photograph the model strikes a standard 'glamour' pose, less insistent on sheer muscularity than the poses seen in body-building competitions (above).*

149 MICHAEL LEONARD (*b. 1933*), Change into White (*1994–96*). *British artist Michael Leonard is extremely skilful at suggesting eroticism without showing anything which can be called specifically erotic (right).*

*T*HE 1960S AND 1970S *were a period of liberation for male homosexuals — one of increasingly unbridled freedom. The progress of liberation can be traced in publications such as the catalogues issued by the Athletic Model Guild (recently republished in their entirety by Taschen, a German publisher). In 1968 the posing straps and artificial fig-leaves the photographer had hitherto felt compelled to employ abruptly vanished, while the poses adopted by the models became much more overtly sexual. Full-frontal shots featuring erections were not slow to make their appearance.*

The initial reaction to the liberated climate embraced two apparently contradictory processes. It validated the private or semi-private work of photographers like Wilhelm von Gloeden, George Platt Lynes (*1907–55*) and Minor White (*1908–76*), and made it much more publicly available. It also drew attention to photographers and illustrators whose main focus during the years of suppression had been erotic rather than strictly artistic, leading to ideas that their work deserved to be recategorized as art.

The most striking example of this process was the Finnish-born erotic illustrator Tom of Finland (Tuoko Laaksonen, *1920-91*), whose drawings first reached the American gay male public as cover illustrations for Athletic Model Guild catalogues. Not all of Tom's figures are nude, or even semi-nude, though they were usually engaged, whatever their state of dress, in explicitly sexual acts.

Tom was well aware of the fetishistic impact produced by carefully selected items of clothing, such as tall boots and leather bikers' jackets. He used these to exaggerate the masculine aura of his figures. Tom claimed that his drawings had originally been inspired by the German soldiers with whom he had fleeting sexual relationships in Helsinki during World War II. Basing himself on these, he invented a new homosexual icon, a cheerful, exaggeratedly muscular boy-man who was a close cousin to the super-masculine, but somehow innocent, bodybuilders who featured in 'peplum' movies. This cycle of films was very popular with gay men, who in fact formed a large part of their public. It is therefore amusing to note the close connection between some of the wild Pop Art posters devised to publicize them, and some of Tom's narrative scenes.

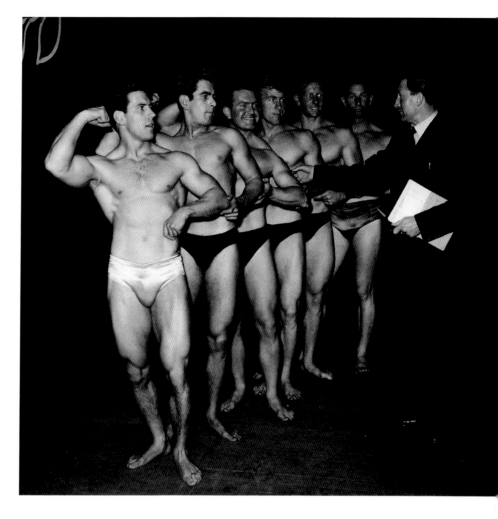

Tom's art rose to respectability on the presupposition that the chief task of a newly liberated homosexual iconography was to explore the exuberant hedonism that now possessed the world of gay males, especially in the United States. In general, however, there was little sign of the appearance of a specifically gay art movement at this time, to provide a parallel for the feminist art movement that asserted itself during the same epoch. There is no gay male equivalent for Judy Chicago's massive feminist installation *The Dinner Party*, first exhibited in 1979.

It is interesting to reflect, nevertheless, that the first presentation of *The Dinner Party* more or less coincided with a much less public male homosexual event – the publication of the photographer Robert Mapplethorpe's *X Portfolio*, which documents sado-masochistic practices among males in images of deliberate formality. A close-up of a fist entering an anus, for example, offers forms similar to some of those found in Brancusi's sculptures.

The Dinner Party and the *X Portfolio*, both monuments to a particular moment in American culture, nevertheless present striking contrasts. Chicago's purpose in making her environment was democratic and educative, and its creation involved the skills and energy of a great many other women in addition to herself. The *X Portfolio*, as its name suggests, was a secretive elitist enterprise

150 Physical Training (*1938*). *At a time when homosexuality was strictly forbidden, 'healthy life' photographs like this had clandestine erotic appeal (left).*

151 Bodybuilders (*1955*). *The 1950s saw an enormous growth of the bodybuilding cult, and massively muscular physiques came into fashion (above).*

171

152 TOM BIANCHI (*b. 1949*),
Untitled 4. *Photographs
showing open displays of male
affection, like this one, only
became publishable in the 1980s.*

which made its impact largely through gossip. Unlike *The Dinner Party*, many more people knew of its existence than had actually seen the images it contained. The cool formality of Mapplethorpe's photographic style intensified the effect of his imagery, while at the same time emphasizing the elitism of the whole enterprise.

The male nude, and indeed homosexual imagery in general, did not take a major place in the art of the 1970s for more than one reason. The general climate of the avant-garde visual arts was at that time increasingly hostile to figurative work. This was a trend which had begun in the mid-1960s. The period saw the rise of Minimal and Conceptual Art in the United States and of *arte povera* in Europe. Feminist art did make use of figurative images for its own purposes, but still had strong links with the intellectual movements of the time, notably with French Structuralism, which it adapted to suit its own purposes. Where feminist art was soon supported by a growing body of critical writing, 'queer theory' (as it came to be called) had yet to manifest itself. That is, there was as yet no analysis of homosexual difference and no debate about whether or not there was a special homosexual position in society. When it arrived, queer theory proved to be as much about the situation of lesbians as it was about that of gay men. In this sense it can be regarded as an offshoot of feminism.

When gay male artists began to take up specific theoretical positions, this could be seen as being, in large part at least, a reaction to the outbreak of the AIDS epidemic, which brought the saturnalia of the 1970s to an abrupt halt at the beginning of the following decade. In developed societies, AIDS made its first impact on male homosexuals, intravenous drug-users and haemophiliacs. Homosexuals formed by far the largest group and had the highest social visibility.

AIDS seemed to deprive gay males of the liberty they had so recently gained, and to mark them as being, once again, a pariah sect. In reaction to this, a new level of organization within the gay community was formed. In the 1970s gay men had joined together almost entirely for hedonistic purposes – in bars, in bathhouses, in the vast dance-halls which were popular at the time. Now they came together for mutual support, in the face of the disaster which had befallen them. They learned to resist and to fight. To be a male homosexual now implied being a member of a political pressure group, and even those who disliked this identification nevertheless found themselves classified, willy-nilly, as potential activists.

In the world of contemporary art, this development took place within a larger but closely related context. The Conceptual Art of the 1960s and 1970s had largely been about ways of perceiving the world – an example is Joseph Kosuth (b. 1945) whose installation features a real chair, a photograph of a chair, and a dictionary definition of a chair. Now, under the influence of the German sculptor Joseph Beuys (1921–86), it took on an increasingly political aspect.

153 DAVID HOCKNEY (b. 1937), Two Boys in a Pool, Hollywood (1965). *Hockney's hedonistic celebration of homosexual life in Los Angeles helped to pave the way for gay liberation.*

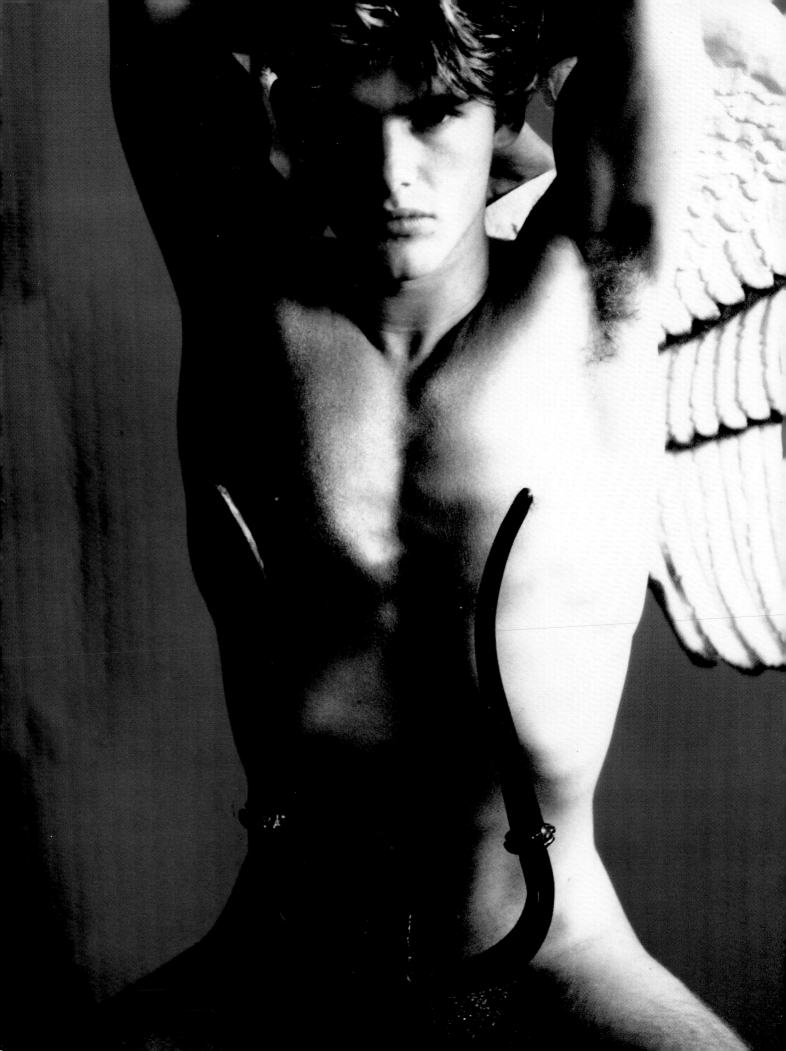

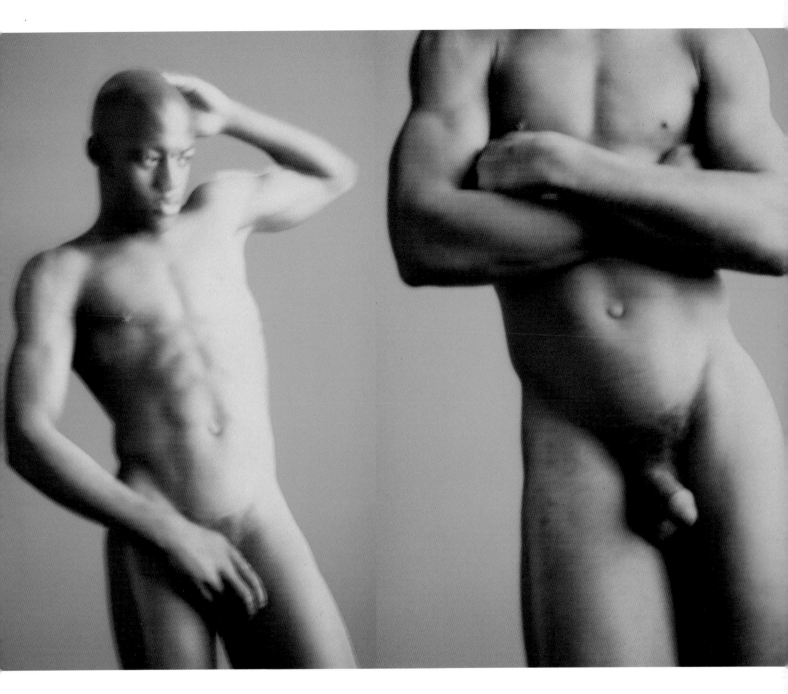

ROLAND BEAUFRÉ, **Untitled**.
*In these three images French
photographer Roland Beaufré
celebrates the gay ideal of the 1990s.*

AP " Hylas, Hercules + Apollo

Beuys was perhaps the first artist who used the museum (or, in a broader sense, exhibitions of contemporary art) as a forum for political discourse. The centrepiece of the Kassel Documenta of 1972, for example, was Beuys' Bureau for Direct Democracy, in which the artist tirelessly debated political and social issues with all-comers. Beuys asserted that there was no difference between his activity as an artist and his participation in political discourse – the latter activity he categorized as 'social sculpture'. Museum and exhibition curators tacitly accepted his point of view.

Though Beuys did not immediately influence American art – he had long been famous in Europe before his work was discovered in America, and transmission of his ideas, in an age of mass communication, was in this respect remarkably slow – his example did, in the end, affect museum attitudes everywhere. Museums could not deny other artists the freedoms they had offered to Beuys. This had a particularly important effect in the United States, where nationally visible opportunities to express radical ideas were often otherwise lacking. The ideas themselves were, however, increasingly present and the art world was one of the places where they made the most impact. In the late 1980s and early 1990s museums often offered a platform to various members of what came to be called the rainbow coalition. The rainbow coalition consisted of various minorities, and of people who thought of themselves as being placed in a minority situation. This last proviso has to be added since, in addition to members of identifiable racial and cultural groups, such as African Americans and Chicanos, it embraced the activity of feminists – and women are certainly not a minority of the American population or of the human race. It also included members of the newly militant gay male community.

The characteristic art of the rainbow coalition is hortatory and admonitory. It excoriates injustices; it makes claims for moral superiority. It also tends to be didactic. As such, it does not usually offer opportunities for the creation of new images of the male figure. Where male imagery is present, as in some of the complex compositions of David Wojnarowicz (1954–82), it is employed largely for its shock value, and is usually lifted from another source, such as male pornographic magazines. When the nude male figure does play an important role in the avant-garde art of the 1980s and 1990s, it is often in the 'autobiographical' context which has already been discussed.

The success of feminism has, however, had one very strange and far-reaching consequence for the contemporary visual arts, and this is an increasing concern about any use of the nude female figure by artists. Female nudes are said, by some influential feminist theoreticians, to encapsulate men's power over women. They symbolize, it is said, the domination of the female sex by the male gaze. As a result, this whole

155 DELMAS HOWE (b. 1935), Hylas, Hercules and Apollo (lithograph, 1995). Gay New Mexico artist Delmas Howe equates the fantasy of cowboy life with homoerotic episodes drawn from classical mythology (left).

156 DELMAS HOWE, Pantheon Study IV. Here, again, the Western cowboy is presented as the equivalent of the classical Greek hero (below).

157 VICTOR PALACIOS, Untitled. A young gaucho is photographed as an object of erotic desire (over page).

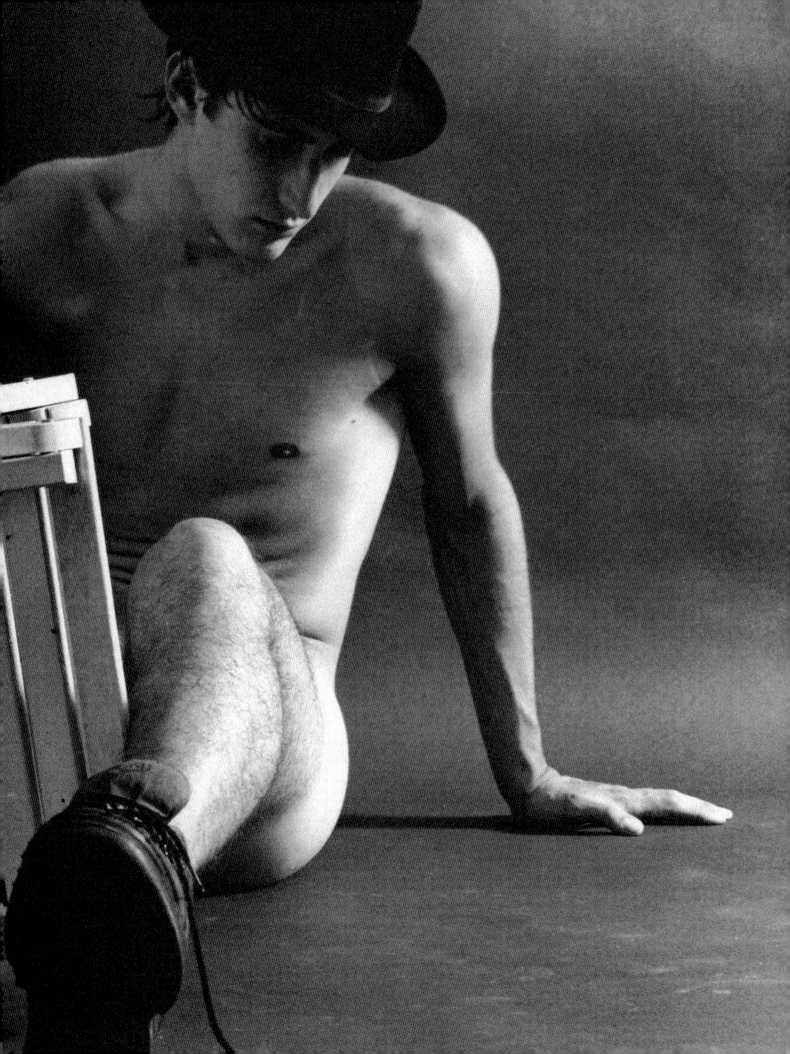

158 TOM OF FINLAND (*Tuoko Laaksonen 1920-1991*).
*Tom's erotic drawings, made – as he himself declared –
for purely erotic reasons, have achieved mainstream
respectability. This example shows his typical muscular
boy-men, comfortable with their own sexuality (above).*

range of imagery, so important in the history of Western painting, has largely been banished from the realm of high art, though it continues to flourish, albeit in somewhat subdued and diminished guise, in that of mass culture.

Though feminists have also objected to representations of nude men, they have found this objection, for obvious reasons, more difficult to sustain. The result has been a rise in interest in making representations of the male, especially in photography. The diminished role of the figurative image in contemporary painting and sculpture has to some extent been compensated for by the way in which it, almost necessarily given the actual nature of the medium, dominates photography. And in photography itself, the human figure, rather than the landscape or the still life, tends to be king.

Photographs of the nude male have increasingly taken on a double or even a triple function. In the first place, they serve, as in fact they have done ever since the invention of photography, as the mirrors of homosexual desire. It is therefore ironic that, after spending so many years in the realm of the forbidden, they should now be less forbidden than equivalent photographs of females.

We live in an age that has witnessed a powerful but uneven revival of puritanism, often intimately linked to what were once thought of as 'liberal' values. The male nude, simply because it is now more marginalized than the female equivalent, as a result of the way art developed in response to the rise of a new middle class in the eighteenth and nineteenth centuries, has often escaped the full weight of this attack. In fact, it is to some extent protected from it by the position of homosexuals within the rainbow coalition, which has also been a great promoter of what is seen as 'politically correct'.

At the same time, the last two decades have witnessed an increasing tendency to eroticize the male body. In contemporary advertising, male nudity or near nudity is now seen as a powerful sales weapon, effective with more than one group. It sells to homosexual men, who notoriously tend to have higher disposable incomes than their heterosexual counterparts. It sells to women,

159 BALY HINTER WIPFLINGER, From Aladdin's Lamp (1994). *A simple pose which indicates the subject's relaxed state of mind concerning his own nudity (over page, left).*

160 BALY HINTER WIPFLINGER, Torment (1994). *Bondage subjects remain as popular with the gay audience as they were for the supposed straight audiences for epic movies in the late 1950s (over page, right).*

183

161 EDWARD LUCIE-SMITH, John and Richard
(1997). *The recent relaxation in public attitudes
towards the open expression of homosexual affection
has made it much easier for photographers to make
romantic studies of this kind.*

who have become much more frank in their expression of their own sexual needs. Hence, for example, the advent of the male stripper, who often performs for an audience that consists entirely of women. 'Hen nights', with a stripper as entertainment, have become occasions for raucous female bonding. Finally, male nudity sells goods to straight men, who are encouraged to identify themselves with the physical attractions of the model. Notable instances of this have been advertising campaigns for Calvin Klein and for Versace.

Thanks to the impact made by feminism, and the general climate of puritan disapproval of what is sexually explicit, which feminism has sometimes encouraged, the crossover from the commercial sphere to identifiably 'artistic' territory has taken place more easily when male bodies are being pictured rather than female ones. This transition is, after all, also a move from the realm of mass culture into that which is undeniably elitist. Bruce Weber's frequent inclusion in museum shows is a mark of elitist approval, as well as a sign that the images he makes do not play too prominent a role in contemporary wars about gender. Invitations of the same sort are not extended to leading 'calendar' photographers such as Patrick Lichfield, who continue to specialize in female nudity or near-nudity. Though Lichfield is an English aristocrat, what he produces remains culturally déclassé. The pin-up has lost the brief respectability it enjoyed in the 1960s, and Jeff Koons is now almost the only ranking member of the avant-garde to make use of heterosexual 'top shelf' source material. Since Koons' basic subject is the idea of 'taste' – its presence or absence; how bad taste is transformed into good taste – this is significant in itself.

Yet there is more to it than this. The meaning of male imagery seems to be becoming more ambiguous, as it begins to appeal to a wider public. In a society which identifies with images of speed, action and physical prowess, male bodies have an advantage. The erotic quality of many sports photographs has often been commented upon, and men feature in these much more often than women. If we see the nude or near-nude as a sportsman, the eroticism of the image, while still present, is contained and made palatable to all.

One can claim, therefore, that the male nude as a subject for art is currently going through one of its periods of radical transition. Given a central role by the Greeks, then banished for a long period by Christian asceticism and hatred of the body, it was revived by the Renaissance, only to fall victim, but only very gradually, to the social and economic forces which created modern society. Now that very society is beginning to feel a need for this range of imagery again, while remaining somewhat afraid of some of the darker forces to which it seems to appeal.

162 ROBERT TAYLOR (b. 1958), Big Tool (1993). Homosexual fascination with genital size is crisply satirized in this silhouetted image.

Index

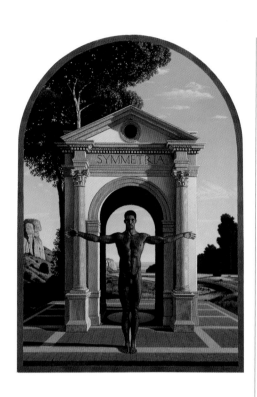

Numbers in **bold** refer to the picture numbers in the text.

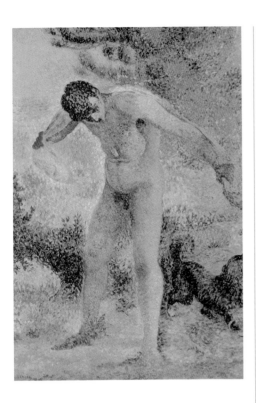

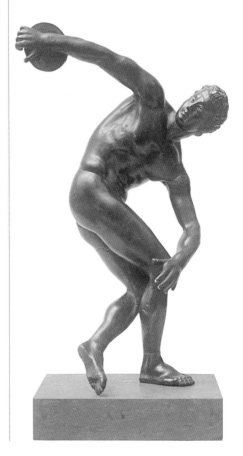

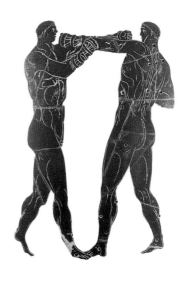

Acknowledgements

AKG photo, London; p.31

Albertina Graphic Collection, Vienna/The Bridgeman Art Library; p.153

Jim Amaral; p.139

Doris Ammann, Zurich; p.86–7, 167

Archaeological Museum, Bari/The Bridgeman Art Library; p.24

Artephot/Visual Arts Library; p.2, 14(L), 16, 18(L), 22–3, 30, 32, 33, 34–35, 40, 41, 42, 49, 58, 60(TL), 63, 65, 80, 83, 88, 95, 114, 121, 134, 136

Ashley/Gaze International; p.122

Athens Museum of Cycladic & Ancient Art/Visual Arts Library; p.39

Roland Beaufré; p.176, 177

Tom Bianchi/Lizardi/Harp Gallery, Los Angeles; p.50–1, 144–5, 172–3

Bonhams, London/The Bridgeman Art Library; p.18(R)

The Bridgeman Art Library; p.14(R), 36, 71, 102, 116, 142, 156, 175

British Museum, London/The Bridgeman Art Library; p.9(B), 46, 112, 131

Tony Butcher; p.5, 6, 8, 43, 146

Luis Caballero; p.37, 92

Santiago Cardenas; p.26

Rex Chan; p.166

Judy Chicago/Through the Flowers; p.124–5

Wes Christensen/Lizardi/Harp Gallery, Los Angeles; p.141

Christie's, London/The Bridgeman Art Library; p.48

Ricardo Cinalli; p.89

Mario Cravo Neto; p.123

The De Morgan Foundation/ The Bridgeman Art Library; p.68–9

Ian Dickson/Redferns; p.77

George Dureau; p.27, 126, 127

Edimedia/Visual Arts Library; p.98, 147

Mary Evans Picture Library; p.38, 70, 119

Fitzwilliam Museum, University of Cambridge/The Bridgeman Art Library; p.19

Jack Fritscher; p.99

William Fogg/Lizardi/Harp Gallery, Los Angeles; p.9(T)

Galleria Degli Uffizi, Florence; p.115

Gilbert & George; p.154–5

Nohra Haime Gallery; p.129, 158

Elizabeth Harvey-Lee/The Bridgeman Art Library; p.76

Scott Hess/Lizardi/Harp Gallery, Los Angeles; p.11(B)

Javier Hinojosa/Courtesy of Iturralde Gallery; p.128

Baly Hinter Wipflinger/Gaze International; p.44, 45, 168, 184, 185

David Hiser/Tony Stone; p.108

Harry Holland; p.163

Delmas Howe; p.178, 179

Hulton Getty; p.13(T), 53, 72–3, 170, 171

Christopher James/Lizardi/Harp Gallery, Los Angeles; p.100–1

E.F.Kitchen/Lizardi/Harp Gallery, Los Angeles; p.113

Kunsthistorisches Museum, Vienna/The Bridgeman Art Library; p.96–7

Michael Leonard; p.169

Peter Liashkov/Lizardi/Harp Gallery, Los Angeles; p.7(B)

Louve, Paris, France/The Bridgeman Art Library; p.7(T), 10(B)

Edward Lucie-Smith; p.62, 110, 186

Roberto Marquez/ Riva Yares Gallery; p.78, 162

Meadows Museum, Dallas; p.82

Museum of Fine Arts, Budapest/The Bridgeman Art Library; p.47

Zhao Neng-Zi; p.75

Museum L'Orangerie/Visual Arts Library; p.17

Victor Palacios; p.180–1

Petit Palais, Geneva/The Bridgeman Art Library; p.74

Private Collection, London; p.54–5, 56, 57

Kim Poor; p.11(T)

Prado, Madrid/The Bridgeman Art Library; p.64

Roberto Rincón; p.25, 109, 132–3, 160–1

Zsuzsi Roboz; p.15

Stephanie Rushton/Tony Stone; p.130

Jean Rustin; p.159

Pablo Suarez/Lizardi/Harp Gallery, Los Angeles; p.157

Robert Schoclkopf Gallery/Visual Arts Library; p.120

John Sonsini/Lizardi/Harp Gallery, Los Agneles; p.12

Southampton City Art Gallery/The Bridgeman Art Library; p.137

James Strachan/Tony Stone; p.103

Robert Taylor/Gaze International; p.187

By arrangement with Tom of Finland Foundation, Los Angeles; p.182

Arthur Tress; p.61, 164

Victoria & Albert Museum/The Bridgeman Art Library; p.107

Visual Arts Library; p.10(T), 20, 29, 40, 52, 59, 78, 84, 85, 94, 106, 138, 148, 149, 150, 151, 165

Wallace Colection, London/The Bridgeman Art Library; p.60(BR)

Jonathan Webb; p.105, 110, 143

Patty Wickman/Lizardi/Harp Gallery, Los Angeles; p.90–1

Peter Willi/Louvre, Paris/The Bridgeman Art Library; p.66–7

Donald Woodman; p.118

Copyright